PAINTBRUSHES
AND PISTOLS

PAINTBRUSHES AND PISTOLS

How the Taos Artists Sold the West

SHERRY CLAYTON TAGGETT
AND
TED SCHWARZ

John Muir Publications
Santa Fe, New Mexico

To my daughter Laura Ann Brown who met the long years of research
this volume required of me with patience beyond her youthful years.
Though I cannot replace the hours lost between us, I dedicate this
book to her with all my love.

—Sherry Taggett

John Muir Publications, P.O. Box 613, Santa Fe, NM 87504

First edition. First printing

Library of Congress Cataloging-in-Publication Data
Taggett, Sherry Clayton.
 Paintbrushes and pistols : how the Taos artists sold the West /
Sherry Clayton Taggett and Ted Schwarz. — 1st ed.
 p. cm.
 Includes bibliographical references and index.
 ISBN 0-945465-65-3
 1. Taos school of art. 2. West (U.S.) in art. 3. Art, American—New
Mexico—Taos. 4. Art, Modern—20th century—New Mexico—Taos.
I. Schwarz, Ted. 1945- . II. Title.
N6512.5.T34T34 1990
759.189'53—dc20 90-13431
 CIP

Cover design: Sally Blakemore
Design: Abraham
Composition: Copygraphics, Inc.
Printer: Banta Company
Typeface: Impressum

Distributed to the book trade by:
W. W. Norton and Company, Inc.
New York, New York

Cover painting, "Portrait of Jim Romero, 1916-25," by Ernest Blumen-
schein. This and other paintings and photographs are courtesy of
Fenn Galleries, Santa Fe, New Mexico.

CONTENTS

INTRODUCTION

The romantic image of the American West was one of the great myths of eastern society at the start of the twentieth century. In fact, western settlements were sparse, the pioneering settlers more likely to be cantankerous misfits than heroic figures.

Contemporary American society began in the colonies of Massachusetts, New York, Rhode Island, Connecticut, and other early settlements. There were farmers, goldsmiths, artists, and craftsmen. The early institutions of higher education developed there along with museums and libraries. They were good places to have children, raise families, gain an education, and experience all the cultural benefits the new nation had to offer.

The people who left the East during the nineteenth century were frequently the misfits, the losers, the adventurers seeking quick financial rewards. The Mormon church began in the East, encountered violent hostility, and moved West where the members could isolate themselves from others. Men seeking a quick fortune rather than a slow apprenticeship in a family business moved to San Francisco, where they thought the hills were so filled with gold that thousands of dollars a day could be obtained with little effort. Gunslingers driven from respectable cities moved

West, where they delighted in terrorizing small towns or became pillars of the community, channeling their blood lust into such "productive" areas as vigilante groups.

Eastern novelists spun fantasies about such people as Buffalo Bill Cody, a man who delighted in destroying the major source of food and clothing for the American Indian in the guise of helping the railroad expand. They made heroes of men like Davy Crockett, whose death at the Alamo probably did not occur in the midst of battle but rather by firing squad after he was found hiding under a bed when the Mexican army broke through the fort's defenses. Killers who accepted a town marshal's badge instantly became heroic lawmen. Prostitute/robber/murderers became gentlewomen who had been the misunderstood victims of communities that prospered because of their ministrations.

Yet no matter what the reality of the West, farsighted business people recognized that money was to be made in the vast, sparsely settled wilderness. Inside the land were valuable minerals, silver, and gold that could be used in international commerce. On the land were vast forests and seemingly endless wildlife, all of which could be exploited for furs, food, construction, and numerous other uses. And the Pacific coastline was the gateway to the Orient, where international trade had become well established.

In addition to the obvious commercial benefits of the American West, there was the beauty of the land itself. Vast mountain ranges, endless valleys, varied vegetation, and such splendors as the Grand Canyon and the Colorado River were ideal for both tourists and settlers. The creation of the Atchison, Topeka, & Santa Fe Railroad theoretically was going to change the West. Suddenly there was a means of traveling the vast land in comfort. Safe tourism was possible. New communities could be created or expanded. Businesses could become bicoastal, opening up numerous possibilities for marketing, sales, and a variety of profit-making ventures.

The trouble was, almost nobody came. They were afraid to. Although in the real West the American Indian lived primarily in agricultural societies, the dime novels had them taking scalps. The real West was pastoral, quiet, the

2

seasons changing so subtly you had to learn the nuances of the desert and mountains. The dime novels seemed to have a robbery or murder everywhere you went and choking dust storms or thunderstorms ripping into the land while raging torrents of water endangered all in their wake. Yet they molded public awareness in the East, creating images people wanted to experience only through the written word in the comfort and safety of their East Coast homes.

The answer to the dilemma was an unusual alliance among immature, naive men of great artistic talent who became known as the Taos Society of Artists, Fred Harvey, a perfectionist genius in the field of food and lodging, and the promotion-minded heads of the Atchison, Topeka, & Santa Fe Railroad. Together they would create the westward migration that has resulted in the vast metropolitan developments that exist today. In addition, the haphazardly conceived, poorly organized, and highly eccentric Taos Society of Artists also radically changed styles of both American fine art and commercial illustration. This book is the story of the three symbiotic forces that changed the American West as well as American art in the early years of the twentieth century.

It is hard to imagine a more unlikely beginning for a major American art movement. Ernest Blumenschein, founding member of the Taos Society of Artists, was a dude, a dandy, a would-be cowboy whose fantasies were not enough to stop him from playing tennis and bridge and dressing formally for dinner in the midst of some of the roughest wilderness land in America. Blumenschein's primary work had been as an illustrator, creating paintings that conveyed the action of short stories and novels. It was a profession that enabled him to live in the fantasy world of the storyteller, where heroes, heroines, and villains were clearly defined and quite unlike real life.

Fred Harvey was a restaurateur, a British gentleman whose goal in life was to bring a fine dining experience to men and women crossing the United States on the previously uncivilized Atchison, Topeka, & Santa Fe Railroad. And then there was l'Académie Julian, once considered the most disreputable art school in all of Paris, an unlikely

training ground for the last artists who would devote them-
selves to capturing the dying American West on canvas
and in sculpture.

BLUMENSCHEIN

rnest Blumenschein and the other artists who
founded the Taos Society of Artists and ultimate-
ly worked with the Atchison, Topeka, & Santa Fe
(AT&SF) Railroad were illustrators, working in one of the
most respected and highest paying fields for an artist in
the nineteenth and early twentieth century. Photography
had not been invented until the 1840s. It was a slow, labori-
ous, expensive process that could not be used to illustrate
books, magazines, and newspapers. Those media relied
upon drawings and paintings, so it was the artist, not the
camera operator, who interpreted the world for the aver-
age person. The eye of the illustrator, sometimes truthful,
sometimes biased, was the source for understanding the
world.

To be an illustrator was to be the equivalent of the con-
temporary globe-trotting photojournalist, commercial and
advertising photographer, all combined in one. Men and
women with sketch pads, paintbrushes, pens, and ink cov-
ered breaking news stories, climbed mountains, explored
unchartered territory, and recorded the latest scientific
developments. Depending on their market, they might find
themselves on a train, a ship, a horse, a mule, or a camel.
Or they might be asked to fantasize from their drawing

board in New York, San Francisco, Chicago, or wherever their publication was based.

For an artist/illustrator in the United States, it was the best of times and the worst of times. Newspapers and magazines were flourishing at the end of the nineteenth century. Their stories were designed to appeal to people in all walks of life. The New York *Journal*, for example, carried a story about the thigh of a body being found in the East River, *Journal* reporters immediately connecting it to a human trunk held in the morgue. A $1,000 reward was offered for information leading to both the identification of the corpse and the identity of the killer. And in the same newspaper, the story of twenty babies killed and left on the streets of Harlem, a fashionable residential area of the day, titillated readers. The illustrator had to produce a drawing that visually told the story of the article it serviced. Thus the artist for the New York *Journal*'s story about the baby murders in Harlem drew images of concerned police, a fashionable lady seeing a box that held a baby's corpse (the box was tastefully closed, though a baby's face was inset in a corner of the drawing), and other details the artist never witnessed.

And the *Ladies Home Journal* addressed the more sophisticated strata of society. Writer Margaret Sangster defined the magazine's title in a comment made in 1892:

> Lady *was made to be the title of such women as she, dignified, courteous, with manners that may well be called finished, so they are touched with a gentle ceremony, so they are free from haste, and rounded out with leisure.* Woman *is a term for business and service, for everyday use and wont.* Lady *may be defined as* "Woman *in a high state of civilization....*" *My beautiful, great lady, in her lustreless gown of rich black silk, with yellow ruffles at her wrists, and her antique brooch at her throat.*

Edward Bok, the *Journal*'s editor during this period, talked of the fact that women could support themselves on less money than men, if they had to be in the work force. However, despite his belief that she had an easier existence

and needed less money for survival, he still felt that there should be equal pay for equal work. In 1891 he wrote,

> _The atmosphere of commercial life has never been conducive to the best interests of women engaged in it. The number of women in business who lose their gentleness and womanliness is far greater than those who retain what, after all, are woman's best and chief qualities. To be in an office where there are only men has never yet done a single girl any good; and it has done harm to thousands . I know whereof I speak, and I deal not in generalities._

And somewhere in between the two types of publications were the Sunday supplements, a new kind of magazine added to newspapers every week. These often had stories about new discoveries of different cultures and unusual beings. One story had a French scientist and explorer encountering a race of primitive people, all of whom had tails. Another told of the women of South Sea islands, all of whom were naked above the waist. The fact that neither the artist nor the writer had ever experienced such a culture meant nothing. The story would sell newspapers and the illustrations would sell even more papers. No one admitted that the images were a way to sell sex in a manner acceptable to the public, though it was such drawings that led to the scorn the illustrators often received from others.

There were also literary magazines and general interest publications that carried commentary, fiction, and information needed from day to day. The types were as diverse as the readers they served, and they sold in quantities well beyond contemporary circulation, at least relative to the population as a whole. In the years before radio, television, and movies, they were almost the sole commercial entertainment that could be brought into the home. The public's appetite for illustration seemed endless. Most illustrations were serious attempts to show a story, and many were genuinely beautiful images that some people framed for their walls.

The problem with illustrating was that it was not always a respected profession. "Nice" young men and women who entered the arts painted for museum and gallery exhibition and sale. The more sophisticated the community, the less respect illustrators had, even though they were the backbone of contemporary culture. Men like Blumenschein were exposed to illustrations long before they had a chance to see what would be called fine art. Newspapers, magazines, and books had pictures that both re-created events and stimulated the imagination. Yet to many people, such illustrators were held in no higher regard than today's photographers who provide the pictures accompanying stories in *Playboy, Penthouse,* and similar publications.

Fine artists, working through galleries, museums, and other locations, also held men like those who formed the Taos Society of Artists in disdain. They intimated that such individuals were less skilled than themselves because they were not free with their subject matter. A fine artist could paint as he or she pleased, letting their "muse" guide them as they created a masterpiece.

Fine artists were not pure and noncommercial, however. For example, the high-class bars and restaurants serving wealthy men made a point of commissioning respected artists of the day to paint erotic images of women in various stages of undress. The work was always tastefully done, yet far sexier than anything "nice" people could normally see. Many such works of art could easily have been considered the mild pornography of the time. Yet the artists solemnly created it, proud to be producing sensitive life studies of beautiful women which were always hung in places of honor.

What was not said was that the women were as delighted with such images as men, though they dared not bring such work into their homes. Instead, each Sunday afternoon the ladies were welcomed in the bars, clubs, and restaurants their husbands frequented during the other six days of the week. They would take walking tours through the fashionable entertainment districts, going in and out of the clubs to admire the works of art. Their expressed

motivations and interests were a genteel fiction meant to preserve everyone's reputation.

The result of this hypocrisy was that some men came to look on illustration, especially of novels and short stories, as an honorable profession, not to be scorned. Joseph Pennell, one of the most successful illustrators of the 1880s, once wrote, "An illustrator receives more publicity from a magazine which publishes illustrations than any other artist, for though large numbers of people may see in one city an art exhibition, an illustrated magazine is an art gallery for the world."

Some of the illustrators were also reporters who were involved with various scandals caused by the aggressiveness of the press at the end of the nineteenth century. Perhaps the most dramatic was the incident in which famed illustrator Frederic Remington was sent by William Randolph Hearst to Cuba to illustrate the violence of the Spanish against the Cuban people, who were demanding their freedom from foreign rule.

Hearst was typical of the newspaper tycoons of the 1890s. He had just purchased the New York _Journal_ and needed ways to increase the circulation. He delighted in stories about murder, often offering rewards in order for the readers to look on the mysterious deaths as games for which there would be prizes. Nothing was too outrageous if it resulted in a good story, and the alleged violence in Cuba seemed perfect. When Remington could not find any, Hearst sent him a telegram stating, "You furnish the pictures, I'll furnish the war."

Many people believed that the illustrators, through Hearst, were directly responsible for Americans going to war against Spain. They state that the illustrations he encouraged (Remington showed a naked woman being searched by Spanish soldiers, for example) and the prose he used forced the politicians to act despite the facts being to the contrary. Most of the men who eventually moved to Taos delighted in the excitement of such a life, at least in their early years. As illustrators, they were both the visual chroniclers and the instigators of the news, the ideas, and the attitudes of the American public.

The postal regulations of the day also helped the cause

of illustrators. Books became quite expensive, but magazine rates were very reasonable. Dime novels were actually magazines requiring frequent illustrations, and the heroes were generally working-class people who went from rags to riches, an approach that assured a wide popular market.

And all this competition increased the money paid to the top illustrators. *Collier's Weekly* assured Charles Dana Gibson of one hundred assignments at $1,000 each for his illustrations at the turn of the century. And by 1905, Gibson was given a salary of $65,000 per year.

Other artists also reaped large rewards. But even new artists at the start of their careers were given lucrative assignments. And among these were the men who founded the Taos Society of Artists, including Ernest Blumenschein, who was lucky enough to illustrate a number of stories by Jack London which were set in the Yukon Territory where gold had recently been discovered.

The idea that Ernest Blumenschein would fancy himself a cowboy and, after much hesitation, ultimately run away to the West might be seen as the manifestation of a rebellious streak raging from early childhood. His father was dictatorial, a perfectionist to whom no one could measure up, neither wife nor son nor the pupils to whom he taught music.

Blumenschein's mother was remarkably like the woman he ultimately married—extremely gifted yet willing to sublimate her talents to her husband's wishes. Leonora Chapin Blumenschein was a brilliant painter quite capable of museum representation at a time when her husband, William (Wilhelm, originally) Leonard Blumenschein, felt this was improper. Just as he had given up drawing for a career in music, ultimately becoming a composer and conductor, so she was expected to abandon painting to teach music and sing for others in their hometown of Dayton, Ohio. The difference was that William Blumenschein might have been considered a talented Sunday painter whose work, though pleasant enough to look at, would never have commercial value. Leonora, however, was a fine artist whose work was of gallery and museum quality, but to please her husband, she confined her "show-

ings" to the walls of the family home. Tragically, she died while still a young woman, and Ernest Blumenschein did not fully appreciate her talents until he, too, had become an artist.

Not that Leonard Blumenschein, as William was generally known, was without skills in his own right. He was a composer and conductor as well as a teacher, professions that were part of his family tradition. In fact, Leonard's father, Johann Georg Blumenschein and his half brothers, Jacob and Nicholas Jung, formed their own orchestra while still living in the city of Hesse, Germany. It was believed to be the finest such musical group in Hesse. In addition, another of Johann's sons, Phillip Blumenschein, was the conductor of a circus band. Yet despite this fact, Leonard was encouraged to take a career outside of music. It was hoped that he would become a businessman, a career he pursued while in high school in Pittsburgh, Pennsylvania, working part-time at Harne's Dry Goods store, advancing to cashier after graduation.

Leonard was too much like the rest of his family to stay with business, though. He wanted to become a composer and stayed at Harne's only long enough to earn the money to travel to Leipzig, where he felt he could gain the best training in music theory and composition. He spoke fluent German, having been born in Brensback, near Darmstadt, on December 16, 1849, then being raised from the age of two in the German community living in Pittsburgh. His education had been in English, but his parents and family friends usually spoke their native tongue, a definite advantage for him.

Leipzig in the mid- to late 1800s was to music what Paris was to art, although Germany was more conservative. It had been the home of Robert Schumann, Johann Sebastian Bach, and Felix Mendelssohn and was currently where Richard Wagner was developing his opera _Der Ring_. The Gewandhaus orchestra and Thomaner Choir were considered among the best in the world, and Leonard was able to regularly attend their performances.

Leonard Blumenschein's professional life was ultimately successful. He was credited with having composed fourteen anthems, fifty pieces for the piano, seven secular

quartets, and twenty songs. Among other accomplishments, he was the director of the Dayton Philharmonic Society for almost thirty years and led the Springfield Orpheus Society, the Ohio Saengerfests, and the Indianapolis Lyra Society, among other groups, usually for one or two years at a time. These made for a respectable career, but both his work and the groups he led were considered second-rate. The communities were small, and the compositions were not of a quality that would get them played by major orchestras.

Leonora Chapin's life was one of unfulfilled promise. She was one year old in 1849 when her mother divorced her father, an alcoholic ne'er-do-well. A second marriage seemed to be happier until that man met an untimely death. As a result, by the time she was seven, Leonora had had three fathers, none of whom, including the last man, John Hull, who raised her to adulthood, were ever close to her.

The Chapin family itself was a prominent one, descended from Deacon Samuel Chapin who arrived in the Massachusetts Bay Colony in 1635, several years after the *Mayflower.* Ethan Allen, a Revolutionary War activist, was also part of the family. However, even those historical connections were rather incomplete. The deacon was viewed as just another British misfit who settled in the least tolerant of all American colonies, a colony that not only had witch trials but was also notorious for jailing, torturing, and murdering Quakers who dared to discuss their religion within its territory. As a result, Ernest Blumenschein would later lie about his family history, claiming that the deacon actually came over on the *Mayflower.*

Leonora was a victim of intolerable child abuse, always done "for her own good." Her stepfather routinely beat her for behavior problems, as did her teacher at school. She frequently ran away, upset by what she had to endure.

Oddly, her stepfather, John Hull, took a certain perverse pride in the abuse, eventually writing about her in a poem meant to serve as part of the family's history. He wrote:

> She now is in her school-girl days,
> The pet of all—such charming ways!
> Her father whips her with a straw,
> Which she tells mamma, and says: 'Law!'
> Her teacher squiched her legs one day,
> To guide her in the proper way.
> "O, whip, and whip, they are but bones,"
> She said to her in off-hand tones.
> Her teacher turned her head and smiled.
> How can she whip the artless child?

Another part of his family poetry dealt with her regular truancy:

> When school is done, she comes not home.
> "She's run away, do send her home!"

The truancy led her to attend several schools, one of which her stepfather called the "school of spear." The others included the Salem School and Maplewood School, a seminary near Pittsfield, Massachusetts, from which she graduated.

Leonora used her musical skills after graduation, teaching from home and singing in the Episcopal church to which the family belonged. She also had her first serious romance, a romance that ended with the man rejecting her for another woman. She was so emotionally overwrought that her father suggested she take a trip abroad to gain a new perspective on life. This was a radical change of attitude for him because this was still a period when such an action would not be deemed fully "proper."

The trip abroad, always with a chaperone, would soon become part of a wealthy woman's proper "finishing." However, this was a time when such a trip was still not fully accepted internationally. Too worldly a woman might question the authority of men, something that was not considered proper. As James Fenimore Cooper wrote in *The Notions of the Americans*, "There is something repugnant to the delicacy of American ideas in permitting a lady to come. . . in contact with the world." Leonora planned to use the trip in a manner she desired, not the way her father had hoped. She had an intense interest in art and had

apparently been learning the field as best she could on her own. Europe, she knew, was the place for serious study, and she had the romantic notion that she could stay abroad, paint, sell her work, and travel. In a time when women were expected to be supported by men, when having to earn one's own way was considered a disgrace, her decision bordered on the scandalous. She chose to remain silent about it, accepting the idea that her relative, Sarah Hatfield, would act as her escort to Leipzig when she traveled on the steamer *Rehin*. There she would study singing and music, or so it was assumed.

There is no record of where Leonora studied art, though experts who viewed her work compared it with such masters of the time as Turner. Tragically, her skills, ideals, and daring were too much for Leonard Blumenschein, whom she met on an excursion boat on the Rhine.

Blumenschein seemed the ideal future husband for Leonora. She thought of him as a free-spirited rebel, much like herself. After all, had he not abandoned his business career to pursue music against his family's wishes? And did he not share her love of music and art? She admired his courage, his drive. And he delighted in her free spirit, her discipline, and her strength of purpose. What she did not realize was that his upbringing made him feel that the very qualities he loved in the single Miss Chapin must be crushed in any woman who would be his wife. And she failed to understand that the determination to study music would be the last rebellious act against family conformity Leonard would ever make. They were tragically destined for failure as a couple, something they did not realize when they married in 1873 and still had not realized by the time Ernest was born on May 26, 1874.

Leonora had become pregnant on the couple's wedding night or within a few days of the marriage on August 5, 1873. They held the ceremony at her parents' home in Springfield, Massachusetts, then moved to Smithfield Street in Pittsburgh where two other children were born— George, in August 1876, and Florence, in June 1878.

Everything was difficult for Leonora. She was comfortable in the small town in which she was raised. She was entranced with those sections of Europe where she had

lived and worked. But Pittsburgh was a big steel town, Andrew Carnegie's industrial empire, which was growing rapidly with people from all walks of life. It offered the worst of urban areas and was a dramatic culture shock. Thus, it was a relief when, after Florence's birth, Leonard was asked to move to Dayton to become the director of the Dayton Philharmonic Society and the organist for the Third Presbyterian Church. He would also be able to teach, a combination of activities that would ultimately enable them to pay their bills.

Leonora quickly found that her husband was a tyrant. He followed the German peasant standards that insisted that the man was the head of the house, and he gave no thought to the woman's interests, talents, or personal needs. He was extremely abusive, not only within the family but also as a teacher.

Ernest Blumenschein was never able to admit the dark, violent, brooding side of his father. Instead, he tried to justify the older man's actions by stating, years later, "My father set high standards of music before the people of Dayton....I was brought up with those same standards, the highest ideals of his art, and shall always be thankful for this early impressive example." And Blumenschein desperately wanted his father's approval, a fact that made him far less objective than one of his father's piano students, Mariam Folson, who later recalled, "Many people in town would not have thought about sending their daughters to him because he was so severe. He would slap your knuckles with a stick if you played a piece carelessly."

The elder Blumenschein's actions were not totally improper for a teacher of the time. In fact, lightly rapping a pupil's knuckles was then a common form of discipline. Unfortunately, he seemed to take such matters a little farther than necessary, being as harsh with rules for students as he was with rules for his wife.

The attitudes of the day were chauvinistic as well, something Leonora knew well. Yet she still seemed to have expected better from her husband. She had been seduced by the romance of two people who had run away to Germany to fulfill their dreams of becoming skilled in the arts. And unfortunately, he was even stricter than the conven-

tional wisdom about male/female relationships which permeated their times.

In 1881, Leonora discovered she was pregnant again. Ernest was seven and demanding his mother's attention. The other two children were too young for school. Her painting was discouraged by her husband. She was not able to lead the life she had anticipated. And the idea of another child, with all the attendant responsibilities, seemed overwhelming to her. Angry and overwrought, she attempted to give herself an abortion, infecting herself with blood poisoning instead.

A self-inflicted abortion was not uncommon during the late nineteenth century, but it was considered a scandal, especially for someone from a proper family. It is not even known how quickly the doctor was summoned because his very presence could have proved to be an embarrassment. But even if he came immediately during the period when she was still bleeding heavily, the field of medicine was not advanced enough to save her from the infection. She died, though the official cause of death was listed as pneumonia to keep the family from ridicule. And as usual, her stepfather chronicled her passing in his own inimitable way:

> On February 15th, '81,
> Christ claims his bride, her work is done.
> A message from the Dayton home: —
> "Leonora's ill! O, mother come!
> For mother's heart can reach the flower,
> She's called to bloom in Eden's bower.
> Pneumonia fell has seized her throat;
> But still she sings a joyous note:
> Although she is delirious then,
> 'Tis; — HAPPY!! and AMEN!!!

The children reacted to their mother's death in quite different ways. Ernest appeared to want to be as much like his father as possible—a driven perfectionist whose emotions would be revealed more in his work than in his relationships with women. He would be a man's man, engaging in baseball and football when he went to Dayton Central High School. He made baseball team captain and played

the game until well into his fifties. He also took up the violin, a reaction to his father's urgings since his father felt that the instrument would help take his mind off the loss.

George, just five at the time of the death, needed the greatest comforting and care to get through the trauma, yet none was made available to him. He was left to drift, seeming to lose all interest in life from that moment on. Ernest described him as "a rolling stone, careless and irresponsible." He frequently skipped school and often ran away from home—ironically, the same type of behavior his mother had shown as a child. But George also was filled with self-hate, drinking too much, fighting in the Spanish-American War, destroying his three marriages, and ultimately becoming an alcoholic.

Florence, the youngest, was quite different. It is not known whether she was the strongest of the three children or whether the fact that she was so young and taken immediately to Springfield, Massachusetts, by her grandparents, the Hulls, made the difference. All that is certain was that she grew to be attractive and happy, successfully graduating from school, marrying a musician, and raising a family without regrets.

Leonard did the "right thing" by his sons, remarrying a woman of rather severe appearance named Jenny Kumlar. She was the "right" kind of woman for Leonard, subservient to his demands, willing to confine her role in life to that of housekeeper and mother, and giving birth to two children, Jeanette, in 1884, and Carl, in 1886. However, Leonard would endure even more tragedy in 1891 when both his children by Jenny died unexpectedly of diphtheria.

Death in early childhood was common during this period, when old age was considered to be no more than the late forties. But that reality did not alter the extreme pain the family shared. In fact, the two children by Jenny Kumlar were kept secret by the family. It was only by chance that a researcher came upon the graves.

If there is greatness in the work of Ernest Blumenschein (and there would be mixed feelings whether he was the greatest or one of the lesser artists among the Taos Society), it seems to have stemmed from his tragically fre-

quent encounters with untimely death. He was never able to fully commit to another person, a fact he eventually shared with the artist Mary Sheppard Greene who would become his wife. In a letter he wrote to her on January 4, 1904, a time when they were not yet married yet seemed deeply in love, he said, in part,

> *When I'm with you not at work, your love seems to be the joy of my life: your presence etc. But when I return to my self and in the calm air of night come face to face with my old mistress she tells me the truth—art has the prior claims, art has the soul of the man and his conscience. All the struggles, the disappointments and discouragements have but bound me closer to my great love, my work, and all the pent-up feelings, the inborn creations of my imagination, all the beauties my talent tries in vain to reflect demand and compel a life of servitude, a life of excruciating pleasures and pains.*

This attitude was strengthened later in the letter:

> *I love you as much as it seems possible for me to love a woman. I respect and admire all your beautiful abilities, but art is more necessary to my life than a woman's love and companionship.*

And he added,

> *To have both would be ideal happiness, the fullness of joy. But I don't even know my trade. And when I do, can I make a living? This is a gloomy letter, but the truth and because of that it is beautiful and must be respected.*

Ultimately, Blumenschein did have both the love of a woman and the skill to paint and sell his creations. Yet he never fully committed. He always remained the eccentric, the loner, the man seemingly afraid of coming too close to anyone because such closeness invariably seemed to lead to death or separation.

Ernest was mildly rebellious during his years in Dayton. His father and stepmother had settled in an area that was largely composed of rigid, conservative, German immigrants. They believed that activities such as dancing had to be banned because overindulgence could lead to sin. All activities other than those related to church were banned on Sundays. At least this was the case among the Protestants. The Roman Catholics in the area were more liberal, including allowing their sons to play in Sunday afternoon baseball games sponsored by the YMCA.

It is not known whether Leonard Blumenschein was aware of his son's actions on weekends and approved them by saying nothing. However, Blumenschein later admitted that he "became a Roman Catholic" on Sundays to participate in the baseball games.

Ernest was also drawing by then, fascinated by art more than any other activity, though he continued to play the violin he had begun studying with his father after his mother's death. Leonard approved of the drawing, an interest he shared, though tragically he saved nothing of the work of his first wife, the Blumenschein who seemingly had had the greatest talent. He had taken all the paintings that were in the family home and destroyed them, denying his son the one legacy she left behind.

The interest in art led to friendships with three other boys, unlikely companions with very different lives. One was Harry Conover, who Blumenschein described as a "pen and ink cartoonist" as well as a musician. He had no interest in art as a career, giving it up after graduation, though continuing with music as a member of the Ayght Concert group in Dayton, of which Blumenschein was also a member.

Paul Compton was one of the artists for the paper. He ultimately went to Paris to study architecture, dying too young to achieve his potential. Another student was an outcast and misfit, the sole black student in the high school, Paul Lawrence Dunbar, perhaps the brightest and most talented of the friends yet the one who would be denied opportunity solely because of his color. Dunbar delighted in writing satire and humorous verse, including cartoons the others illustrated.

The group's creative effort was available each week in the form of a single copy, underground newspaper they produced called *Tom Foolery*. The copy was closely held and given to someone to read only if they paid 5 cents for the privilege. Many of the students delighted in it, and several actually subscribed, giving the four youths a steady supply of nickels and the students a guaranteed chance to read the magazine.

Dunbar's history was a tragic one. Although he is recognized as one of America's greatest poets, he died at 34, never receiving the recognition he would gain when the public stopped looking at his color and started reading his writing. Even Blumenschein, his friend, was condescending to him after they left high school. As he later wrote,

> *I became quite well acquainted with Dunbar—I believe his 1st published verses came out of my paper. They were slapstick humor.*
>
> Tom Foolery *was published weekly (mostly) and done by hand on manilla paper. It was also circulated by hand—for there was only one copy of each number.* Tom Foolery *unfortunately was inspired by the lowest art of the time, by* Judge, Puck *and* Life. Tom Foolery *fulfilled its mission, it decided me on my life's work.*
>
> *I encountered Dunbar a year after graduation, working as an elevator boy. He was busy reading when I saw him in that elevator. I "kidded" him and he confessed he was studying Greek literature. We white boys abused him during the school days. He was so black and we so white and superior. I hope to be forgiven if regret will bring it about, for the pain we must have caused this fine sensitive talented negro.*
>
> *Most fittingly, my father composed music for the funeral of Paul Dunbar, to the words, I believe, of one of his poems.*

Blumenschein lacked the skill to be a cartoonist, and his early drawings were rather simple, with nondescript faces often formed by numerous cross-hatched lines. The

writing that accompanied them was often not much better. For example, one cartoon used to promote the paper showed a gentleman who had come upon a young boy who is crying. The gentleman says, "My boy, who are you and what are you crying about?"

The boy replies, "I'm a second year high school boy and this is the last number of *Tom Foolery.*"

Still, this mix of cartoons, political satire, and sports gave all of the boys experience in meeting deadlines and pleasing the public. Blumenschein also created caricatures of local people, especially some of the students who graduated with honors from his high school. The highest-ranking male, a student with top grades and excellent achievement, was shown barefoot in a perambulator, dressed in Buster Brown clothing, clutching his big toe with his left hand, an upside-down doll in his right. Surrounding him are the top-rated females in the class, all looking at him without expression.

The satire was probably motivated by revenge. Blumenschein drew for *Tom Foolery,* played shortstop on the baseball team, played on the football team, and played the violin in the orchestra but did not bother with official academics. His grades were so low that he was in the bottom third of his class, despite the fact that his skill with a violin earned him a scholarship to attend the Cincinnati College of Music in 1892.

He faced graduation with mixed emotions. His stepbrother and stepsister had just died, and his parents were grief-stricken. He had done poorly in school, yet his skill as a musician gave him the opportunity to go to the big city of his dreams. Cincinnati was not only the home of a major college of music but also of the first professional baseball team in America, the Red Stockings, who were organized just four years after the Civil War.

The Red Stockings were legendary in their time. They were either one of the greatest teams in the history of baseball or they played against some of the worst players ever encountered. Either way, their scores were phenomenal. It was not unusual for them to record 100 runs per game, for example. And Blumenschein would have a chance to experience the team for himself.

Yet he had made another discovery about himself during this time. He knew that he wanted to be an artist, knew it with all the intensity of his father's decision to become a musician. The only difference was that Leonard Blumenschein had shown genuine ability as a musician. So far as most locals could tell, Ernest had more enjoyment of art than he did skill as an artist.

Leonard did not want his son to be an artist, but he also did not want to demand that he study music. Instead, he worked out a compromise he felt certain would result in his son's having to accept the scholarship to Cincinnati. He said that he would send his son's artwork to one of the major illustrated New York weeklies, *Harper's Young People*, to see what the editorial reaction would be. The magazine regularly saw the work of both major artists and teenagers trying to draw. The staff would have the expertise to properly judge what Ernest had done as well as his potential. To Leonard's surprise, the reaction was favorable.

"Dear Master Blumenschein," the letter began. It was dated June 4, 1891, and for some reason was signed by the Puzzles Editor, not the Art Editor. "Your father wished to know our opinion of your effort at drawing. In reply the art editor of *Harper's Young People* directs me to say that the specimens which you submit show enough talent to warrant, in his opinion, further study. You need careful instruction in practical work. When the experiment is carried out for, say, a year, you can then decide whether there is enough promise to continue. The ranks of illustrators are very full—overcrowded in fact, but talent always commands success. You show talent which is promising."

Although Ernest would eventually become far more successful in his chosen field than his father had in his, he did not have his father's courage to pursue his desires regardless of family reaction. His father asked him to accept the scholarship and he agreed. However, if art mirrors life, Ernest's true feelings seem to be revealed in his paintings. For so long as Leonard Blumenschein lived, every self-portrait his son created showed him holding a violin. Once his father was dead, Ernest continued creating self-portraits from time to time. But never again was a violin to be seen in any of the pictures.

It was fall 1891 when Ernest Blumenschein encountered the excitement of the big city and the discipline of the Academy of Music. More than forty years earlier, Cincinnati had become the largest city west of the Alleghenies and was considered a center of cultural activity. The Cincinnati Museum School of Art began attracting successful artists to teach, then changed its name to the Cincinnati Academy of Art and attracted such artists as Joseph Henry Sharp, Fernand Lundgren, Frank Duveneck, and Henry Farny. These were men with highly successful careers whose backgrounds included training at every major art center in Europe. By 1900, Cincinnati was considered to be at least the equal of New York City as a center for art, and some critics felt that it might be where American art gained new respect throughout the world.

The violin and music instruction proved boring by the end of the first semester, so Ernest added a course in art taught by illustrator Lundgren (1859-1932). Admission was limited, the students chosen through competition. They had to go to one of the downtown parks, sketch whatever they desired, then submit the sketch as proof of both ability and potential. Ernest's sketch was judged the best in his class. It was also Lundgren who encouraged young Blumenschein to abandon music for painting, a decision he announced to his father the first summer he returned home.

Leonard could not dismiss his son's musical skills just because Ernest was unhappy with his education. He agreed to help support him in his study of art provided Ernest agree to always take at least one course in music. Ernest readily complied and delighted his father by spending the summer playing semiprofessional baseball during the day and performing with the Ayght Concert group of Dayton at night. Yet whenever he had a spare moment, he could be seen working with a sketchbook, constantly practicing his art.

Ernest returned to Cincinnati, this time to start formal training in art. Unlike the course he took from Lundgren, this training was typical of the manner in which both art and photography were first learned at the turn of the century. He was given small geometric objects such as cones,

balls, cubes, and pyramids. Then one light was positioned to cast shadows. The artist would have to sketch the shape coupled with the light and shadow, the photographer doing the same exercise, only recording it on film. Then the light would be moved to a slightly different angle. Each time the image would change and the artist would have to prove that he or she understood how to record subtle differences in shading. This was all done in pencil or pen and ink. Color was permitted only after all students, regardless of skill, completed the introductory course.

The second semester allowed more interesting training. The better students were rewarded with their first life drawing classes. Males attended morning life study classes, and females attended them in the afternoons. Both male and female nude models were used, but the careful separation of the sexes was meant to ensure propriety. A rather humorous situation existed for the students, however. They became so accustomed to seeing male and female nudity that it became boring for them. Instead, the males would gather in the hallway as the females came out, hoping to catch a glimpse of bare ankle showing beneath one of the long skirts or dresses that were fashionable at the time. Frequently this would happen during the winter when women would put on their boots, having to raise their legs and brace themselves on a bench or other object. It was the hint of the forbidden, not the nudity, that proved exciting for them.

Portrait and sketching classes were always coeducational. The students were also encouraged to attend frequent social activities ranging from daily "penny teas" in the lunchroom to costume parties and an annual exhibition/party organized by the student group, the Society of American Fakirs. Participating students had to provide a caricature of either a famous painting or a piece of sculpture, duly inscribed with a variation of the name of the original artist. It cost 25 cents to view the collected works, and the money was donated to a student scholarship fund.

Blumenschein blossomed in art school. Whereas his high school efforts showed talent but were inconclusive, his training at the academy revealed genuine ability. He was allowed to study advanced oil painting under Thomas

Satterwhite Noble (1835-1907), the chairman of the art department and one of the more successful American portraitists.

By the end of the term, Noble and Lundgren explained to Blumenschein that he needed advanced study. They wanted him to go to New York to attend the Art Student's League, one of the nation's most important art schools. He would need to send a portfolio for their evaluation, but this would not be a problem. They were certain he would be accepted, and they were right.

Blumenschein proudly returned to Dayton in June 1893, carrying his letter of acceptance. His father accepted the inevitable and, though having limited income, agreed to help support his son. Naturally, the youth also took his violin.

Blumenschein never could accept his real talents and interests. He had to please his father, and this meant being perfect in everything he did. As a result, he found that it was emotionally easier to lie about his actions than to let anyone know he might, at some period in his career, have been less than the best. This was the case with his New York experience.

The National Conservatory of Music in Manhattan had hired Antonín Dvořák, the internationally known composer and conductor, to organize and direct a symphony orchestra. Blumenschein was one of many hopefuls who applied for a position, his skill far less than that of others. He was not a professional of the caliber of those whose life's work was music, and he was competing in a city where the musicians were world class. His work was viewed as competent at best.

Instead of accepting the reality of his skills, Blumenschein lied to everyone. He related the story that he played a D-minor scale as part of his audition piece. The sound was so brilliant that he was immediately made first violinist. The only problem with this story is that it never happened, a fact no one checked until many years later. At that time, a thorough reading of all programs from the seasons when he supposedly played was undertaken. Not only was he never listed as first violinist—he was never listed at all. Even worse, some of the dates for the concerts conflicted

with times when he was known to have been elsewhere. The only concert where he might have been involved proved to be one where the orchestra was composed of black musicians and one white woman, a piano virtuoso.

As near as can be determined, the closest Blumenschein ever came to being connected with Dvořák was on December 15, 1893, when he attended the world premier of the New World Symphony (Symphony No. 9 in E minor, opus 95). However, he did become familiar enough with the work of the composer to speak knowledgeably of the man when interviewed.

THE NEW YORK EXPERIENCE

New York was a cultural shock for Ernest Blumenschein. For the first time, the many museums gave him the opportunity to study some of the finest works by the best artists of the world, and he could spend hours looking at how they applied paint, their brush strokes, and the other technical factors of the craft. In this way he was able to learn more about composition and design than he had from many of his instructors in Ohio.

In addition, there were approximately a dozen art schools in the city, many of them quite famous. There was the Art Students League, of course. There was the Cooper Union Art School, the National Academy of Design, the Salmagundi Sketching Club, and others. Each used major artists secure enough in their reputations that they were delighted to teach, passing on their secrets to the students. Each also had a library related to art, providing an additional means for self-teaching and the study of works that could otherwise be viewed only through world travel.

This was also a period when the major bars, motels, nightclubs, and restaurants felt that it was fashionable to collect art by major painters, displaying it for their patrons. Many of these had bars where a free lunch was provided with the purchase of a drink. Students took advantage of this situation, purchasing one beer and then eating the free lunch, their only good meal of the day. They were a drain on the establishment's profits, but they were doing nothing the owners could complain about. It was only

when they took the lunch without first buying a drink that they would be met by a large, powerful man working as a bouncer, getting themselves thrown out of the establishment.

The club scene was also Blumenschein's first introduction to erotic art. For example, at the Hoffman House, a "men only" club that was a popular hangout for art students, the owner spent whatever money it took to obtain paintings from some of the finest artists in the world. These paintings were frequently of subjects that had previously been taboo in the life of the rather naive art student. Thus, he was undoubtedly both shocked and delighted with work such as the extremely valuable ($10,000 when purchased) painting by Adolph William Bouguereau, *Nymphs and Satyr.*

The Hoffman House, though catering to prurient interests among the intellectuals, was so proud of its valuable work that it issued a catalog of its holdings. In addition, this was one of the establishments, mentioned earlier, where a Ladies' Day was held on a weekly basis.

But the main appeal of New York was the Art Students League, where successful artists returned to teach classes. The students were charged a tuition of $5.00 per month, scholarships being readily available for those without funds. The students without means of support would study for a time, then drop out to work at whatever jobs they could find, returning when they had enough money for tuition once again. But return they did, because they could be taught by the major artists of the day—Augustus Saint-Gaudens, William Merritt Chase, Kenyon Cox, John W. Alexander, John Twachtman, and others. Ironically, a few years later, between 1911 and 1914, Blumenschein would return to the school to teach courses in painting and illustrating the American West.

Despite the respect many American artists were receiving, Paris was still considered the world's most progressive city for art. Movements such as impressionism had their start in France, being discovered by American students, then brought back to the United States approximately two years after such art was considered routine in Europe. Like most of the other students, Blumenschein wanted to see

France for himself, both to study and to visit the great museums. He also knew that if he entered the field of fine art, he needed "proof" that he was a serious painter. This came only from an artist being able to note on a résumé that he or she had experienced the mandatory study period in Europe.

Yet even as Blumenschein saved his money and prepared to go to Paris in late summer 1894, he knew that his career would probably not be in galleries. Instead, he had decided that he wanted to be an illustrator, to create the visual accompaniment to someone else's words. He wanted to capture on canvas or in pen and ink the emotions, excitement, beauty, or horror of a story. He wanted to work within the parameters of fiction or nonfiction, becoming one of the artists whose work was familiar to the readers of *McClure's, Saturday Evening Post*, and *Harper's*. But first he had to go to Europe.

CHAPTER II

PARIS,
WHEN IT SIZZLES

Illustrators did not have to go to Europe to learn to paint. Many were American trained and never left the United States. Certainly when the AT&SF Railroad began to take advantage of their skill, no one cared where the illustrators had trained so long as their paintings were an effective advertising medium. But Europe was considered the birthplace of fine art and Paris the city where the best artists gained their skill. What the artists found in Paris helped them academically but was often quite different from their expectations.

Paris in the late 1800s had a way of diminishing the pompous in its visitors. Blumenschein arrived expecting sophistication and prepared to act the part (much as he later attempted to act the part on his first trip to Taos). The problem was that Paris was ahead of the civilized world in the arts and far behind in personal hygiene. Bathing, the Parisians were well aware, could cause such diseases as the "pox," one of those vaguely defined conditions no one could pinpoint but everyone could recognize when they got it. The rich substituted fragrant oils and perfumes, not to improve their odor but to be different from the poor who could not pay for such adornments.

There were bathtubs in Paris, of course, though not

many and certainly not in the inexpensive Latin Quarter where most of the art students had to find places to live. Only the best hotels routinely installed them for American tourists, but just one per floor.

Oddly, bathing and art appreciation had once been an important ritual for the aristocracy. During the sixteenth century, Francis I spent hours in the bath, then stepped into a room whose walls were covered with paintings he collected from such great masters as Leonardo da Vinci, Michelangelo, Raphael, and Titian. There he dried himself while studying the collection. To share the pleasure, the king built an elaborate art grotto where the women could bathe, then enjoy works of equal quality on the walls. What he did not tell them was that he arranged hidden mirrors so he could watch them cavort naked. As was obvious by the time Blumenschein reached Paris, this attitude toward bathing had disappeared.

Blumenschein became a student in the Académie Julian located on the Rue de Dragon in the Latin Quarter. The atmosphere was as Bohemian as the surroundings, and, though undoubtedly shocked by what he had seen, he quickly adapted. The fact that there were also students from Russia, Germany, England, Egypt, Sweden, Turkey, and other nations, each experiencing his or her own culture shock, eased the transition. Everyone was a little uncomfortable, and everyone was proud of adapting to the naughty life of Paris.

Blumenschein was able to afford an adequate apartment, though most of the students were renting typical Latin Quarter apartments. These rooms were unheated and had bare floors and one or two well-worn chairs. Only the beds were designed for comfort. They were well made, soft, and attractive. As a result, most people entertained their guests in the bedroom, a fact that many observers joked was the cause of the frequent adultery among French couples.

L'ACADÉMIE JULIAN

M. Rodolph Julian was a Parisian hustler who would do anything and everything for money. He boxed professionally, then posed as an artist's model when younger men of

greater speed and skill began beating him in prizefights. Finally, he was almost penniless, having just enough money to rent a studio for a few weeks. He knew no trades or skills, but he did know the love affair nineteenth-century artists had with Paris. He also knew from his days as both model and failed artist that many artists would pay anything, go anywhere, if they thought they could gain greater knowledge of painting. He conceived the idea of opening his own school.

Using showmanship that was only slightly more sophisticated than modern matchbook advertising, Julian placed a sign reading "Académie de Peinture" outside an old dance hall in the Passage des Panoramas. For days he sat alone, unable to afford any greater promotion yet unable to draw even one student to his headquarters. Then, as he faced almost certain bankruptcy, one youth slowly trudged up the stairs to see what courses were offered. Before he could escape, Julian grabbed an easel, pushed it in front of the student, and mounted the posing stand. Then, as the naive youth decided to stay and paint, "l'Académie Julian etait fondée." Or so Julian bragged after his school was relocated to relatively massive quarters in the Rue du Fauboug St. Denis where separate facilities for men and women existed.

Although Julian knew nothing about the arts, he did know the power of promotion. As an increasing number of students arrived, he managed to convince well-known painters and sculptors to act as visiting professors. Whatever their motivation for participation, the new professors brought an additional expertise that helped the school become second only to the Beaux-Arts, the largest and most renowned of the Paris academies. In fact, by the time Ernest Blumenschein became a student, the school had a total of five locations throughout France and an enrollment of more than 600 students.

One student described the seeming chaos that existed in l'Académie Julian in the 1890s. He wrote,

> At the Académie there were no rules, and, save
> for a massier in each studio who was expected to
> prevent flagrant disorder, there was no discipline.

31

*I believe the professors were unpaid. You elected to
study under one or more of these, working in the
studios they visited. . . . So great was the number
of students, two models, not always of the same
sex, usually sat in each studio. Our easels were
closely wedged together, the atmosphere was sti-
fling, the noise at times deafening. Sometimes for
a few minutes there was silence; then suddenly the
men would burst into song. Songs of all kinds and
all nations were sung. The Frenchmen were extra-
ordinarily quick to catch foreign tunes and the
sounds of foreign words. There was merciless chaff
among the students, and frequently practical
jokes, some of them very cruel.*

There was also a slightly disreputable side to the life-
styles of the students. As Blumenschein later wrote,

*The wise French thought they had solved one
of a young man's troubles by furnishing "gri-
settes," quite simply young women who would live
with students for board, room and entertain-
ments. . . . The American boys could find no happy
medium. When one left school with a French girl
on his arm, he practically gave up work for that
winter. . . . At least half of the Americans fell for the
girls: and that was the happy student days for
them. The other half studied seriously and benefit-
ted by the great education France could give.*

Actually, the men who did not enjoy the company of a
"grisette" looked on them as prostitutes and felt more com-
fortable picking up the girls of their dreams in the cafés.
Unfortunately, most of these youths were not sophisticated
and lacked the courage to actually approach women who
seemed to be available. So they settled for producing end-
less sketches of the young ladies as well as their surround-
ings. Their skills rapidly improved, much to the disgust of
their libidos.

The oddly mixed reputation of l'Académie Julian
attracted a number of American artists including Blumen-

schein, Bert Geer Phillips, and Joseph Henry Sharp. All were painters and/or illustrators with varying experience in the New York market. Sharp, thirty-six years old in 1895, was nine years older than Phillips and fifteen years older than Blumenschein. His career was far enough advanced that he had been to the American West and had painted the Indians, the settlers, and the beauty of the undeveloped land. It was his stories, shared with the two younger artists at the Académie Julian, that would trigger their imaginations.

The American West was undergoing a transition in the minds of the American public during this period. Much of the land that had been dominated by the Indians had been taken by a combination of force and white man's illness. In areas such as California, certain diseases, previously unknown to the American natives, were introduced by missionaries, soldiers, sailors, and the occasional settler. The diseases often ravaged entire tribes; in some instances, travelers found Indians starved to death within a few yards of stored food. Their weakness had been so great that the short distance had proven overwhelming.

In other areas, wars between occupying troops and Native Americans had destroyed many of the latter and moved most of the survivors onto reservation lands. Nomadic people were forced to become farmers to survive. Warriors were denied their arms, their dignity, and their culture.

A number of the Indians survived by entering the white man's world as entertainers. They toured in Wild West Shows, the forerunner of vaudeville, their appeal a little like that of wild animals in zoos.

The Indians in the shows—sometimes former warriors of great renown, at other times alcoholic drifters playing on their heritage—were caricatures of once-proud men as they endured roles in dramatic "re-creations" of past defeats. They were paid to be humiliated in much the same manner as early black entertainers performing in vaudeville.

Yet for the public, the Wild West Shows were the West. Dime novels had begun to make their appearance, making lies of the careers of notorious prostitutes, cowardly killers,

and other disreputable lowlifes, elevating them to the status of cult heroes. Killers who wore badges and shot others in the back became heroic figures who participated in showdowns on Main Street in the stories written by the novelists. Indians were always deadly, crude people who would commit any dastardly act against a white man, woman, or child. But reading such stories and actually seeing the "savages" live were two quite different things. The Wild West Shows were the "westerns" of a nation that did not yet have movie theaters. The actors became the role models for real life, at least for the naive.

Blumenschein and Phillips were among the naive. They were the equivalent of drugstore cowboys, young men who talked and painted a good adventure so long as they did not have to live it. Had they been born two generations later, they might have moved to Texas, Arizona, or California, donned Stetsons, boots, jeans, colorful shirts, and neckerchiefs, then sat around drugstores, telling lies to impressionable young women. Instead, they became enamored with anything that seemed to hint at cowboys and Indians, determined to lead a life of adventure, no matter how vicariously.

Wild West Shows had a tendency to go bankrupt in unusual places. Periodically, an international Wild West touring company would strand the cowboys, Indians, gauchos, and other members in Paris. Unable to perform in French theaters, they posed as models for art students, including those at the Académie Julian, to earn enough money to return to America. They were also willing to tell any type of story the students wanted to hear about their past, adding to the myths of their heritage.

Blumenschein and Phillips were excited by the cowboys, the Indians, and Sharp's stories. They learned of New Mexico and the beauty of the Taos Pueblo and longed for the excitement that the West had to offer, knowing nothing about surviving in territories lacking the amenities of the big cities.

During this period, Taos and other sections of the West were undergoing radical changes. The Indians who survived the taking of their lands and the devastation caused by illness began to adapt to their new circumstances.

Some were converted to Christianity, white men's dress, and white men's ways. Others clung fiercely to their heritage, their hearts saddened as their children frequently either adopted the life-styles of their conquerers or became depressed, alcoholic, and without purpose. Still others, such as the Indians of the Taos Pueblo, became an odd hybrid, maintaining their religion and traditional dances yet draping their bodies in Sears Roebuck & Company's best white sheets.

But no matter what the reality, many Americans were becoming concerned with two issues. One was the vanishing Native American whose life-style and facial types had not been recorded in large numbers by artists and photographers. The other was the problem of a people conquered, many Americans wanting to somehow reach out to the Native Americans in a gesture of friendship. Where black/white relations would be the hot topic of the 1960s, Indian/white relations were the prime focus of interest when Blumenschein, Phillips, and Sharp first met in Paris. Thus, the men would have the opportunity to be a force in a new kind of American art that grew in demand because of the issues of the day.

Although the Académie Julian had a rather unconventional beginning, it quickly was established as the school for the most serious students. This was because the primary training program in France for French artists was the École des Beaux-Arts (students from other nations were generally refused admission to it), a school open only in the morning. M. Julian had the wisdom to keep his school open morning through night, six days a week. Such a schedule was ideal for students working their way through school, lazy part-timers, as well as dedicated students who wanted to work in a structured environment.

Blumenschein's ability to adapt was seen in the way he tried to shock an old friend, Henry Theobold of the National Cash Register Company of Dayton. Theobold traveled to Europe to expand the markets for his company's products. He and Blumenschein joined together for a tour of the community, Ernest trying to shock Henry with the sights. However, nothing impressed the businessman until he was

taken inside the academy itself. As Blumenschein later related,

> We eventually arrived at the Rue de Dragon and stopped before the old art school, Académie Julian. Would he like to see an art school in action? He would. The place looked bleak and gray. Paris you know is gray and dark and rainy most of the winter. We passed under an arched entrance to a courtyard, turned and climbed a dark winding stairway of stone steps, groped our way along a very dim hall. Pausing at the end of the hall before a large door, I felt around in the dark for the knob. Henry was dressed in a trimmest American style with Derby and the same long toed patent leathers. I told him he would make a hit. Artists didn't wear clothes like that. I opened the door upon a huge high room blue with light and smoke. When his eyes became adjusted to the sudden change he saw above the heads of many men, a nude woman, posing with arms outstretched—and twenty feet away, a man stark-naked, on another stand. At last the Cash Register disappeared from Henry's consciousness.

Despite the success of the academy, classes were loosely structured and the staff apparently unpaid. The students selected their teachers according to skills and personality. For example, Blumenschein was interested in studying drawing and selected Benjamin Constant and Jean-Paul Laurens, the latter famous for massive historical murals frequently used in office buildings. Both men were considered extremely conservative and technically quite accurate.

Laurens's work was a little odd in that he seemed preoccupied with death. His murals frequently showed mass executions or the aftermath of violent confrontations. Yet the accuracy of the images caused them to be reproduced in history books.

Constant began his work as an artist of heroic subjects. By the 1880s he was interested in portraiture and was in

great demand by members of British society. He painted many of the wealthy nobility, including both Queen Victoria and Queen Alexandra.

His training would later be obvious in the work Blumenschein produced. The majority of quality paintings produced from 1902 to 1912 were portraits. The western paintings he did during the decade that followed were primarily figure studies. And it was not until the late 1920s that landscapes were his preferred subject, human figures becoming of secondary visual interest.

The classroom sessions were intense. A male and female model would pose nude for the students for 8 hours a day. They worked in 55-minute shifts, having 5-minute breaks every hour. The students had to be evaluated twice a week, and the best work was placed in a monthly competition. The winners of the competition were awarded a medal and a small amount of cash as an incentive to work hard.

Separately from the school program, the teachers developed their own contest wherein they would assign a weekly subject for composition. The students would handle this separately from their regular work, submitting it for Saturday morning judging. The winner would then be able to select the place within the classrooms where he or she would position the easel for painting. This was actually a more coveted prize than the monthly award because the classrooms were frequently extraordinarily crowded. The better the position, the easier it was to see the figure and produce quality work.

As an additional incentive for the weekly winners, they were invited to compete in a monthly contest during which they would be given seven hours to complete a sketch. The best work created under such pressure was awarded 100 francs, a sum of money that could mean the difference between affording a private room and having to double up with another student.

There was also an annual show whose judges condescended to view the work of the students. This was the famous Salon held in the Palace of Industry on the Champs-Elysées every May 1 and 2. Anywhere from 2,000 to 3,000 paintings were displayed in the Salon, the names of the

artists, young or old, carefully noted by the wealthy patrons and gallery owners. Acceptance meant that you would have customers for your work and patrons to support future projects. Rejection meant that you would have to starve in a garret for another year.

There were three types of work submitted to the Salon and sold separately from the approved galleries. The first was the standard Salon piece that was always realistic to the point of seeming almost photographic in nature. Some of the pictures were meant to advance morality, each painting showing great heroes from history, the saints, or, oddly enough, nudes presented in a way that depicted some period of history. This was often a sophisticated version of the type of illustrations used in American Sunday supplements. You could show images that bordered on the sexually explicit and that certainly were highly erotic so long as you placed them in a historical context.

The second type of image was a carefully reproduced vignette from daily life. This might be an image of children at play, men working, or even a portrait that contained every detail of the subject's appearance.

Another form of painting, quite popular with the young yet not meeting the standards of the Salon, was the impressionist and post-impressionist work. The artists used color, form, and various techniques to create work that might be visually exciting yet did not have the graphic sense of realism required by the Salon. Such works, though often respected by many, were shown only in a limited number of locations—usually the less reputable galleries such as Durand-Ruel and the Gaupil Gallery, the latter owned by Vincent van Gogh's more rational brother, Theo van Gogh. Cafés and nightclubs, such as Chat Noir, the Café de la Paix, the Moulon Rouge, the Café des Varietes, the Rat Mort (Café Pigalle), the Soleil d'Or, the Café de la Place, and the Café de la Rochefoucauld, also displayed these works. They did this not for the money they would make from sales or because they believed in the style of art but because by becoming mini-galleries, they assured themselves of a steady stream of art students, their families and friends, as well as those interested in counterculture art who would look at the work, then stay

to eat and drink. Few paintings were sold, but the artists felt victorious over the Salon by having their own hangings, and the club owners found using their wall space a cheap form of advertising.

The would-be impressionists who believed in art for art's sake and produced lesser-quality works were the more typical students. They were so busy attacking the conservative nature of the Salon artists that they failed to produce truly quality works. They were rejected by everyone and created the myth of the starving, misunderstood artist who might have to die for art.

There was one artist who rebelled against the Salon in so creative a manner that he prospered, much to the shock of the officials. This was Auguste Rodin, the sculptor, who convinced three Parisian bankers to loan him 80,000 francs. He then rented a pavilion at the Place de l'Alma to hold his drawings and sculpture. The structure was placed near the Great Exhibition, and the public thought that his work was officially "approved" as they paid admission to see it. The result was that he repaid his loan, then made substantial sales that would otherwise have been impossible.

Even more radical than the impressionists were the symbolists and the Nabis. These were the ultimate practitioners in avant-garde art when Blumenschein arrived. The symbolists wanted to use art to bridge the dichotomy between the materialistic and spiritual worlds. And the Nabis felt that nature was not a fitting subject for art. Instead, they glorified color used in a decorative manner. Religious mysticism was popular with many people, and the free use of color was their way of relating.

Blumenschein's tendencies were to work with the establishment, a fact that would ultimately lead him to the joint venture with the railroad. Instead of relating to his peers, he chose to go with the Salon, gaining the exhibition of two works, _The Flute Player_ and _The Lake_. This was unusual since the rebels almost invariably studied at the Académie Julian while the École des Beaux-Arts trained students in the manner of the Salons.

The Flute Player was a painting done hurriedly in order to meet the deadline for submission to the Salon. It was in

a traditional style of the day and not much different from illustrations Blumenschein had sold to *McClure's* magazine. The flute player is sitting to the left of a table, the sheet music propped against a stack of books, a candle lighting the scene. On the wall behind are several paintings, the lines of the paintings carefully counterpointed with the lines of the figure. *The Lake* was a more traditional scenic work produced in watercolor.

Blumenschein received his first "international" acclaim for his oil painting. The art critic for the Dayton *Herald* praised the Salon acceptance. However, as was the custom of the day, especially with smaller community newspapers, the critic felt compelled to warn him about the wicked ways of the society he lived in:

> *We are surprised and delighted to find that two of the pictures accepted and exhibited in the Salon in 1896 were the work of a Dayton boy, Mr. Ernest Blumenschein. When you consider that this is an exhibition by French artists, who are prejudiced against foreigners, and that of the works offered by even French artists, not one in ten is accepted, you will appreciate the honor conferred upon a young and unknown American.* The Flute Player *being the picture, the flute by the light of two candles on the table. Mr. B. has undoubted talent, and if he will keep himself free from the temptations that surround an artist's life in Paris, and add to his gift continued perseverance and industry, for talent without application is worse than nothing, he will do honor to himself and his native city.*

The comments reflect the morality of the times. It was as though Blumenschein had been forced to study in an artistic no-man's-land, someplace between Dayton and Hell.

Blumenschein may have stayed with traditional painting to gain the approval of the Salon judges, but he won his friends' approval by participating in an annual student affair that was a mockery of the Salon. The event included

a dance preceded by a counterculture parade consisting of floats re-creating famous paintings. The students frequently chose paintings liberally laced with nudes, then used their life study models or stripped off their own clothes and posed in the appropriate manner. Everyone was shocked, the local police arrested the artists, the dance was held, then the community delightedly looked forward to the next year's festivities. The outrageous behavior of the parade was never mentioned in Dayton. However, Blumenschein sketched the event, wrote about it, and sold the material to _Harper's Weekly._

Athletics continued to be Blumenschein's passion in France. Baseball was not played there except for an occasional game held by the American students. As a result, he began playing tennis in earnest. He joined a tennis club, where he played every Sunday morning and also played in tournaments.

Other activities for the young student included the American Art Association, which held an annual minstrel show. Blumenschein played such parts as "Bro' Michael" and "Miss Newgirl, a recent widow." He also went to various cabarets to play auction bridge and to talk with other American students. It was in such surroundings that he met both Bert Geer Phillips and Joseph Henry Sharp. They were older, but their shared interests in art and, ultimately, the American Southwest, made them lifelong friends.

BERT GEER PHILLIPS AND JOSEPH HENRY SHARP

They were two of a kind, romantics in love with cultures outside their own, raised on the fantasy of the American West. Phillips was raised in Hudson, New York, near limestone quarries that had been the site of Mohican Indian wars. He found Indian arrowheads and was stimulated by the stories of James Fenimore Cooper.

Sharp was an Ohio boy, born September 27, 1859, in the small town of Bridgeport, where he also fantasized about Indians. As he later explained during an interview for the August 1932, issue of _New Mexico Magazine,_

> *I always was interested, even as a small boy. I guess it was Fenimore Cooper who first attracted me to the Indian. It was the romance of youth, of boyhood I suppose. But boys always did like Indians. When I came to know them I liked them for themselves. Perhaps they attracted me as subjects to paint because of their important historical value as first Americans. There is something very intriguing about "First Americans." Then the color of their costumes and dances, this no less attracted me. Their color is glorious and so belongs to them and to their country.*

It was an odd stimulus in that Cooper, the novelist, spun tales filled with fantasy and two-dimensional heroes from his home in New York. He knew neither Indians nor wilderness country, a reason his writing was stimulating primarily to urban dwellers and small, impressionable boys like Sharp and Phillips.

Sharp had more encounters with Indians than did Phillips during childhood. When he was six he discovered that there were several Indian families living near Bridgeport. He got to watch the boys at play and was fascinated by their target practice with bows and arrows. They would set up "shinplasters," worthless paper money issued locally during coin shortages, and shoot them. Some of the more skilled would also use three-cent silver pieces as targets. These coins, issued from 1851 through 1873, were extremely tiny, smaller than a dime, and hitting them with arrows required great skill.

Both Sharp and Phillips were drawing from the time they were young. Phillips drew before he could write and was still a young child when his watercolors took first prize at a county fair art exhibit. Sharp worked with chalk and slate, drawing instead of doing his schoolwork, much like Blumenschein. However, whereas Blumenschein participated in school activities, Sharp was more of a rebel, a fact that made it surprising, at times, that he survived into adulthood.

For example, he loved to do gymnastics, using the iron trestle work of a railroad bridge spanning a river for work-

ing out. He was skinning the cat, a maneuver where the acrobat is suspended by his hands above the ground, raises his knees to his chest, then turns himself inside out so far as his arms will allow, when he lost his grip. He landed in the water, drowned, and was carried home by a man who witnessed the accident. There were no signs of life, something his mother would not accept. She turned a barrel on its side, tossed her son face down over the rounded section, and began rolling his body in a crude version of artificial respiration. He survived, but the shock of hitting the water and apparent infection caused by the water filling his ears eventually left him deaf.

Sharp was still able to raise hell. As a 12-year-old, he and four other boys were participating in one of several summer parades held in their community. They rode ponies and used ocher obtained from a local druggist to paint their faces like Indians. When they became bored with the slowness of the parade, they began shouting war whoops and galloped around the participants and the audience. Sharp and his friends were convinced that they stole the show, though what their parents thought of this is unknown.

Deafness was viewed as a blessing by Sharp. Although he learned to read lips and never went anywhere without a pencil and a small pad of paper, Sharp delighted in what he felt was an increase in the sensitivity of his other senses. He felt that he had a better understanding of people and the world around him because of his handicap. He also liked being able to concentrate more intensely when drawing.

Sharp's life proved even more difficult the year he began to lose his hearing. His father lost his money in the economic depression that followed the Civil War, a trauma that caused him to suffer a fatal heart attack. He left school for several months, taking a job in a nail mill and copper shop where he was paid 42 cents for a twelve-hour day. He kept half the money and gave the other half to his mother to help with household expenses.

At 14, Sharp was no longer able to stay in school under any circumstances, his deafness proving too great a handicap. He moved to Cincinnati, living with an aunt and tak-

ing art lessons at the McMicken School of Design at the University of Cincinnati. It was one of the first art schools west of Philadelphia and gave him his first formal training in painting with oils and pastels. He also worked as a water boy for carpenters in order to make himself self-sufficient, still sending half his money to his mother.

In 1881, after eight years of training, Sharp saved enough money to travel to Europe for study. Then, in 1883, the 24-year-old experienced a lifelong dream by traveling to Santa Fe, New Mexico, and other parts of the American West. He painted the Indians, attended ceremonial dances, and was delighted to find that the Pueblo Indians were still living as they had centuries earlier. He became a recorder of a way of life that would soon vanish.

Sharp did not see Taos, though. Instead, he traveled to Albuquerque and then on to Tucson, Arizona, ultimately taking the train to the Pacific, then traveling by ship up the coast. He made a point of always locating and painting Indian tribes wherever he traveled during this period.

In time, Sharp became a teacher at Cincinnati's Art Academy, and took Addie Byram as his wife. He also continued talking about the West he had seen, finding other artists who shared his love. Then, in 1893, he visited Taos during his second trip to the American West. He had become an illustrator and was working for *Harper's Weekly*, his drawings appearing in the October 14 issue. The work was so well received that he obtained several commissions for paintings of the area from numerous publications.

The teacher in Sharp kept him critical of his own work. He felt that no matter what success he had, he was not so technically skilled as he needed to be. He decided to travel to Paris for two years of intense study. He would also visit various cities of Europe which held museums with important collections. But the most important part of the trip, at least so far as the history of Taos was concerned, was his decision to study at the Académie Julian.

By contrast, Phillips had an easy childhood. The family was financially comfortable and lived in a beautiful area. Bert was a youth who delighted in the world around him, his only "naughty" act as a child being the regular taking of his father's muzzle-loading shotgun to go rabbit

hunting with his friends. The problem with the gun was that it had a substantial kick when fired and would smash against his shoulder because he did not know how to properly brace himself. He would return home, sneaking the weapon back in the house, then spend several days forcing himself to hold his body normally so no one would suspect what he had done.

Phillips knew he wanted to be an artist, to record the beauty all around him, but his desires conflicted with those of his father. William Phillips felt that his artistic son should become an architect like a close family friend. He could not understand why his son insisted that such a profession was wrong for him, that he did not find buildings to be beautiful, only people and nature.

Ultimately, a compromise was reached when Phillips was sixteen. Father and son had been arguing over whether Bert should be apprenticed to a local architect. They agreed that Bert would finish high school in the traditional way. Then William Phillips would send his son to New York City where he would study as many different areas of art, including architecture, as possible. Then, based on the knowledge gained from that experience, he would select his career. William was certain his son would become an architect. Instead, Bert reached Manhattan and immediately enrolled in the Art Students League to study with Benjamin Fitz, later transferring to the National Academy of Design. His education lasted five years and was followed by another five years of independent work as a painter.

Moderately successful and recognizing that additional study was in order, Phillips gave himself two years to travel, paint, and study in Europe. First, he went to England. There he visited estates where he received commissions to paint aristocrats and also painted the working people in his spare time. His last months there were spent in Devonshire, a fishing and sheepherding area, where he deliberately became an eccentric. Just for fun, he bought himself a giant white umbrella to diffuse the light on himself when he worked outdoors, then dressed himself in a manner that was typical of the more flamboyant artists of the time.

Eventually, Phillips left England and journeyed to Paris,

where he enrolled at the Académie Julian to study under Jean-Paul Laurens and Benjamin Constant. It was there that he met Blumenschein and was able to share his love of the West. And when Sharp arrived, a man who had actually seen the West, their lives were changed forever. Although they did not realize it, the Taos Society of Artists had been created.

THE COMING OF
FRED HARVEY

W hile Americans in Paris contemplated the life of
the drugstore cowboy, changes were taking
place in the Southwest: the development of the
railroad and, more important, the coming of Fred Harvey.

Arizona's Grand Canyon had everything anyone could
want in a nineteenth-century tourist attraction. First,
there was its beauty. Endless vistas, red rock almost glow-
ing in the sunlight, good weather, the chance to interact
with different cultures, adequate lodging, and friendly peo-
ple all awaited tourists. Next was the convenience of travel-
ing there on the AT&SF since it had extended its line.
Finally, there was the cost, the price being realistic for
middle-income families as well as the wealthy. The only
problem was that almost no one cared. This was caused, in
part, by a lack of familiarity with the territory and, in part,
by the deadliest part of a cross-country rail trip—the food.
Prior to Fred Harvey's arrival in 1876, travelers on the
AT&SF were offered two types of food: barely edible and
badly spoiled.

The minimum food available on a train trip consisted
of boiled eggs preserved in lime and biscuits so light and
delicate that they were nicknamed "sinkers." On cross-
country travel such as the Grand Canyon trip, passengers

would be offered a greater variety: coffee, made in massive containers just once a week, and sandwiches, usually a choice of fried eggs (grease was reused and generally rancid) placed between two slices of stale bread or dry, salty ham sandwiches, also made with stale bread. In either case, the prices were extremely high.

Unless the food was offered in the occasional, poorly run dining car, there would be at best a twenty-minute stop for food. An honest rail stop manager would make the sandwiches to order, working quickly so passengers could bolt down what they were eating and return to their seats before the conductor announced the departure to the next town. Yet even rail stop managers had problems, because the trains seldom adhered to their schedules, sometimes arriving several hours later than expected. Often, this meant that there was no one to provide service, the manager and any staff having long since gone to bed. At other times, they would stay at the station, rousing themselves from slumber when they heard the train, feeding the passengers, then returning home to bed. Either way, the dishes were washed when it was convenient. But with such an irregular schedule, cleanliness was seldom convenient. The plates were usually filthy, passing from hand to hand for days at a time.

Occasionally, there were stops where food was not to be eaten but was to be used in a subtle form of robbery involving both the station operators and the railroad line staff. The passengers would be told that no food could be brought on board the train after being purchased at the stops. Since they were used to having to order, then bolt down their food in twenty minutes at the legitimate stations, this did not seem to be a problem.

But the passengers then discovered that their orders were not being filled with the same speed as at the legitimate stops. Instead of first come, first served, everything was delivered at once when the conductor suddenly announced that they had to reboard. The passengers, who had paid for their food in advance, realized that they either had to give up their lunch and the price they paid for it or miss their train. The idea of being stranded in the wilderness was not appealing, so, grumbling, the sandwiches just

out of reach, they reboarded. What they did not know was that the sandwiches had spoiled days or weeks earlier. The food was never meant to be eaten. It would be sold again and again until either someone was foolish enough to actually take a bite out of a sandwich or it became so discolored that even the greediest of vendors could no longer sell it. Either way, the money the passengers paid for the sandwiches they "rented" was split between the station staff and the dishonest members of the train's crew.

Two circumstances gradually changed the conditions of the AT&SF line. The first was the slow migration of Americans to the West. Many followed the rail lines, establishing their homes near the various stops to ensure that they would have regular contact with the East. These were people who were not seeking to pioneer in the West or find gold and silver in the boomtowns of Colorado, California, and elsewhere. They simply wanted a change, to be part of growing communities that still allowed them to return easily to the East where they were raised. Cities such as Topeka, Kansas, gradually evolved in this way. These growing rail line cities offered train passengers amenities such as bars near enough to the stations so that those wary of food scams could legitimately buy drinks and whatever else the bars offered. There was competition for the station food suppliers, places where the passengers knew that their money would at least pay for something of real value.

The second development was the construction of quality housing for rail crews to use during layovers. In 1872, at a time when the AT&SF extended across Kansas, the railroad did not provide housing for the crews, who had to fend for themselves. If they were lucky, boarding houses were available for them. If not, they made whatever arrangements they could.

A delightful story is told about a housewife in Granada who struck a deal with three crew members. Her husband was out of town six days a week, during which time the men would use his bed. They had to stay away the seventh day when he returned from the land claim he worked the rest of the week.

All went well until the man returned home a few hours earlier than expected. The three boarders, having been

warned that he knew nothing of the arrangement, hid under the bed when he entered the room. At the same time, a chicken got into a nearby wall, scratching and creating a noise similar to that of a rattlesnake. For more than an hour the men were terrified, trapped in one direction by a potentially irate husband and in the other by what they thought was a snake waiting to strike. At last the husband left, the men fled, and, a week later, the AT&SF agreed to start building crew quarters for layovers.

Concerns for the crew led to the idea that perhaps it was time to develop a commercial food service, both for the staff and for the public. Topeka resident Peter Kline contracted with the Santa Fe for such a venture, then sold out to Fred Harvey, a man who would change both the dining habits and the art world of America.

Harvey was an unlikely man to be an indirect but important force in art. Born in 1835, he migrated to America when he was fifteen, landing in New York and obtaining a job as busboy for the Smith and McNeill Cafe, where he earned $2.00 per week. The food business fascinated him, and by the time he was in his early twenties, he was able to enter a partnership to run a restaurant in St. Louis. The restaurant profited until the Civil War when his partner, panicking over the future of the nation, grabbed all liquid assets and disappeared.

Harvey drifted from job to job for several years, eventually taking a clerkship on a mail car on the Hannibal and St. Joseph line. Leavenworth, Kansas, was his headquarters, and he gradually rose higher in the business. Later, he became general western agent of the Chicago, Burlington, & Ohio Railroad and opened a lunchroom in Topeka, Kansas. This return to his first love also led him to realize that there was a tremendous need for quality eating establishments to serve the various railroads. He soon took control of the AT&SF line's facility, which had been started by Peter Kline.

Harvey brought amazing changes to railroad dining. In 1888, he was able to offer a complete dinner for 75 cents. The meal started with blue points on shell, then continued with items such as filets of whitefish, Madeira sauce, young capon, hollandaise sauce, asparagus with cream

sauce, salmi of duck, charlotte of peaches with cognac sauce, and numerous other delicacies.

Harvey had no illusions about what attracted men to eating establishments. They wanted quality food at low cost, attractively presented in comfortable surroundings. The most appealing part of his presentation, besides having it prepared on clean plates, was a phenomenon known as the Harvey Girls.

"Young women of good character, attractive and intelligent, 18 to 30," read the advertisements that appeared throughout the East and Midwest. The women who responded were a mixed lot. Some had a sense of adventure; others simply wanted an escape. There were heiresses rebelling against the society in which they were raised, schoolteachers tired of talking to children about adventures they had never experienced, prostitutes seeking new customers with less harassment from law enforcement, young women fleeing broken love affairs, and young women who wanted a different future from those around them. Most were rejected.

Harvey wanted young women who could handle being in a highly structured, morally controlled environment, work what frequently proved to be long hours, and always treat customers with a friendliness found only in the greeting of close friends who had been separated for what each felt was too long a time. Prostitutes stood no chance of being hired. Schoolteachers were next in line for rejection, as they were too independent for Fred Harvey's taste. The classroom experience left them unsuited for life in his restaurants. Some teachers admitted that they wanted what they perceived to be the wild, free life of the West, unfettered by the strict social conventions in which they had been living. The West may have been wild, but Harvey Girls were fired if they tried to behave in such a manner. Their job was to bring grace, gentility, and a sophisticated refinement to men who would otherwise lack such a settling atmosphere.

The women he hired wore standard uniforms of black shoes and stockings, a plain black dress with an "Elsie collar," and a black bow. Hair had to be in a simple style, the only permitted adornment being a white ribbon neatly

tied. The hours were set if the trains ran on time. When the trains were late, the Harvey Girls stayed on duty until the passengers had been properly fed.

Harvey Girls had to live in chaperoned dormitory settings. They had to sign contracts stating that they would not marry for a year. Harvey knew, however, that the best would often be wooed, fall in love, and wish to marry within six months. Instead of suing the women for breach of contract, he generally tried to attend their weddings or give a party in their honor. He also made certain that he held a celebration for the girls who survived six months unwed, showing them how much he appreciated their actions. He knew that if they survived that long and enjoyed their work, he might keep them on his payroll for up to four more years.

The living conditions may have seemed overly strict, but the pay was so generous that the longer the girls worked, the wealthier they became. Base wage was $17.50 a month plus room, board, and the very generous tips they received. The scheduling was such that the girls averaged between eight and ten customers at a time, turning over those customers several times a day. Most of the girls were able to earn and save more money than many men working at what were considered good jobs.

Ultimately, an estimated 5,000 Harvey Girls married, frequently taking railroad officials as their husbands. They also became legendary, the subject of songs, poems, and even a movie. J. C. Davis of Devore, California, was among those so impressed by the Harvey Girls that, in 1895, he wrote a poem to them:

> Harvey Houses, don't you savvy; clean across the old Mojave,
> On the Santa Fe they've strung 'em like a string of Indian beads,
> We all couldn't eat without 'em but the slickest things about 'em,
> Is the Harvey skirts that hustle up the feeds.

And in 1906, S. E. Kiser wrote one of the first popular songs about the women. The lyrics included,

Oh, the pretty Harvey Girl beside my chair,
A fairer maiden I shall never see,
She was winsome, she was neat, she was gloriously
 sweet,
And she certainly was very good to me.

There was a set price for all Harvey House meals so long as the variety was great. At some lunch counters where meals were necessarily less sumptuous, he charged less than the 50 cents he charged elsewhere.

The basic breakfast in a Harvey operation was almost as plentiful as the dinner served by the Harvey Girls. Steak, hash browns, eggs, six wheat cakes, syrup, apple pie, and coffee were normal. Yet it was the service that was so special and that took careful planning. For example, when the train was approaching an early morning stop, the brakeman would check to see how many passengers wanted meals. Then he would ask how many would be using the lunch counter and how many would want the more formal setting of a dining room. This information was telegraphed ahead to the station. When the train was one mile from the stop, the engineer blew a signal whistle that could be heard by the restaurant attendant. He would ring a gong once, the signal for the waitresses to set the first course on the tables. The gonging was repeated as the train stopped, letting the waitresses know that the passengers were coming inside.

Harvey insisted that all the men wear jackets to eat. He wanted strict formality despite the fact that the trains were often stopped in extremely rugged country. Since many of the male passengers were improperly dressed and might not even own such formal wear, Harvey arranged for each station restaurant to maintain an assortment of conservative alpaca coats in various sizes. The coats were provided for wear during the meal. If a customer protested, the Harvey Girls were under orders to ignore the man. The rules would be obeyed or the customer would not eat.

There were certain rewards, though. Regardless of a man's upbringing or social status, once seated, he was served with Irish linen, crystal, bouquets of fresh flowers from California, English silver, and other finery. This was

the case in the most isolated, rugged locations as well as in the most sophisticated.

As the first course was being consumed, one waitress would ask the customers whether they wanted milk, coffee, and/or hot or iced tea to drink. The waitress would then turn the cup based on their answer. If the cup was left upside down, the "drink girl" would pour hot tea inside. The same position, though tilted against the saucer, meant iced tea was desired. Coffee was poured into a righted cup, and milk was brought to a customer whose cup was upside down, then left slightly separate from the saucer.

The manager would bring out the platter of meat, steaks carefully cut. The food service was meant to attract passengers, not make maximum profits. Any manager allowing more steaks cut from a slab of meat than the company felt was proper could be fired. By contrast, if he produced fewer steaks than ordered from a slab, giving the patrons more meat than usual, there would be no complaint.

Train travel was slow, and the passengers could easily tire of the same menu. As a result, Harvey arranged for four days of completely different menus. In that way, the passengers would experience no repetition.

The only complaints against the railroad's Fred Harvey restaurants came in smaller communities where existing facilities could not compete. The railroad absorbed the shipping costs of their own food and maintained experts in both Chicago and Kansas City to buy the best food in such quantity that discounts in cost were achieved.

The cost factors changed with time. By 1918, an adult had to pay a dollar for a meal that had cost 75 cents thirty years earlier, not much of a change but one that still made the railroad nervous. Their arrangement with Harvey was such that the meals did not make a profit. Sometimes the dining facilities broke even. Sometimes they actually lost money. Either way, Harvey, as well as the various presidents of the railroad during his time as food service manager, felt that the meals ensured an increase in customers.

No businessman faced with the "sinkers" and other gastronomic horrors of business travel would ever consider taking a vacation on the railroad if it was at all pos-

sible to avoid it. The idea of taking a wife and children was laughable. However, with the Harvey food service, the railroad was a pleasure to travel, and business increased rapidly.

Perhaps the most important man involved with railroad promotion was Edward Ripley, who took the Harvey operation and the Taos artists and used them to sell some of the most underused rail lines in the nation. During his twenty years as head of the railroad, he took it from a period of receivership at the end of the nineteenth century to one of the most properous in the nation by the 1920s. He almost doubled the number of miles the trains could travel and increased the gross income from $30 million to $126 million while providing jobs for 75,000 men and women.

Harvey had opened new doors for Southwest travel and tourism. He also gave the AT&SF an incentive to seek new ways to market the Southwest. Ripley recognized this asset and also one other. He spotted a painting the famous nineteenth-century artist, Thomas Moran, had made of the Grand Canyon, a new route for the AT&SF. Ripley bought the painting, had it lithographed and framed, then distributed it to thousands of homes, hotels, schools, rail stations, and anywhere else he could. He did not realize it, but he had just taken the first step in assuring the future financial survival of the Taos Society of Artists. And with this action, coupled with the excellent quality of the service his rail line could offer, he would change the face of southwestern art, commercial advertising, and the way the American West was again opened for settlement.

CHAPTER IV

TWO DUDES,
SOME BAD GUYS, AND
THE NEW OLD WEST

M eanwhile, with no inkling of the future role of the railroad in their lives, Ernest Blumenschein and Bert Phillips returned to New York from Paris to work as illustrators. Sometime later, Blumenschein was asked by *Harper's Weekly* to cover a Wild West Show being held in Madison Square Garden. He described the Indians in the show as "ugly looking bucks." They wanted a dollar each to pose for him, though he ignored their requests and began sketching. He also was surprised by their actions: they were playing card games rather than engaging in what he might have thought were more traditional pursuits. Blumenschein wrote,

> The card game grows very exciting, attracting to the six squatting figures quite an audience of interested onlookers who often add to the intenseness by throwing their recent pay into the circle to bet on a "draw." . . . The Indian plays cards with great fervor, drawing the edge of the second card slowly over his first, to get the full benefit of the excitement should fortune fall his way and he have a 'suit.' If he has high cards, how he does bet! and the lookers on behind him bet. Then with

*quick breath he takes his next card. An ace of his
"suit." Whoop! Hi yi! those behind him join in the
yelling, to the discomfiture of the apparently stolid
losers. And Black Heart goes to stock himself with
tobacco for the week.*

Having been introduced to tales of the American West
in Paris, then having met "real" cowboys and Indians in
New York, Phillips and Blumenschein decided to see the
West for themselves. The performers, amused by the enthu-
siasm of the "drugstore cowboys," made them an offer they
could not refuse. According to Phillips, they were told,

> *"If you fellers want a good outfit cheap I know
> where I can get you the whole thing for ten bucks;
> if you will give me the lariat. There is a good sad-
> dle, chaps, spurs, bridle and lariat that one of Bill's
> cowboys raffled in a saloon on Second Avenue.
> The feller who won it (must have been the bar-
> tender) ain't got no use for it." We gave him the ten,
> and that day he came in the studio with the out-
> fit on his back. It filled a trunk. We were definitely
> committed to make good.*

The first stage of the adventure was taken in comfort.
Phillips and Blumenschein, "Phil" and "Blumy" as they
were known, took the train to Denver, Colorado, where they
outfitted themselves properly. They knew there were no
Indians in Denver; yet they also knew that somewhere out-
side the city limits there would be action, adventure, vio-
lence, and sudden death. Not theirs, of course, but some-
one's, and they would have the opportunity to witness the
great drama that was typical of what had been occurring
on the land for centuries. Then they would translate what
they had seen onto canvas, using the experience to
improve their illustrations, perhaps selling individual
paintings in galleries as well.

In theory, Blumenschein should have been the more
sophisticated of the two travelers. He had been working as
an illustrator and received an assignment from *McClure's*
magazine to visit Arizona and New Mexico. But that work

had been in midwinter, a quiet time in the Southwest, and he had stayed along the rail lines, never venturing very far from "civilization" because his assignment was brief. He was convinced that there was something more just over the horizon, and now the two men would experience it firsthand.

The young artists armed themselves, of course. Cheap novels had prepared them for the harshness of men such as killer-turned-lawman Bill Hickok, the Earp Brothers, and Henry "Billy the Kid" McCarty (aka William H. Bonney), as well as the Indians who were constantly on the warpath. Phillips, at 30, was older than his friend and should have had more maturity. But he was caught up in the fantasy as well. As a result, Blumenschein brought a shotgun, a weapon that was intimidating because even a man who could not aim well was likely to hit his target. Phillips purchased a $2 navy issue revolver, a powerful handgun with a long barrel meant to improve accuracy. As Phillips later related,

> *Never, in the history of the West was there two such inexperienced "Tenderfeet" let loose; we did not know how to harness a team nor saddle a horse! The liveryman, from whom we were to purchase the horses, told us he would drive them before a lumber-box wagon, so my partner said, "Now Phil you watch him harness them from one side and I'll watch on the other, between us we should be able to learn enough to harness them ourselves, if we buy them, for we cannot let him know how green we are."*
>
> *We watched carefully, feeling confident that we could learn it all in one lesson. The tryout was satisfactory; after driving around the streets in lower Denver we returned to the stable and bought the team and harness.*
>
> *The new wagon had been delivered to the stable when we appeared next morning. Nonchalantly we "hooked up" the team and drove to our boarding house, loaded on our belongings. We were off at last, somewhat fearful but happy. As we*

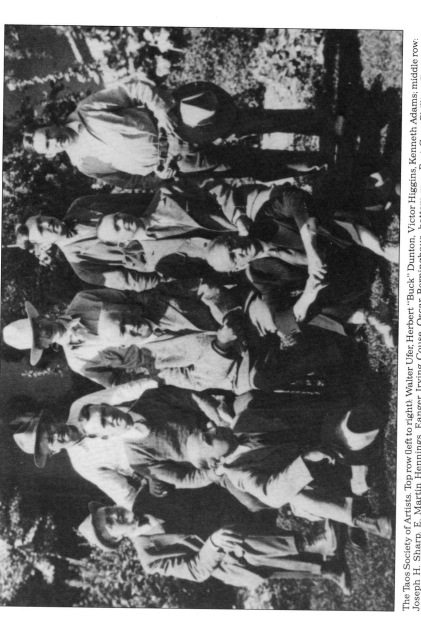

The Taos Society of Artists. Top row (left to right): Walter Ufer, Herbert "Buck" Dunton, Victor Higgins, Kenneth Adams; middle row: Joseph H. Sharp, E. Martin Hennings, Eanger Irving Couse, Oscar Berninghaus; bottom row: Bert Geer Phillips, Ernest L. Blumenschein (Courtesy of Fenn Galleries, Santa Fe, New Mexico)

Ernest Blumenschein in Taos, 1932 (Photo: Will Connell/Museum of New Mexico, courtesy of Fenn Galleries, Santa Fe, New Mexico)

Helen Blumenschein in the Blumenschein home, Taos, 1920
(Photo: Museum of New Mexico, courtesy of Fenn Galleries, Santa Fe, New Mexico)

Bert Geer Phillips in Taos (Courtesy of Fenn Galleries, Santa Fe, New Mexico)

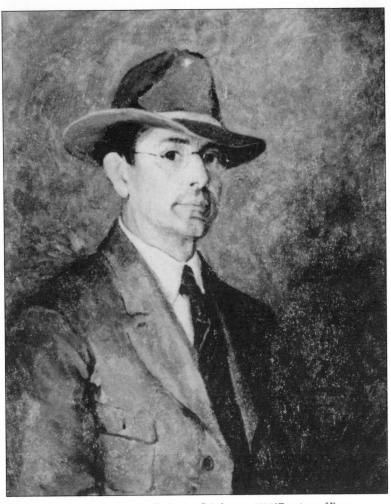

Portrait of Oscar Berninghaus by Catherine Critcher, ca. 1926 (Courtesy of Fenn Galleries, Santa Fe, New Mexico)

Grand Canyon, Oscar Berninghaus, 1916 (Courtesy of Fenn Galleries, Santa Fe, New Mexico)

Grand Canyon, Oscar Berninghaus, 1916 (Courtesy of Fenn Galleries, Santa Fe, New Mexico)

Kenneth Adams in Taos, 1930 (Courtesy of Fenn Galleries, Santa Fe, New Mexico)

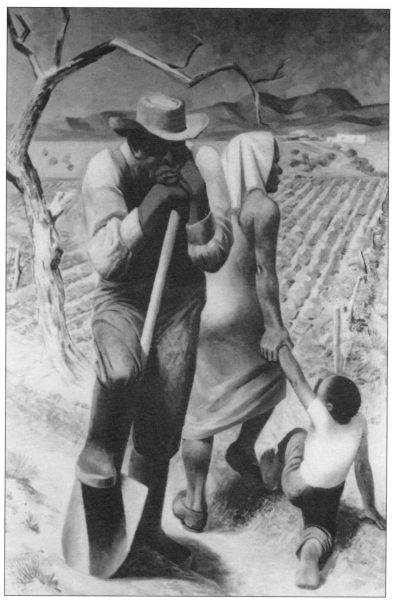

The Dry Ditch, Kenneth Adams, 1964 (Courtesy of Fenn Galleries, Santa Fe, New Mexico)

The accident that started the Taos Art Colony; Bert Phillips (pictured) and Ernest Blumenschein, September 4, 1898 (Photo: Museum of New Mexico, courtesy of Fenn Galleries, Santa Fe, New Mexico)

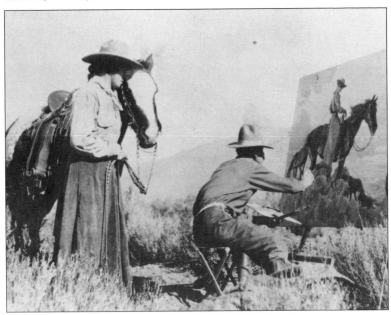

Herbert "Buck" Dunton with model on location, ca. 1915 (Courtesy of Fenn Galleries, Santa Fe, New Mexico)

*drove south on Broadway that bright spring morn-
ing, the last of May, 1898, the West was ours! The
dream of years was coming true—but oh! that
word, but. How many dreams it has shattered as
ours was rudely smashed by the angry farmer,
who, coming in the opposite direction, stopped us
by shouting, "Hey, you fellers, do you want to have
a runaway and kill somebody."...Well, we did not,
so asked what was the matter. "Matter enough," he
exclaimed as he got down from his wagon and
angrily crossed our reins, snapping the left end of
the right horse's rein to the bit of our left horse, and
the right end of the left rein to the bit of the right
horse, giving us a complete control of the team; our
final lesson in harnessing but only the beginning
of many other lessons we little dreamed of in the
adventure before us.*

*That night we camped in Deer Creek Canyon
among the Red Rocks, which is now a part of one
of Denver's scenic drives. We camped in that vicin-
ity all that summer, sketching and painting, get-
ting experience often mixed with dangers we had
not counted on, such as an early morning visit by
heavily armed bandits, who looking us over with
cold hard eyes, evidently decided we had nothing
useful to them, rode away, leaving us somewhat
shaken, but thankful.*

And what of the weapons the two of them had pur-
chased to protect them from just such dangers? They were
buried in the back of the wagon under canvas and paint
supplies. They had purchased them for protection against
the dangers of the road, loading them first into the wagon,
then promptly burying them under all their other pur-
chases.

*The first week we lost one of our horses, choked
on a picket rope. Later a cloudburst washed away
part of our outfit but luckily spared our lives; we
little realized at the time how in later years we were
to read in the Denver papers of similar storms that
coming suddenly, as did this one, many people*

have been swept away by the swollen canyon-stream. A run-away team down the sloping mountain meadow came near crashing our enterprise but the break of a wagon-spring and many bruises seemed as nothing to what might have happened had the traces not broken just before we came to a deep arroyo.

By September, we felt that we were ready for the long trek to the Great Southwest, with Taos as our first stopping place. We had heard of Taos, the home and burial place of Kit Carson [Note: Carson actually died in Colorado, though he was brought back to Taos for burial]; of the Indian people who live in five storied communal houses and the beautiful Spanish girls; romance and beauty; pictures to be painted; adventure, all lured us on.

The trip was filled with difficulties; it was before the days of automobiles, wagon roads were bad; bridges in southern Colorado and northern New Mexico were made of loose poles laid across the log stringers, often over deep arroyos, these poles rolled and sprung under the horses' feet. We expected every minute to see their legs break in their effort, our signs of relief were audible when we were safely across. We began to realize that a kind Providence was with us for in spite of a smashed wheel that cost a three-day delay; repairs at every blacksmith's shop we passed; our last dollar spent, we reached our destination—Taos.

It was only after they had spent their money that Phillips and Blumenschein discovered the true secret of the old West—baling wire. Even the best-made wagons could not handle the rough, uneven terrain. Natives had learned that the cost of repairs such as the two young men had made, repairs that amounted to the regular rebuilding of their equipment, was far too expensive. Instead, they carried large supplies of baling wire hung on their wagons. Each time something broke, they would use the wire for the repair. Not only was it far less expensive but the criss-

crossed wires created an effect much like that of a bed spring, and the ride actually improved.

TAOS

Taos was probably the best community of the Southwest in which the artists could settle. There were Indians, white men, and "Mexicans," though the latter were usually Spanish Americans, many of whom had never lived in Mexico though their families had come from that country and they were bilingual. It was also an extraordinarily peaceful community with just enough wildness in its history to enable old men and liars to regale newcomers with stories of the horrors they just missed.

Taos was originally a meeting ground for Indians of different nations. It was a festival town, a marketplace where fairs were regularly held in at least the late eighteenth and early nineteenth centuries. At first the fairs were located between two communal houses. Later, when the numbers kept increasing, they were located in the town plaza.

The Indians had a market where various hunters and trappers sold the skins of buffalo, beaver, deer, fox, and mink. There were blankets with elaborate designs, beads, knives, horses, and other items for sale or trade. Many of the visitors were mortal enemies who, at other times, in other places, would be at war with one another. Others were hunters proudly watching the sales of the goods they had gathered. And a few were traders, white men, Mexicans, and Indians who would buy the goods, then resell them to hat makers, furriers, the general public, and various merchants.

Taos was also the northernmost point on the Taos-Santa Fe-Chihuahua Trail, which involved torturous trails and dangerous climbs through forbidding mountains. The Taos Valley, where the young artists arrived, is 7,000 feet above sea level and surrounded by the Sangre de Cristo mountains, the Jemez and Nacimiento mountains, and the Picuris Range. The Taos Valley is split by the waters of the Rio Grande, and the climate is such that everything from desert vegetation to trees such as ponderosa pines, aspen, and cottonwoods covered the foothills. The fertility of the

land encouraged settlement and brought three groups into the area over the centuries.

The Indians arrived in the area first, around A.D. 900, eventually establishing the Pueblo of San Geronimo de Taos in the 1300s. The Spanish came 200 years later, and the Anglos arrived in the mid-1800s. The latter was the name for anyone who was neither Spanish nor Indian.

The natural beauty of the land that Phillips and Blumenschein experienced in 1898 was best described by Agnes Laut when she visited the area fifteen years later to write an article, "Taos, An Ancient American Capital," for *Santa Fe Magazine*. She wrote,

> *As you ascend the mesa above the riverbed you see the mountains ahead rise in black basaltlike castellated walls, with jagged tower and battlement thrust into the very clouds. Patches of yellow and red blotch the bronzing forests where the frost has touched the foliage, and you don't go many miles into the lilac mist of the morning light, shimmering as it always shimmers above the sagebrush blue and sandy gold of the upper mesas, before you hear the laughter of living waters coming down from the mountain snows.*

She went on to describe the way the land looked as the sun moved across the sky. She said that the experience was like

> *looking at life through actual rose colored tints, for there is something in this high, rare air that splits white light into its seven prismatic hues. It is never clear, white light. It is lavender, or lilac, or primrose, or gold, or as red as blood, according to the hours and their mood; and if you want to carry the metaphor still farther, you may truthfully add that the hours on these high uplands are dancing hours. You never feel time to be a heavy, slow oppressor of the soul.*

The first artists to encounter Taos were Richard and

Edward Kern of Philadelphia. Edward Kern was a topographical artist who began exploring the West with Colonel John Frémont in 1845. He and Richard accompanied Frémont through Colorado in 1848, experiencing extensive hardships that cost them several members of their original group. They reached Taos on February 12, 1849, resting, making sketches, and recording the experience in Richard's diary. However, it was not until 1893 when Joseph Henry Sharp visited Taos to illustrate articles on the Indians for *Harper's Weekly* that an artist was in the area specifically to record what he saw. It was also Sharp who shared stories about the experience with Blumenschein and Phillips during the period when all three were in France, adding to their interest. He would eventually make Taos his home, though that would not be for several years.

But there was a darker history to Taos as well, a fact that kept Phillips and Blumenschein as much on edge about possible "danger" as the visual aspects of the area excited them to paint. This was the result of the Taos Rebellion, a story repeated often, yet one that reflected a problem fifty years in the past.

It was the essentially peaceful nature of the Taos settlers, the lush land, and the oasislike surroundings in the midst of harsh territory that created the earliest problems. People were willing to pass their time working the land, tending to their animals, living and dying in harmony. They had no interest in power politics, a fact that made them susceptible to those with ambitions. Thus, occasionally there would be an attempt by a Spanish American, an Anglo, or an Indian to try and assert more personal control over the others. This problem came to a head after Brigadier General Stephen Watts Kearny marched what was known as the Army of the West into Santa Fe—then Spanish territory—on August 18, 1846. The following day, having asserted his physical presence, he proclaimed that New Mexico was officially a territory of the U.S. government. The new governor, who was to take his post that September, was a Taos resident, Charles Bent.

Bent had an interesting history that made him a natural target for the wrath of those who resented Kearny's theft of territory. He was a native of Virginia who, along

with his brother, William, traveled to Colorado in 1828. There they built a trading post on the Arkansas River in Colorado, naming the location Fort Bent. William Bent stayed at Fort Bent, eventually marrying an Arapaho Indian woman. He developed no political connections and was seen as part of the Native American population.

Charles Bent was restless, moving on to Taos and marrying a wealthy Spanish woman, Maria Ignacia, who was the daughter of a man who had extensive land holdings. She was also the sister-in-law of Kit Carson.

Bent was sensitive to the property issue in the area. His in-laws had made their money in land, and many people owned land grants provided by the Spanish government. As a result, he helped pass a law that would assure that each New Mexican pueblo (village) would have perpetual rights to the land it obtained under the Spanish. It would also be an independent unit of local government.

Kearny's occupation was bloodless but extremely offensive to Mexican nationalists, who felt that Kearny had no business stealing the territory (it was not officially transferred to American control until 1848). There was also a fear of the new government because the people had been badly hurt by a previous leader, General Manuel Armijo, who had named himself governor ten years earlier, in 1837. Armijo ruled by brutality without discrimination, hurting Mexicans, Indians, and Anglos alike. Kearny and his men had been sent by President Polk to investigate Armijo's actions, but Kearny took on himself the role of simply taking charge and announcing that Armijo was finished. As a result, some Mexican nationalists and a few of the Indians became terrified that Kearny would repeat Armijo's offense, and they wanted him out.

The revolt was led by a Mexican and an Indian, each convinced that the government would take their land. They made their first effort on Christmas Eve, 1846, having first gained courage through excessive drinking of corn liquor. That action was stopped with little violence by U.S. Army troops.

A second attempt occurred on January 18, 1847. Again the men were drunk, though this time they were joined by sympathetic Mexicans and Taos Pueblo Indians. The mob

had no plan other than destruction. By the following morning, the Americans were seeking refuge in the home of Padre Martinez, the Catholic priest. All the men in town grabbed guns and the area exploded in violence. Years later, Tersina Bent, the governor's daughter, would write of the incident she witnessed as a five-year-old. She said that her mother, her aunt, Mrs. Kit Carson, a neighbor, her brother, ten-year-old Alfredo, and other children were present.

The women and children tried to escape through a wall in the adobe house while her father stood his ground, despite being shot repeatedly by arrows.

> *When he did try to escape, he was already wounded and had been scalped alive. He crawled through the hole, holding his hand on the top of his bleeding head. But it was too late. Some of the men came after him through the hole and others came over the roof of the house and down into the yard. They broke down the doors and rushed upon my father. He was shot many times and fell dead at our feet. The pleading and tears of my mother and the sobbing of us children had no power to soften the hearts of the enraged Indians and Mexicans.*

Others died as well, some from Bent's family and others who were connected with the government in some capacity—a circuit judge, the sheriff, and similar officials. Men found hiding were also attacked and murdered. Then the mob continued through the area, burning and vandalizing property indiscriminately. They had lost all sense of political action and were out for violence.

U.S. troops were sent to the area, restoring order and arresting the ringleaders. A soldier shot Tomasito after he was taken to the guardhouse. Montoya's death was more formal. He was given a trial, then hanged for his crimes.

By the time Blumenschein and Phillips arrived, the violence was history that delighted them. A few Mexicans still had ill will concerning the American annexation of New Mexico, but the Indians were friendly and stayed neutral

in any arguments. Blumenschein had already seen Taos as a result of one of his and Phillips's usual blunders. In this case, it was a problem with a wheel that had broken off the wagon before the men learned about baling wire. This was their last use of a blacksmith for the trip. Neither man felt like making the journey down a steep mountain while carrying the large wheel on horseback, but one of them had to do it. They tossed a $3 gold piece to see who would have the luxury of camping by the wagon with their supplies and who would have to make the trek. Blumenschein lost, though the difficulties were almost tolerable after he saw the land that would ultimately be his home. He described the incident:

At 4 p.m., on the third of September, 1898, I started down the mountain on what resulted in the most impressive journey of my life. It took me until dark to reach the foot of this long hill. There I spent the night with a hospitable Spanish-American farmer—one dollar for frijoles, bed, and frijoles again for breakfast. It was early in the morning when I resumed the horseback ride. My muscles soon ached from carrying the broken wheel. What had seemed a simple job when we tossed the coin, had become a painful task. The wheel grew larger and heavier as I shifted it to all conceivable positions, from arm to arm, then around my neck or on my back or balanced on a foot. Even the horse resented the unwieldy load on his saddle and grunted his displeasure at every stop. Vividly I recall the discomfort with no relief in sight on the road, no wagon going my way, no hope to ease sore muscles until I reached Taos, a dim picture of which I had made from Sharp's slight description.

But Sharp had not painted for me the mountains or plains or clouds. No artist had ever recorded the superb New Mexico I was now seeing. No writer had, to my knowledge, ever written down the smell of this sage-brush air, or the feel of the

*morning sky. I was receiving under rather painful
circumstances, the first great unforgettable inspi-
ration of my life. My destiny was being decided as
I squirmed and cursed while urging the bronco
through those many miles of waves of sage-brush.
The morning was sparkling and stimulating. The
beautiful Sangre de Cristo range to my left was
different in character from the Colorado moun-
tains. Stretching away from the foot of this range
was a vast plateau, cut by the Rio Grande and by
lesser gorges near which were located small vil-
lages of flat roofed adobe houses built around a
church and plaza, all fitting into the color scheme
of the tawny surroundings. The sky above was
clear clean blue with sharp moving clouds. The
color, the reflective character of the landscape, the
drama of the vast spaces, the superb beauty and
severity of the hills, stirred me deeply. I realized I
was getting my own impressions from nature, see-
ing it for the first time probably with my own eyes,
uninfluenced by the art of any man. Notwith-
standing the painful handicap of that broken
wheel I was carrying, New Mexico inspired me to
a profound degree. My grunting horse carried me
down and across the gorges, around the foothills
over long flat spaces that were like great lakes of
sage-brush, through 20 slow miles of thrilling sen-
sations.*

*It had to end in the Taos valley, green with trees
and fields of alfalfa, populated by dark-skinned
people who greeted me pleasantly. There I saw my
first Taos Indian, blankets artistically draped.
New Mexico had gripped me—and I was not long
in deciding that if Phillips would agree with me,
if he felt as inspired to work as I, the Taos valley
and its surrounding magnificent country would
be the end of our wagon trip.*

Blumenschein's return was even more arduous because
he was going uphill. His early enthusiasm was further
dampened when he discovered that Phillips had encoun-

tered a lone horseman who warned him of horse thieves in the area. There was a chance that they would be attacked, and Phillips was anxious to complete the journey to Taos.

At first, the men were at a loss as to where to camp after their arrival. They found what they thought was the ideal site, outside the east wall of the Taos Indian Pueblo near a stream filled with mountain trout. However, the Indian governor explained that they were not welcome in that exclusively Indian section and would have to camp elsewhere. "I heard somebody shouting," Phillips later recalled. "And I looked up on top of the five story Pueblo and there was this big old Indian up there in a white robe; I don't know what he said, but I know he meant 'get the hell out of here!'. . .which we did right then and there."

Unfortunately, every other location seemed to be owned by someone who wanted money, and they had none. Finally, they sold some of their supplies to the townspeople and used the cash to rent a field surrounded by trees.

Once again, the drugstore cowboys were taken in a way no local could have been. They did not know enough about land to see a series of springs there that created little more than a perpetual swamp. They had to forfeit their rent money and move on because the ground was too wet for them to stay.

Eventually, the two men found an adobe house in the village where they could cook in an open fireplace and use broad open spaces for a studio. They also became intrigued by Indian activities, convincing a local Indian named Tudl-Tur to pose for them and to teach them to shoot a bow and arrow. They went outside and placed targets on their adobe wall, shooting at them until they became fairly skilled. Their practice left dozens of arrow holes in the adobe, earning them their landlord's wrath.

The two artists worked throughout September, constantly sketching and painting. It was harvest time and they were anxious to capture the activities involved with gathering food and preparing for winter. What they did not realize was that they were also in time for a major holiday held annually on September 30 by the Taos Pueblo Indians.

The celebration's preparation began with the women grinding wheat between two heavy stones, making large

flat cakes that would be baked for eating. The ovens were made of adobe, then filled with piñon boughs that were set afire to warm the oven. When the proper temperature was reached, the coals were removed and the cakes placed in the oven, the baking done by the heat sustained by the oven walls. Once the cakes were removed and the ovens cooled to the temperature of a hot day, dogs would wander inside and nap in warmth.

A tall pole was set in the center of the square, crossbars at the top. This was used to display food, including, in the original ceremony, a live sheep. The sheep had its legs tied, then was suspended upside down for the entire day. The animal suffered constantly in the hot sunlight, frothing at the mouth, bleating helplessly, experiencing intense tortures. By 1900, it was decided to slit the animal's throat before hanging it. But Blumenschein and Phillips witnessed the original ceremony as it had taken place for years, animal torture and all. There was also fruit decorated with ribbons.

Near the pole was a small church where a Catholic priest held a service in Latin. Throughout the service, the priest would ring a bell, a signal to Indians outside the church to fire guns and beat a drum. At the same time, the kneeling congregation would bow slightly forward, the angle of the bow increasing each time the bell was rung.

After the service, a race was held. Half the men who competed wore only a loincloth and painted their bodies in a variety of stripes. They wore eagle feathers and occasionally added other decorations, including animal horns. These men performed a dance that involved swaying their bodies and slowly moving their feet up and down, then slightly forward, making a snaking motion through the open area. Then they were joined by the remainder of the runners and took their places at the starting point of the track a quarter mile away.

The race was something like a relay. Two runners raced from one end of the track to the other and were followed by two different runners who would return. They alternated in this manner for approximately two hours, the crowd consistently enthusiastic. There were no favorites. In fact, if someone seemed to be going too slowly, aged men along

the sidelines would take cottonwood branches and brush their heels, endowing them with greater powers.

When the race was over, the women stood on the houses and threw bread, cake, and fruit at the dancers. Then everyone napped before returning to the plaza in the late afternoon to enjoy the clowns—hideously painted, almost naked men who would run among the throngs engaging in whatever mischief they desired.

The final act of the day involved a mock hunt where the men pretended to follow tracks, listen to the ground, hush one another as they searched, and gradually make their way to the pole where the sheep was hanging. Usually, the animal had died during the day. If it was still alive, its body would be nearly lifeless, no longer moving.

The "hunters" spotted the animal, dancing and singing in delight, then trying to cut the pole with stones that were never adequately sharp. Finally, one of the men climbed the pole and sat on the crossbar holding the fruit. Then he took his knife, cut the rope holding the sheep, and let it drop to the ground. If the animal had been alive, the drop assured its death.

The Indian who had climbed the pole carefully lowered the fruit. Then the sheep was butchered, families taking home pieces of fruit and sheep so that they could make a meal of their "prize." It was a celebration at once barbaric and fascinating to Blumenschein and Phillips.

The culture shock worked in opposite ways for the two men. Phillips realized immediately that he had found his new home. The land, the people, the sky, all were inspirations to him. He knew that if he painted constantly, he would never run out of subjects, would always feel that there was more to be done. He also wanted to understand the people, their beliefs, and their life-style. He had entered an alien world and knew he would do anything to be accepted by it, to both become a part of it and to become its chronicler on canvas.

For me it was a momentous occasion. It helped me to decide that I had come to the end of my journey. In a few weeks I had found more inspiration and material for creative work than I could use in

a lifetime; more than that, I had found the ideal climate for out-door work; also a realization that one artist, alone, could do no more than scratch the surface in this locality, while the Great Southwest, an artistic empire, was practically undiscovered country to the art world. True, some great pictures had been produced by Frederick Lungren [sic], Keith, Moran and others but they were like great nuggets picked up here and there in far away places that seemed too remote to be believed in, especially by people in a profession that had almost lost the pioneer spirit.

Blumenschein, by contrast, wanted the bright lights and the big city. He missed New York, missed the familiar. He was not ready to adjust. In fact, he never fully allowed himself to adjust and made plans to return to Manhattan, taking their paintings to sell. He would be back, they both knew that, but it was the wrong time for full commitment.

Blumenschein's departure after a few weeks was probably wise. He was the more skittish of the two when it came to facing the unusual, and Phillips was about to have two more adventures during this early period of discovery in Taos. The first would be when he had to win the trust of the Indians with whom he worked. The second was when he found himself in jail.

As Phillips explained about winning the Indians' trust,

I had to overcome many superstitions before they really accepted me. Not a day passed that I did not entertain from two to six of them for lunch; eating the same food at the same table has a magic of its own for overcoming misunderstandings. But my reputation as a fast runner (I had learned to sprint as a youth) still stood in my way, for the Indians kept bringing their fast runners for races after working hours on the level road near my studio. One day Sun Elk, my model, said, "Mr. Phillips, you have our fastest man to beat yet, but the others all say that they can run as fast as you until the last few yards when your feet leave the

71

ground and you fly through the air, without touching it." I laughed. He said, "I know that is not true but they believe it, and the old men say you must race on our own race track at the Pueblo because you have a 'Brujah' (witch power)." All right, I told him, tell them I will come Wednesday afternoon. A few days later I rode out and joined a group of several old men and officials of their council on their track just outside the east wall of the village. One old man addressed me, but as I did not understand what he was saying, Sun Elk, who was among the spectators, told me that he wanted me to take off my shoe, adding that I better do anything they wanted. So off came the shoe into which he squinted, turned upside down, and felt into, patted and otherwise examined, until seeming convinced that whatever he was looking for was not there, he handed it back with a grunt. Whispering aside to Sun Elk, I asked what he expected to find. "Well, I think he expected to find an owl feather." Later I learned that owl feathers were regarded by the Indians as having magic power. They all were apparently satisfied so the race took place immediately, and the defeat of their champion ended their black doubt of me for the time being. I had yet to overcome other such doubts, but eventually they were all dispelled.

To Phillips's delight and probably to Blumenschein's dismay, the last violence Taos was to experience occurred not long after Blumy resettled in New York. "Mexicans," as Spanish Americans were known, had been engaging in a certain amount of rowdiness in Taos. Most were Americans of Mexican descent who primarily spoke Spanish or English as a second language. Some of the men were known to get drunk, ride into town, fire their revolvers into the air, have more to drink, then ride out. Usually, no one was hurt and the action was not hostile. Newcomers to the town were frequently frightened by what took place, however. On December 14, 1898, Phillips wrote to his friend to tell him of a rather bloody incident that occurred. It would

be the last of the violence that carried over from the ill will that existed back in the late 1840s, fifty years earlier.

You will be interested to know we, the Americans, are armed to the teeth and expecting an attack from a mob of Mexicans at any moment. The Sheriff was shot last night—three bullets through his dammed head and expected to die at any hour. I can not tell you yet who did the shooting but you will hear later if your old chum is alive to write. We are 17 strong tonight and can stand off a mob of 150. We are well organized and every man has his duty to perform and is only too anxious to do it. "Photo" and I were locked up in jail last night but the "boys" took us out before midnight. And indirectly we are the start of this business. It started like this—we went down by the Church to see a parade—one of their feast days. It was after dark and a gang from the parade jumped us to force us to take off our hats—we didn't take for a cent neither of us being built that way. We had a scrap right there and the Sheriff was drunk and arrested us at the point of a pistol. We had a tustle in Gusdorf's and after a hot time they got "Photo" and while I was gathering up the Americans to get him out on a writ or—The damned drunken cuss came rushing in to Long John's after me, he threatened my life and I had to look down the gun barrel. When he got me to the "coop" he threatened me again with the pistol at my breast.

After getting us locked up he set out for more trouble—in the afternoon he said he would kill an American or get killed. Well! he got what he was after. We are still under arrest, I suppose as we have not had a trial and supposed to be locked up. I can't say all I'd like to tonight as this letter might be held up. The shooting was done less than a half hour after we were locked up and the "boys" organized to rescue us thinking that the mob on failing to find the right man who did the shooting, would vent their spite on us. We heard of his being

killed and fully realized our position but the damned cusses din't scare us. We went over and slept with baricaded door, at my place. . . .

As I write here some of the fellows are laying on the floor. "Long John" a cool brave fellow and others. In the back room some fellows are acting as sentinals on duty an hour or so at a time.

The Bryans and Mrs. G. and Miss G. and Melville are in the other back room. We have another crowd located near in Polk's room. We only go on the street at night rifles and guns as the Mexicans are travelling in gangs. "Photo" has his shoot gun [sic]. You can't imagine what this is like, We din't know Taos. All outgoing roads have been held by them since last night. Don't let this get out—I would not have my folks know of this for anything.

I begin to feel as if this was real "border life" and only wish old Kit Carson was here with us. . . .

The letter was signed "Phil," then had an added note that sounded more like a college student writing home than an adult in the middle of a crisis. He wrote, "Your father sent me the $25.00 order. Many thanks."

The problem was almost completely resolved by December 18, the last time Phillips would mention the incident. It was also the last violence either man would encounter during their lives in Taos. Phillips wrote, in part,

I am writing to let you know that we are still here, except Al Gifford who is now safe in Santa Fe. We were up three nights to keep him safe from the Mexicans as well as to protect ourselves. We would have shot down 100 if necessary to have kept him out of their hands. He was hiding in Scheruch's and we were in Gusdorf's and another party in Polk's the corner next the Gambling room.

The signal was two shots to be fired by Scheruch's son in case Al fell into the hands of the mob, then we would have got in our little work. Their cry was "Kill all the Americans" and "Remember '47."

> *Things are quiet now but we must carry arms at*
> *night as that is the time the damn coyotes go out*
> *to bite. They tried to get the Indians to help but the*
> *Indians said they did not wish to fight but when*
> *they did it would be with the Americans.*

The letter ended with the trivia of life in Taos. He added, "Am painting away on my Indian pictures and some of them seem very promising, am getting what I have needed for years; steady work from model."

Ultimately, the leaders of the mob were arrested and the killer of the sheriff was indicted for murder. Phillips was pleased to learn that he could earn several thousand dollars suing the sheriff for allowing him to be in jail when there was danger from the mob. But he never took advantage of the situation, just went back to his work. He also concluded that Taos was the only place he wanted to live. On January 15, 1899, he wrote,

> *The weather is clear and cold a typical winter;*
> *steady cold, I burn two and three burro loads of*
> *wood each week, and we are cozy and comforta-*
> *ble. I honestly would not come back to New York if*
> *some one would pay my way and give me a couple*
> *of hundred to boot. Am not a bit homesick only*
> *anxious for good warm weather to make my trips.*

And so Phillips settled into Taos. He delighted in the life-style, the people, even the adventures. He had food, shelter, clothing, and supplies for painting—everything that, for him, made life worth living. All that was lacking was his friend. Yet even Blumenschein would soon succumb to the lure of Taos, bringing everything he needed to "civilize" the West—tennis racket, dinner clothes, and a business sense that ensured the survival of what would soon be the most important artist colony in the American West.

THE DRUGSTORE COWBOYS TAKE WIVES

It was a variation of the popular World War I song: How you going to keep them down in Taos, after they've seen New York? That was the question for Ernest Blumenschein after he left his friend Bert Phillips. As much as he loved New Mexico and was fascinated by the endless array of subjects, Blumenschein was not yet ready to experience the rough isolation that Taos represented. He wanted the glamour and excitement of Manhattan. He wanted to be in the midst of the publishing world. He wanted to be able to date women, perhaps to find a wife. And while the lure of Taos would cause him to return each summer for the next several years, he would see Taos only as his second home.

Phillips had gotten lucky when it came to relationships. In part, this was because he was a man of no pretensions and great love. He did not care about anyone's background. He was comfortable with even the most unusual societies, accepting people for what they were, adapting to their circumstances and beliefs instead of expecting them to adjust to him. He later wrote,

The Indians worship all things beautiful. . . . It is not the passive appreciation that is the frequent

*reaction to beauty of many white people. It is an
integral part of their being. Their religion revolves
around the rhythm and life of nature. Their love of
beauty is born of knowledge as well as of what we
call superstition . . .*

*Why not expect something unusual from an
intelligent people who have had only one book for
thousands of years, which they have studied and
upon which they have depended for their physical,
mental and spiritual life—the book of nature. To
understand something of this is to understand
something of the Indian people. Their whole life is
keyed to the rhythm of nature as evidenced by their
sense of design in their blankets, pottery, baskets
and in their music. It is coming out in a new ex-
pression through the watercolor paintings and
mutual decorations by the young people of the
present time.*

The Indians named Phillips Tzu-bar-tu-na, White Eagle
Feather. It was a term of special respect since other artists,
including Blumenschein, were called Bwah-whee-le-tze or
Water-Writing-Old-Man. The latter term was a literal des-
cription of anyone who used watercolors.

The respect Phillips achieved among the Indians right
from the start made him comfortable in his new life. He
had seen the last of the violence that Taos would experi-
ence. He had encountered the culture shock of the Indian
beliefs and been quite comfortable with their ways. He dis-
covered within himself the ability to relate to anyone and
enjoy them. All he lacked was a wife, and he seemed to feel
that that desire would be accomplished in due time. He
just did not expect to meet a woman like Rose Martin quite
so quickly as he did.

Rose Martin was a woman from an unconventional
family. Her brother was a physician who went to work for
the Indian Service, bringing modern medicine to the Taos
Pueblo Indians as well as establishing a private practice
to serve the white men and Mexican Americans living in
the area. She was willing to travel unchaperoned through
relative wilderness, going north from Santa Fe. She also

was eccentric in dress, wearing straw sailor hats that never were quite in fashion but that intrigued the artists, including Blumenschein, who used her in some of his paintings and sketches.

On November 26, 1899, Phillips wrote to Blumenschein concerning his relationship. "After you left, Rose Martin and I were in each other's company a good deal—at the painting class and twice a week I took her to Maggie Simpson's Spanish class. In the Spring I found I loved one of the sweetest and purest girls that I ever met and one who loved me and was a most desirable companion." Phillips told how they went riding together and how she would travel with him to the Taos Pueblo while he was working on his painting, *The Scouting Party*.

The couple became engaged, planning to marry as soon as Phillips found a representative for his paintings. Although Rose's mother and sisters objected to her marrying a struggling artist and living in Taos, when a Chicago agent named O'Brien agreed to handle Phillips's work, they decided to marry immediately. This meant that Rose was immediately cut off from everyone in her family except her brother. As Phillips explained,

> *She has a head and will of her own and loved me enough to cut loose from them, to say like Ruth of old, "Your home shall be my home and your God, my God." As things looked so uncertain until almost the last minute, I never wrote about my affair "de corazon" except to my folks who never had one word of objection.*
>
> *Well, one morning we saddled up our horses and went down to the Presbyterian minister's, took along the McClures, Meyers, Frank Staplin, Manby, Manuel, Miss Rowland, the Craig sisters, and we had the knot tied, got on our horses and started on our wedding trip to Santa Fe. Rode there and back, 150 miles. It was a bright October morning (October 12th); Manuel rode as far as the field where you and I camped—Shantet's. By the way, it was in this field almost on the spot where we camped*

*that I proposed to Rose!! One Sunday afternoon in
the early Spring.*

The marriage was at 8:00 a.m., and they spent a few
days traveling the roads, stopping in villages along the way
in order to find lodging. They went sightseeing, read, and
enjoyed each other's company. They were also fascinated
by the hospitality of the strangers who had them stay with
them before they reached Santa Fe.

When they returned to Taos, they took over Felipe Gutt-
man's house where Phillips and Blumenschein had origi-
nally lived.

*I use our old room for my studio. Had a door
cut through to the front room and the other room
back is our kitchen and dining room. We are snug
as bugs in a rug. While the rooms all open into
each other, they each have a door opening out of
doors, which is handy. No brown stone front, no
expensive or fine furniture, but I am proud and
happy, as what it is I have made with the* soft end
of a brush. *No outside help.*

*Have two fine large bear skins, three Navajo
blankets, and Apache baskets, bead work, etc.,
which gives the style of our decoration. In our
front room is our folding bed; this is also our
"Indian Room."*

Phillips also discussed a side business he had devel-
oped. He and a friend rented a store and filled it with
Indian curios. Phillips did most of the buying, and his
friend handled day-to-day operations. Their customers
were mostly visitors, though the area was becoming
increasingly popular to visit, a fact that seemed to make
the store mildly profitable from the start. Phillips was
delighted with the woman who was so like himself. And
with the marriage, his life in his beloved Taos was even
more secure.

Blumenschein was quite different, though. Younger,
unsettled emotionally, uncomfortable with his relation-
ship with his father and the different cultures in which he

had been living, he felt most at ease advancing his career in the East.

The first couple of years following Blumenschein's return to New York, he apparently got into trouble with the editors at *Harper's*, though exactly what happened is not known. The art buyers for the various illustrated magazines were not constantly seeking new talent. When they learned that someone could deliver with both the quality and the timeliness they needed, they tended to stay with that individual. Yet for some reason, *Harper's Monthly* and *Harper's Weekly* ceased to use his skills after September 1901. He worked for the other illustrated publications for the next twenty years but not for *Harper's*.

Blumenschein was not a man who was comfortable putting his feelings on paper, which Phillips well understood. The correspondence between them was often one-sided and frustrating, as Phillips jokingly mentioned in a note: "Glad to hear from you but can't you borrow some paper and envelopes...postal cards may be frank and open and all that but they are brief and don't tell when to look for you, besides they look cheap for a man with a 'job from Harpers.'"

Phillips was so content with life in Taos that he frequently ridiculed Blumenschein's need for a more exciting nightlife. On January 4, 1899, he wrote,

> *Not hearing from you I made up my mind that you had returned to the land of pretty girls, ice-cream and the theatres.*
>
> *By this time you have undoubtedly plunged into the whirlpool of dress suits, linen collars, late lunches, etc. However, I'm sorry you did not stay West long enough to learn that Arizona was still a territory—you speak of "kicking" yourself all over the state of Arizona. Perhaps the state of Arizona is a state of homesickness, if so I'll let you off on that plea.*

The brief trip to Taos had resulted in a portfolio that caused magazines to go begging for his skills. *McClure's* magazine decided to serialize the novel *The Gentlemen from Indiana* by the then-unknown writer Booth Tarking-

ton. The same publication wanted him to illustrate articles by Hamlin Garland. That was all in January 1899. The following month, *Harper's Weekly,* for which he was still working, sent him to New Orleans for Mardi Gras celebration coverage. July saw ten illustrations of his in *McClure's,* the work done for a story called "Soldier Police of the Canadian Northwest." And the month after that, *Harper's Monthly* had him illustrate "Street Fairs in the Middle West."

The world seemed to be at Blumenschein's feet. He was twenty-five and immensely successful. His work was not commanding the top dollar among illustrators, some of whom earned $65,000 to $70,000 per year at a time when many families were comfortably getting by on less than $3,000 per year. But it was high enough so that he was financially far more secure than the average business leader.

It is often said that a young person does not know what he or she desires from life until experiencing it, and such was the case with Blumenschein. He delighted in the idea of being an illustrator until he was earning his living in this manner. Then he realized that he was the victim of the editors. He had to define his imagination according to the article, short story, or book he was illustrating. The parameters of his vision were always restricted by someone else, then further restricted by the skill of the engraver. He began to realize that he wanted to be the type of artist who could go anywhere, do anything, and sell his work through galleries and patrons.

Blumenschein was also extremely insecure about his skills. Unlike Phillips, who took his basic training and then felt that everything else came from hard work and experience, Blumenschein wanted ongoing instruction. Financially secure and able to send illustrations back from Europe, he returned to the Académie Julian in September 1899. Yet even that was a culture shock, as he wrote to a friend, Ellis Parker Butler, in one of his few lengthy letters.

> *I've had my fill of Paris and its bad air. Here the atmosphere would cause a lily to droop her head and die in shame. There is not choice of thoughts,*

*no standard of life (at least in the Latin Quarter).
Everything that's natural is to be listened to, consequently vulgar ideas are as common as better
ones.*

My effort is to rise above the common vulgarities and beastliness.

Part of the problem with Paris was his maturity. He had been a late adolescent when he first arrived in Europe. Everything was new, exciting, different. The students might be juvenile in their behavior one minute, talking like affected "artistes" another and serious students at some other time. These reactions were all normal and similar to the way Blumenschein himself behaved during his earlier stay. But now he was successful, able to travel anywhere in the world on assignment, and he was frustrated. He also was thinking about Taos and resenting the fact that he still lacked the freedom to go West and paint.

Paris was good to him in one way, though. He returned to his student days customs of playing bridge and tennis, met a girl in one of the cafés, and had a short-term romance with her. Little is known of the girl except her height, for she towered over the 5'6" artist. One of the more humorous incidents in their brief courtship was when he wanted to engage in a little chaste passion with her. They walked to a graveyard, where he climbed on a tombstone to increase his height. Then they began kissing and holding each other, Blumenschein finally able to look down on the girl.

On January 16, 1900, Blumenschein became more comfortable with his surroundings. He decided that he wanted to be like Phillips and move to Taos to become a full-time painter no longer dependent on assignments as an illustrator. He wrote to his friend, Butler:

Am working in school and happy with my painting and study of the grand pictures in the Louvre. I'll hope I'll not have to return to illustration, and will make an effort to borrow money if necessary, in order to get to Taos where living is cheap and inspiration on every hand....

> *If I can only keep up my painting and study*
> *(which is possible in Taos) I may eventually do*
> *something in the picture line. Painting is my*
> *joy. . . . My illustration was no doubt of benefit but*
> *it put me far behind in color, leaving undeveloped*
> *the color muscle which needs years of careful*
> *training.*

The problem Blumenschein faced with his work was that he was not achieving the quality he desired. He was comforted that his illustrating would support him, but he longed for greater skill. That he had become close friends with Phillips and Sharp, both of whom were older and more experienced, may have added to his concerns. He was trying to compare his work with that of men who had had more time to mature in their talent.

The year in Paris was financially rewarding. *Harper's Weekly* bought illustrations of the opening of the Paris Exposition, political stories from France, and even images of the American West, though the latter were painted from memory. At the same time, he was painting. One of his subjects was the young, then little-known dancer Isadora Duncan, who would ultimately become world famous. He experimented with the picture, using swirls of color to re-create the dance, beginning a departure from the strict realism of his Salon work.

The return to New York in September 1900 resulted in Blumenschein's immediate hiring by Richard Watson Gilder, the editor of *Century Magazine*. This time the subject was another departure from the West. He was to illustrate articles by Wilson Fawcett concerning heavy industry in the Northwest. His subject would be steel smelters in Pittsburgh, mining in Minnesota, and ore transportation in the Great Falls region. The editors felt that he was capable of handling any subject, especially after successfully juggling illustrations related to both the West and Paris while living in Europe.

In 1901, Blumenschein was reminded of how much he had been intrigued by the West when he traveled to the South Dakota Sioux reservation on assignment for *McClure's*. Dr. Charles Alexander Eastman, a man in his

early forties, had written about the Santee Indians based on his experience of being raised as a child of a mixed Indian/white marriage. The book remained a major success for forty years, keeping Blumenschein's work before the public. Later he would write of that trip:

> *Being a good ball player, I was enabled to get close to the young Sioux, who took me with the team for games with clubs of neighboring cities and towns. As we drove over the prairies to and from our games, the boys seemed happy, and they sang almost incessantly. I found them better disciplined than the average white boy, but not quite the fighters in a crisis on the ballfield. They were apt to get rattled in a pinch.*

Ernest also took a side trip to Taos, then later wrote of the New Mexican countryside:

> *I am wildly enthusiastic over my surroundings. I live in a little adobe town built up by a tiny stream which cuts through the desert and loses itself in the painted canyon of the Rio Grande. Everything about me is inspiring me to work.*
>
> *Music is all I miss. But we have that in the storms that tie all the instruments of nature to noble harmonies, and in the quiet nights that fill a man's soul with a calm rhythm in accord with all that is serene and beautiful.*

Blumenschein returned in triumph to New York following the 1901 trip to the Southwest. There was growing interest in the American West, and he was granted an exhibit of his work in the Carnegie Building in November 1901. Much of the work displayed involved his trips to New Mexico and elsewhere. He was lauded by the critics, including the Dayton paper, which stopped issuing warnings about sin and depravity, instead praising "his bold style, his originality and imagination." He also received so many commissions from publications that he not only had to start turning down editors but also had to hire two assis-

tants to help him complete his work.

A humorous sidelight was the circumstance that resulted from one of the commissions Blumenschein had to turn down. It was for a trip to Arizona and New Mexico. The man hired in his place was an unknown artist with a questionable future. The artist produced a series of color landscapes so brilliant that he instantly became famous. His name was Maxfield Parrish.

Oddly, Blumenschein was not happy with his success in New York. His best friend was living in Taos, producing the types of paintings he had always wanted to create and loving every moment of the new life-style. The artists with whom he had gone to school in France held his work in disdain because illustration was not considered to be proper work for a "true artist." Finally, Blumenschein knew he had to prepare for a different career. He had saved $3,000, more than enough to support himself in France for a prolonged period of advanced study. He also was in such great demand that he knew he could take a commission for illustrations any time he desired. He was fairly certain that the right direction for him was to become a painter in Taos, and for that he needed extra training.

The decision was far more fortunate than Blumenschein imagined. The photographic process was being refined. Where once a photographer had to make an exposure of several seconds or more in bright sunlight, the film was becoming more sensitive, enabling pictures to be taken of events in action. At the same time, reproduction techniques were being developed which would soon make it practical for pictures to be reproduced in newspapers and magazines. The illustrators who survived would find themselves limited primarily to cover art and the advertising field. Many, such as Norman Rockwell, would see greater wealth than illustrators had ever known, but their clients and their work would be radically different. The job market for people like Blumenschein would shrink, and he was not the type who would easily be able to adapt to such change.

Paris Once Again

The return to Paris in fall 1903 was another shock for Blumenschein. He had become quite comfortable with the formality and sophistication of New York. He liked the lifestyle of refinement he had known and was no longer able to relate so easily to the Bohemian world of the French art students. He undoubtedly had become one of the pompous Americans even he had ridiculed when he made his first trip abroad.

Arriving with money, Blumenschein no longer needed to worry about living in student hovels. He took a studio at 18 rue de Boissonde, working half a day and studying half a day. He also made certain that his money would not run out by accepting commissions from book publishers seeking illustrations. These included his most successful at the time, the frontispiece for *Indian Fights and Fighters* by Cyrus Townsend Brady. The illustration involved the portrayal of the Battle of Little Big Horn. It showed Custer and the handful of surviving soldiers surrounded by the Indians who were moving in for the kill. It may or may not have been historically accurate, but there was a renewed interest in the battle at the time and the book publisher allowed the illustration to be reproduced in many different forms. It was thus the first of Blumenschein's work to reach an unusually large audience.

The rather snobbish attitude Blumenschein seemed to convey when he first returned to France quickly dissipated as he returned to old haunts and activities. He again became part of the minstrel show, not realizing that he was about to play before his most enthusiastic audience, Mary Sheppard Greene. She went so far as to have a mutual friend introduce them.

The relationship that developed was an odd one, not unlike what occurred between his father and mother. Mary Greene was a brilliant artist whose skills were probably far greater than Blumenschein's. She had also exhibited in the Paris salons, though her work had won medals in both 1900 and 1902. She was five years older than Blumenschein,

descended from great wealth, and had known both tragedy and triumph in her early life.

The Greenes were originally from Providence, Rhode Island, but after her father died when she was quite young, her mother decided to move with her daughter to Paris where they had resided for more than a decade. Mary had studied art at the Adelphi Academy, the Pratt Institute, and, in 1895, the Académie Julian. She had also managed to combine the best of two cultures, developing into a woman who was comfortable in any surroundings, a cultured sophisticate without pretensions.

Mary's mother and her friends were shocked when she began dating Ernest Blumenschein. He represented the worst in an American artist, a mere technician who was an illustrator, a brash, aggressive individual who never seemed to fit in with anything other than boisterous activity. She, however, was a well-established painter. Her work was in as much demand by galleries and patrons as his was by magazine and book publishers. She had achieved what he could only fantasize about.

Mary's attitude was quite different. She saw a young man who needed nurturing and encouragement. She delighted in the aggressiveness she lacked. She was pleased to see someone who was pursuing a dream and seemed to enjoy the quiet encouragement she was able to provide him. She also fell deeply in love with him, an emotion he was unable to handle. He wanted nothing more than to be with her when they were together, but he withdrew from his emotions, making art his only thought when they were apart. He distrusted women as a result of his mother's "abandonment," holding deeply mixed feelings of love and hate as a result of her death from the self-inflicted abortion. He had been through a period of great trauma with his stepmother and was afraid of any commitment. He also wondered if he would be able to support a wife in his new field, only illustration providing him with a certain income.

Mary and Ernest began exploring Paris as only two moneyed lovers were able to do. As students, they delighted in the wild and wicked cafés and bistros in the Latin Quarter, the Boulevard du Mont Parnasse, and other locations. The

money he earned from illustration enabled them to go to the best night spots, and their relationships with the other students also took them to the least reputable places. They delighted in a life of music, food, drink, dancing, and romance. It was only natural that Mary informed her mother that she and Blumenschein were thinking of marriage. It was also natural for Mrs. Greene to become irate.

The bond between mother and daughter had seemed close until Mary told of her love. Their closeness was a result of the loss of Mary's father. They shared a home and a foreign city where both were feted because of Mary's respect as an artist. The idea that this brash young American, an illustrator no less, would enter such an ordered world infuriated Mrs. Greene. She insisted that her adult child "go back and be a good daughter again." And those words were so devastating for Mary that she begged Blumenschein to understand. She had to listen to her mother, to accept the fact that the romance she and Blumenschein were experiencing was not based on a solid foundation.

A compromise was reached in fall 1904. There would be no more dating on the streets of Paris. Blumenschein would only be allowed to call on Mary at her mother's home. They would be given privacy to talk, though it was an unspoken condition that their conversations remain with the art they both so dearly loved.

The stress of the situation was too much for Blumenschein. The two talked of eloping or otherwise forcing the acceptance of the relationship. Toward this end, he enlisted the aid of his father, seeking to simultaneously gain Leonard's blessing and assistance. He thought he had taken a step that would fill the older man with pride and that his father would assist them in gaining the necessary marriage papers. He was very wrong.

In a letter dated January 12, 1905, Leonard Blumenschein showed that his attitude toward his son's relationship was little different from Mrs. Greene's. He wrote,

Monday morning broth [sic] your Vesuvious [sic] eruption script and after perusing concluded I would not take action on your request for mar-

*riage papers as I intended . . . blast the mothers-in-
law! . . . when the old mother-in-law comes along
everything is wrong from A to Z. Since this mother-
in-law business is as old as history, and always an
infernal nuisance—it's a device of the devil's
anyhow—we—me and Mom just concluded we
would not help you along into a road of misery—
just now. Your artistic instincts would greatly suf-
fer, your peace of mind would only be destroyed,
and your happiness would be only make-believe,
and your earning powers would be nil, nil and
below!—Go ahead with your studies and attend to
the business you went abroad for. If you and the
girl truly love, you can afford to wait until you are
both in this country, and until her old Vesuvious
blows off her d. old head for good. Maybe you
and the girl will change your minds if you do not
see one another so often. Put your love to the test
and see if it's 100 fine! Meanwhile take best of care
of yourself and don't be foolish.*

What his father did not say was that Blumenschein's
sister, Floss, was also having trouble with her in-laws.
Their father did not want to get involved in further squab-
bles, especially since he thought that the relationship was
mere infatuation.

The reply left Blumenschein deeply despondent. He
could not go against his father, nor was he comfortable
going against his own heart. He recognized that his work
was changing, his illustrations suffering as his painting
improved, then decided that his painting was of little value.
He felt that all his plans were wrong, that he had nowhere
to go except in past directions. In a letter to Butler written
in January, shortly after receiving the letter from Leonard,
he stated, "I'm not painting great pictures, but I'm sure I
am progressing in a direction that will develop me. I have
given up all ideas of doing anything but excellent illustra-
tions. This is my line and I know it."

The letter to Butler was the rare occasion when Blumen-
schein revealed his emotions. For most of his life, he would
cultivate an air of being totally in charge. He would seem

doggedly determined to do whatever he wanted, disregarding the feelings of others, including his wife's. But for the moment he was torn, revealing his feelings to his friend, then talking for many hours with Mary who convinced him to move forward with his painting. She believed in his potential and encouraged him when he was no longer able to encourage himself.

The intensity of the relationship convinced Mrs. Greene that further opposition to her daughter's marriage was futile. In June 1905, she gave her blessing and the wedding was set for the Littleton Episcopal Mission Chapel near the Bois de Boulogne. Everything was fine until Blumenschein revealed the same adolescent behavior Mrs. Greene had sensed previously in her soon-to-be son-in-law.

Buffalo Bill Cody's Wild West Show had been touring Europe. It stopped in Paris, and Blumenschein had gone to see both familiar faces from his New York encounter and the new men and women who were a part of the program. While talking with them, he discovered that they were planning a baseball game for the day he was to get married. Placing his priorities in order, he agreed to participate. Unfortunately, he sustained a minor injury to his knee during the game and entered the church late, limping and thoroughly upsetting his new mother-in-law. He also had to remain standing in a service that normally required frequent kneeling.

The marriage brought about a radical change for Blumenschein. For reasons never made clear, and perhaps never quite understood by either man, Leonard Blumenschein reached out to his son in the one area they could share—art.

The incident resulted after Blumenschein completed an assignment from *McClure's* to handle further illustrations for the story of a little-known writer who was receiving an increasing amount of attention for his work. Blumenschein had produced black-and-white illustrations for an early work called "The God of His Father's." This time he produced four-color (these were actually full-color works, expensive to produce but with tremendous impact for readers accustomed almost entirely to black-

and-white illustrations) art for the story, "Love of Life." The author was Jack London, a writer who would ultimately become one of the most successful in the United States.

Both the quality of the full-color artwork and the novelty of it brought the illustrations great fame. Leonard saw the work and wrote to his son in a manner he had never before been able to bring himself to do. He praised Blumenschein in a simple, yet deeply moving note: "We have heard many favorable and extravagant comments. Everybody has seen your work and everybody is proud of you. We too!"

For Leonard Blumenschein, this simple letter was the first time he had expressed love for his son. Neither man seemed able to directly reach out to the other. There had been too many years of withholding emotion. There had been too many years of estrangement caused by personal weakness neither could overcome. There had been too much pride, too much pain, too much confusion. The elder Blumenschein still could not say the simplest and most difficult words in the English language—"I love you." But he could find it in his heart to praise the man his child had become, and once starting, he found he could not stop. Four days later Blumenschein received a note that had been written on December 11, 1905. In it, Leonard said, "I am being 'held up' daily on the streets by all sorts o' people desirous of saying something nice about your work in Dec. *McClure's*. The most of them say: 'Aren't you proud of him!'"

The letter continued, explaining that a friend, a local bookseller, had clipped the art from the magazine and was prominently displaying it in his store. The work was so new, the use of color so fresh in the magazine industry, the reaction was as electric as when people first encountered television and three-dimensional movies many years later. And Blumenschein was a part of that pioneering change.

It is likely that the first few months following the marriage were the happiest that Mary and Ernest Blumenschein would ever know with each other. Certainly they were closer than at any time in later years. Blumenschein was more relaxed, less neurotic, and less a caricature of himself than he would become when they finally moved to

Taos. His father loved him, he realized for what may have been the first time. More important, his father accepted him, his wife, and his work. In addition, not only were commissions coming with such frequency that the couple could afford a relatively expensive fifth-floor studio apartment on the Left Bank but they also began sharing in each other's careers. Mary encouraged Blumenschein's fine art work, and Blumenschein encouraged his wife to begin doing illustrations either on her own or in conjunction with him. Neither was jealous of the other. Neither put personal interests ahead of the other. It was a period of success, happiness, and mutual vulnerability, a type of love he had never experienced before.

Mary's early illustrations were done for *American Magazine's* short stories. In addition, she and her husband periodically worked together, mutually planning the illustrations, then dividing the work, she creating the women and he creating the men. They both signed the artwork.

Blumenschein had reached the top of the illustrator's profession in everything but pay, though his earnings were still quite high. The major authors of the day desired his touch, and his work began accompanying such by-lines as O. Henry, Willa Cather, and Joseph Conrad. When *The Tales of Edgar Allen Poe* was being published, he was chosen to do the illustrations.

In 1908, having studied extensively, he turned to portraiture as well. One of his first paintings was a portrait of the Ellis Parker Butler family which came to the attention of the editors of *Century Magazine*. They reproduced it in their December 1909 issue, declaring it to be one of the finest examples of recent American art.

The Blumenscheins were involved with a society of American ex-patriots, adventurers, and world travelers who felt that any trip to Paris should extend over two to three years. They were all sophisticates, a world Mary was quite comfortable in and to which Blumenschein was able to adapt.

The Butlers had traveled to Paris in 1907. Others arriving at the same time included the famed novelist and playwright Booth Tarkington and his wife, who lived on the Rue de Tournon. Tarkington was an artist "groupie," a man who

had wanted to paint before being forced to admit that his skills were with a pen, not a brush.

Tarkington also collaborated with Harry Leon Wilson, another American living in Europe, to produce the play, *The Man from Home*, in 1906. Wilson, married to American artist Rose Cecil O'Neill, wrote his most famous work in 1915 — *Ruggles of Red Gap*. That story, about a British butler hired to work for a rancher in a western town, ultimately became a successful film.

Tarkington became the subject of one of Blumenschein's first portraits completed during 1903 or 1904 when the writer first visited Paris. It would later be used in *Harper's Weekly* in November 1905 as the illustration for a review of Tarkington's novel, *The Conquest of Canaan*. Forty-two years later, the same portrait would be used for the frontispiece of Tarkington's last book, *Your Amiable Uncle*, which was a collection of letters written from Paris to the author's nephews. Yet despite the obvious respect the portrait attained, both men seemed to be slightly angered by the outcome of the work.

Tarkington appeared to be a self-destructive individual, a chain-smoker and heavy drinker who lost all inhibitions after consuming too much wine and liquor. Blumenschein captured that fact with a number of design elements in the painting.

Tarkington was captured looking to one side, as though in deep concentration while writing. A lighted cigarette is in one hand, a still-smoking remnant of another in the ashtray, as though the writer snuffed out one and immediately started another. An empty carafe is shown to the left, the obvious implication being that it has been consumed during the work session. The cigarettes, the smoke, and the carafe are all obvious design elements, points of brightness in contrast to the dark clothing the writer is wearing. At the same time, they may have represented a certain hostility between the men, a hostility that led to the ultimate insult for Blumenschein. The writer wrote a dedication to his wife, Louise, in the left margin of the portrait. This was a horrible desecration, not only because such an action was simply "not done" with a painting but also because Blumenschein never felt quite finished with his

paintings. He liked to work on them for years or until they sold. Only his illustrations were considered complete when first done because the deadline allowed no further work.

There were other "sophisticates" in the group of Americans abroad, all of whom were in the arts and letters. They included James Montgomery Flagg, a painter, illustrator, and satirist; Thomas Nelson Page, a novelist who was named U.S. ambassador to Italy during World War I; newspaperman William Hereford; and Vance Thompson, the founder and editor of the biweekly publication *M'lle New York* and author of both romance novels and biographies. They were the forerunners of groups that would meet in Paris in the 1920s; for example, those who gathered around Ernest Hemingway, and in New York's Algonquin Hotel, where Dorothy Parker, James Thurber, and other wits of the day spent time at the famous Roundtable.

The Blumenschein entourage met regularly either at the Restaurant de la Tour d'Argent for dinner or the Café du Dome on the Boulevard du Montparnasse for drinks. They would discuss art, literature, and the state of the world—young increasingly successful sophisticates living an existence that few could imagine.

The joy of Paris was a mixed blessing for the couple. Ernest Blumenschein was comfortable among the French, yet he was beginning to feel his goals suffering for the experience. The type of painting he wanted to do for the rest of his life could only be accomplished in the American West. He longed to return to Taos, to see the land, the people, and the colors of a life that was so different from all else he had experienced.

Mary agreed with him, though for different reasons. She was pregnant with their first child, a son as it turned out, and was nervous about the quality of French medical care. She agreed with Blumenschein that it would be nice to return to America, though she was thinking of New York, not an Indian village in the middle of nowhere. New York would allow for the same type of sophisticated gatherings of friends they were enjoying in Paris. She would be able to continue her painting and illustrating, perhaps increasing her commissions when she was able to

meet directly with editors and art directors. And they would have proper health care for their family.

On December 13, 1906, Blumenschein wrote a letter to Butler telling how much he had come to love the American tourist, despite the fact that the Europeans saw such individuals as being rude and crude. He wrote, in part, "Notwithstanding all the ugliness of our cities, all the vulgar tastes of the people, all the crudeness that characterizes the American all over the world, I can't help loving him be it habit or 'bringing oop.' "

On Christmas day, less than two weeks later, Mary gave birth to Ethan Allen Blumenschein. She and Ernest were joyous. They had a son, and their life seemed to be complete. Tragically, the boy died 48 hours later, and suddenly both of them began to hate life in France. It was as though they secretly blamed the country for a situation that was out of their control. In their grief, they turned their anger toward Paris, venting their helpless rage in the only way they knew.

Within six months, Blumenschein was seriously looking toward home. On June 8, 1908, he wrote to Butler, "Blood is the thickest tie and we love our Americans and the U.S.A. It's big and grand and inspiring in many ways. And the people are too! We can't have what Europe has, we don't want it. After a pleasant meal of delicious and gentle Europe, we are glad to get back in the beehive and bustle. We love it because—because I suppose, we're brought up on it, and it's part of our formation."

The couple was making their decision slowly. They had money, respect, and friends in Paris. They had adapted to the customs, the language, and the people. Moving thousands of miles away, even though to their native land, seemed a difficult effort. Yet they both agreed on one thing: if Mary became pregnant again, they would return to New York. She did become pregnant in 1909 and they sailed for New York that September. Two months later, on November 21, 1909, Helen Greene Blumenschein was born. This time the child was healthy and the couple felt their family complete. But Blumenschein never got over the loss of a son. He took to calling his daughter "Bill" as an apparent form of the grief he had suffered when his first child died.

AMERICA ONCE MORE

The return to America was also a time for reflection for Blumenschein. He had gone to Paris to study at a time when the French art world was seemingly in turmoil. He was subjected to myriad influences, including his wife's.

First, there was the traditional realism of the salons, something both he and Mary respected. They made a practice of visiting the Louvre once a week, there to select a single painting for study. Unlike most artists, they made no attempt to copy the painting or sketch various elements of the brush strokes and other technical details. They brought no drawing implements with them. Instead, they just looked, taking photographs with the camera of the mind.

Then, there were the assignments for illustrations. These were literal images, the artist's imagination locked within the parameters of the story. The structure forced a sense of realism as great or greater than occurred with the studies of the masters.

Finally, there was the influence of what was called post-impressionism, the dominant art form of France from 1900 to 1910. Eleven young painters, influenced by the work of Cézanne, Gauguin, and van Gogh, had an exhibition of their work in 1905. The exhibition, held in Paris and called the "Salon d'Automne," introduced the work of Derain, Matisse, Roualt, and Vlaminck. They were called "les fauves" for their use of color and composition, spawning what came to be known as the fauvist movement where bright colors dominated the paintings.

Next came cubism and its practitioners, such as Picasso (*Les Desmoselles d'Avignon*) and Duchamp (*Nude Descending a Staircase*). It was 1907 and a group of artists in Germany, including Ludwig Kirchner and Emile Nolde, were establishing their own expressionist movement—Die Brucke (The Bridge).

There was a fascination for some of the work, if only because of the thought behind it. Cubism, for example, had as one element the effort to show three dimensions in two

planes on canvas. A Picasso portrait in this style often made sense only if you looked on the image as an attempt to show all sides. Thus he might include one eye as seen in profile and a second eye as viewed head on. He would walk around the person, noting details from different angles and sides. There were aspects of the person as viewed from 360 degrees instead of a portrait completed from just one angle.

The new art forms reached American shores in February 1913. An art exhibition was held at the 69th Regimental Armory in New York. It was the first time Americans had been exposed to large numbers of post-impressionist works, and *Century Magazine* asked several respected artists, including Blumenschein, to comment on their views of modernism.

Blumenschein explained that "post-impressionism . . . is creation, not a mirror." He then discussed the fact that earlier artists had always painted according to a prescribed formula. The only personal emotion visible in the painting came from the subject matter or, to a lesser degree, through an individualized style. He showed that a painting's title "often lead[s] the mind [of the viewer] away from the land of color and form and emotion into ethnology and mythology, literature, history, episodes of life, and many other regions where the artist's ideas are completely lost in what might be called the literary ideas of the onlooker." The artist sacrificed that which made him or her unique to the subject matter.

Blumenschein went on to explain that when you looked at his own paintings, you would find that "the composition always took the shapes and lines that would represent sentiment of my composition. . . . if a dramatic sentiment, the lines would be full of action and the masses pregnant with tragedy—long violent lines in angles giving movement. If a poetic sentiment, the masses and lines would not disturb the eye with a violent suggestion, but would be quiet and flowing. If a majestic sentiment, then the masses would be large, sculpturesque, and dignified. And in the conception . . . and inseparable from the form, would be the color scheme."

Then, discussing the post-impressionist movement and how such artists work, he said,

> *The scheme of decoration, the pattern, the design, the composition seems to be the chief consideration with the Post-Impressionists. . . . [they] are being simpler. . . for dealing with large, flat masses of color. . . [rather] than subdividing a hundred colors to produce one large tone, . . . are being more decorative and imaginative, for it takes more ingenuity to arrange a design of colors and lines that harmonize into a decorative composition than to state faithfully the exact truth of the color of lights and shadows, . . . and are getting more of. . . personal feelings upon canvas, and less of what one is taught to observe by conventional education.*

But the intellectual aspects of the paintings being produced were not so important to Blumenschein or the other artists who would soon settle in Taos. What mattered to them in Taos was the raw beauty of the land and the shocking cultural differences that the community offered. And nowhere were the differences so marked as with religion, especially with the savage rituals of the men known as the Penitentes.

THE PENITENTES

———➤◆◄———

B y the time the artists who would form the Taos Society were all living in New Mexico, the scene had changed in many ways. The violence that had marked Phillips's early days was over. The Christian faith was altering some of the Indians' religious practices. And daily life within the community often seemed to be not much different from that found in other small southwestern towns. At least on the surface.

Bert Phillips was never satisfied with knowing only the obvious. He wanted to search below the surface of a community, to learn the hidden secrets, then re-create them in his paintings. His work was quite different from that of the others in that regard, and this may have been the reason he was comfortable from the time of his arrival in what amounted to an alien culture. Whatever the case, early on he became one of the few white men in Taos to discover the highly unusual and illegal actions of the Penitentes. He also sketched and painted many of their more public ceremonies. He either did not record the private ones or had the sense to hide or destroy those drawings. To be known as a witness to such secret, holy, and violent activities was to risk the possibility of retaliation and, perhaps, death.

The Order of Penitentes began as a legitimate organization within the Roman Catholic church. The members were all males who led exemplary lives. They believed, however, that it was important to periodically undergo painful experiences because full entrance into the next life, even Heaven, began with suffering. The more pain endured while alive, the less one's suffering at the entrance to the hereafter.

The primary activity of the Penitentes was the re-creation of Jesus' suffering and death on the cross. At first, this was done simply, almost symbolically. Later, the men allowed themselves to be brutalized almost to death, and it must be assumed that a number of men lost their lives either during the ceremony or as a direct result of the experience. The Catholic church leaders were horrified, many of them banning groups from using the Penitente chapels, or *moradas*, for Penitente activities. The organization was banned by the Vatican in 1889, though individual groups, often acting in secrecy, carried on the tradition in the Southwest, at least through 1921.

The New Mexican Penitentes were mostly, if not entirely, Hispanic. The group considered itself a religious order even after it was banned. The members came from all walks of life, including laborers, criminals, school-teachers, and wealthy business leaders. They also put on a pre-Easter ceremony that was looked on as little more than an American passion play on the order of the less violent passion plays common in the Middle Ages.

It is believed that the ceremony Phillips and his wife witnessed originated in the seventeenth century as part of the Third Order of St. Francis. This was a Franciscan organization that engaged in various forms of self-denial during the Lenten season. The members would fast, limit their pleasures, and re-create the Passion of Christ in a harmless theatrical manner.

As the ceremonies became more brutal, they also became quite structured. The Penitentes met in the morada, where they would pray, chant, and sing. Then, on Shrove Tuesday, new applicants could go through a ritual of admission.

The applicant would enter the morada where wooden

crosses were leaned against the walls. There was a dimly lit altar covered with cheap statues and prints of sacred paintings. Blood-soaked scourges made from yucca were hung on the wall, and raw goatskin rugs, also blood-stained, were on the floor.

The applicant would approach the leader, called the Sangrador, as the others chanted. Then they would pray and each applicant would take an oath of secrecy and obedience to the laws of the order. The applicant would then strip to the waist and kneel, his back to the Sangrador, who would use either sharpened flint or shards of glass to make three deep incisions across the back but below the shoulders, then three more running down the spine so that, on healing, the scar would form a permanent cross.

Next came ritual beatings of extreme brutality. Officially, there needed to be only three blows administered by the Elder Brother or some other officer in the order, as well as a single blow by any member who has been offended by the initiate. However, to show his devotion, the initiate was expected to request a far greater beating. The request was spoken in a form of code, the numbers used equaling the number of blows.

For example, the initiate might say, "Now by the Grace of God, Brother, I beseech you to give me the three meditations of the Passion of Our Lord," the signal for three more blows. Then he may make the same request for "the seven last words, the five wounds of Christ, the ten commandments, the forty days in the wilderness, the thirty-three years of Christ's life," and so forth. The strongest and, seemingly, most spiritually masochistic would receive 130 blows with the scourge. If he remained conscious and able to move, he might also then wash the feet of all the Brothers present.

The public awareness of the Penitentes began with the Wednesday before Easter when there were secret self-flagellations, praying and fasting, along with an occasional procession. By Thursday, there were several processions between the morada and the Calvario. Small crosses were set on the Calvario to represent the setting at Calvary where Jesus ultimately died.

Oddly, there were two different attitudes within the

orders. Some believed that the processions should be open, the men taking the most heavily traveled roads where they were certain to be spotted. Others moved in secret, taking back roads and looking for anyone who might witness what they were doing. Someone caught observing their actions would be beaten or killed. The reasoning behind the radically different attitudes of different Penitente groups was never discussed.

The self-flagellation caused great physical weakness, so most of the orders did not fast every day. However, they limited themselves to foods considered holy which also happened to have excellent nutritional value. For example, one of the most common such foods in the Taos area was a substance made by taking sprouted wheat, then boiling it until it became as thick as jam. The boiling also caused it to become quite sweet and pleasant tasting while still retaining full food value. The dish was called *panoche* and was prepared by the women connected with the order, even though they could never be members.

The order was altruistic and caring throughout the rest of the year. The members supplied food and medical care to the poor and anyone in trouble. It was only during the period just prior to Easter that their religious fanaticism became obvious.

Bert Phillips eventually painted the processions of the Penitentes, a scene witnessed by many in the community. They would walk with one man carrying the cross, the others behind. It was a public aspect of their ritual and safe to view. However, he and his wife, Rose, witnessed much more, the full rite that was banned to outsiders.

Bert and Rose Phillips had a zest for life that was much greater than that of the rather stodgy Blumenschein, who often preferred a vicarious awareness of human existence. Phillips kept his friend constantly abreast of the violent events that comprised the most interesting experiences in Taos during the latter part of the nineteenth century. The letters were much like reading pulp novels, the adventures vicarious rather than firsthand. Blumenschein did not have to see the blood. He did not have to hear the screams. He could continue with his love of the beauty and the fantasy of the Southwest, being careful not to make the area

his permanent home until such time as the community evolved into a more "civilized" society.

Phillips, by contrast, seemed to enjoy the exhilaration of the physical danger and was comfortable in the midst of violence. Both he and his bride wished to experience cultures to the fullest, acting as observers of society, whether that meant the greatest beauty the land had to offer or the most inhumane acts. They were part voyeurs, part contemporary anthropologists, and fully accepting of life as they found it.

Still, nothing quite prepared Phillips for witnessing the ceremony of the Penitentes. He needed to talk about it, yet the practitioners, since becoming banned by the church, had strict rules against revealing their activities. Anyone revealing what was seen and done would be harassed at best, murdered at worst. Phillips sent a letter out to Blumenschein, along with a warning not to reveal what he had dared to write about it. Yet even that did not ease the pain of the memories of the event. Phillips decided to write an article about his experiences for _The Frontier Monthly._

The article, which appeared in 1903, was entitled "The Penitentes of New Mexico" and was written by "Herbert Geer." The writer was identified as a transient who happened to witness the Penitente ceremony while passing through Taos. In reality, "Geer" was a pseudonym Phillips used in case any locals read the article and felt the need for revenge against the person who broke the code of silence.

"Geer" at first wrote of himself as a traveling businessman who for years had journeyed through the various western territories, including New Mexico. He spoke of learning Spanish, including the dialect spoken by the sheepherders whose camps he visited in the course of his travels. Then he told how he had chanced to be a guest of a man who learned from Mexican friends that there was going to be a reenactment of the crucifixion by the Penitentes the next evening, Good Friday.

Having been warned that a stranger would not be tolerated at the ceremony, Phillips concocted this elaborate ruse to hide his identity because he and Rose were rare spectators. They were respected enough to be allowed to be

present, but it was known to both of them that they would be identified and killed if Phillips went public.

The ceremony itself was described accurately in the article. Phillips/Geer wrote,

> *I was awakened by the most dismal and indescribable singing that the voice of man ever produced. There seemed to be a sort of melancholy accompaniment from some shrill, weird-sounding pipe or flute, and with it all came wet-sounding thumps which sent a shiver down my spine. . . . There, in the fast-coming light of dawn and not more than fifteen feet from my window, was the strangest procession it had ever been my lot to behold. In the lead I could make out a group of darkly-clad figures carrying crosses and images, and then the singers and musicians—if such they could be called—followed by others who seemed to be officials of some sort.*
>
> *Immediately before me there were at least a dozen men whose heads were covered with black cloth much like the death cap of a felon going to execution. Their bodies were bare, except for a pair of short, thin, white trousers. At least it was apparent that the garments had been white, but so soaked with blood were they that the backs and parts of the garments looked more like red flannel.*

Phillips explained that the men all carried flagellantes, a whiplike device made from braided yucca plants. One end was thick and meant to be held by two hands. The other end was flattened into a circular, plate-shaped form six inches in diameter.

The men moved in a deliberate pattern. They would take three long strides, so practiced that they were almost identical in length. As they moved the whips would drop forward, then be brought up and back with great power, their shoulders and wrists acting as hinges to increase the speed as the quirts smashed against their own backs. The action was intensely painful, the backs of the men torn and bleeding with each blow. Yet they remained almost silent

in their solemn movement, the sound heard by observers being the striking of the platelike end against their backs.

Much of the activity of the Penitentes was centered four miles south of Taos Center in the village of Ranchos de Taos. The village held one of the oldest of the Spanish mission churches and was the center for Penitentism. At the close of the Lenten season, the walls inside the church were covered with human blood. The area looked like the walls of a slaughterhouse, only to be covered to hide the evidence before Easter morning.

The surrounding area had more signs of the Penitentes. There were heavy wooden crosses stacked near buildings. These were used for ritual parades and were not guarded. However, a couple of miles away, Bert and Rose discovered what was known as "The Place of the Cross." Near there, in a small, cleared space hidden by rocks and away from the normal trails, was a cross fifteen feet long, the location being the "Calvario" where the crucifixion would be reenacted.

It was evening when a file of whippers emerged from the Penitente House.

> _They were preceded by a bearer of the crucifix, a pitero (flute player), and two men with matrakas (wooden rattles such as used by the night watchman of old), besides hermanos (brothers), acting as guards. They were dressed like those of the morning, and applied the flagellante with the same vigorous stroke and heart-sickening noise._
>
> _One, who followed behind at some distance, with two men acting as escorts, pounded himself mercilessly, and, taking a different route from the others, was gone much longer than the rest. Judging from his speed at the time he left, we decided that he must have covered two miles, all the way beating himself incessantly. I was the first to discover him returning, and noted that his blows lacked the speed and force at first given. At some distance we could see that he was unsteady; he reeled several times, but kept on with agonizing pluck until within two hundred feet of the mor-_

> *ada, he fell unconscious from suffering and loss of*
> *blood. His limp form was borne into the building.*
> *Then came the cross-bearers, dragging with*
> *tortured steps the great wooden beams, under*
> *whose weight they staggered to a distant Calvario*
> *(about four hundred yards). When one fell ex-*
> *hausted upon the cold earth his cross was laid*
> *upon the prostrate form so that it would not touch*
> *unholy earth and in such a way that it must have*
> *added to his agony. This scene continued until the*
> *fanatical Mexicans had exhausted the ranks of*
> *those penance-doers.*

As horrible as the march had been, Phillips and his wife knew that there was worse. This was the public reenactment of the walk of Jesus to Golgotha, the Place of the Skull, where he was crucified. The private ceremony began after dark, at approximately nine o'clock in the evening. Bert and Rose had to hide in a clump of piñon trees near where they had found the cross the previous day. It was there that the crucifixion would take place.

> *The shrill sound of the pito announced that*
> *the slow-moving procession was drawing near. As*
> *they reached the place of the crucifixion the pitero*
> *and the chanting brothers ceased their noise and*
> *several men seized the perspiring, panting wretch,*
> *who was staggering under the weight of a heavy*
> *cross, and released him from his burden. Quickly*
> *he was thrown, back down, upon the prostrate*
> *cross at his feet, and the men with ropes of rawhide*
> *began to bind him to the wood.*
> *"Bind me not! Nail me! Nail me to the cross*
> *like the blessed Master!"*
> *The man's feeble voice came like the wail of*
> *one who looks into the face of death and then I*
> *heard the sound of blows, and I was sure that the*
> *sacrifice of Jesus was again to be commemorated*
> *in the most cruel fashion.*

The Phillipses were near shock as they witnessed the

horror of a man actually being nailed to the cross. Depending on how long they left him, his body strength, and other factors, they could be witnessing a ritual murder/suicide.

In his article, Phillips said that he briefly cried out, startling the participants. The men seemed to want to check for witnesses, then apparently decided among themselves that the sound came from a coyote. They raised the cross, sinking it into the ground, then packing it tightly with dirt. The man who had been crucified cried out in agony at the jarring that caused the nails to rip against his flesh. Yet the pain was also his joy. This was the high point of his life.

When everything was secure, the men knelt in prayer, then left. They went to the church where others would gather for normal worship services. But instead of taking their place in the pews, the Penitentes who had crucified one of their own prostrated themselves so the worshipers would have to step on their battered bodies to enter. Then the Penitentes returned to their march. "There were the sounds of rattles, the clanking of chains, weird cries, groans of anguish, wild howls of despair, and above all, the dull swish, swish of the whippers. The spectators in the gallery were awed and frightened into silence only broken by the sobs of hysterical women and little children."

A few hours later, Phillips and his wife returned to the site of the cross. It was empty by then, two small Mexican boys staring at it. Phillips had no way of knowing if the man had died or been removed still alive, aided in recovery so that he could join the Penitentes the following year. The boys may have been his brothers, his sons, or just curious children who had chanced upon the cross. Whatever, the questions could not be asked, the issues could not be resolved.

The stories of the Penitentes were history by the time most of the artists settled in Taos. They were fascinated by the incidents they heard from Bert and Rose Phillips and others. They were horrified by the extremism of the groups involved. Yet Taos was becoming so settled that most of them were more familiar with the school plays in which their children acted out Dickens's _A Christmas Carol_, with the new restaurant that proved the community had grown to a size able to support such a venture, and with the mun-

dane necessities of life in a small town.

The paintings that were eventually sold to the railroad, the work that would comprise the body of art attributed to the Taos Society, the world the artists enjoyed—all were quite different from the harsh reality that Bert Phillips had first encountered. He would be haunted by the spectacle of the Penitentes the rest of his life, a demon he dared not exorcise through art because the ceremony was one he should not have seen. And though Phillips's work would never be considered the greatest of that of the artists, it would frequently have a depth to it that the others' work lacked, a layer of emotion that came from experiencing a world without the romantic trappings Blumenschein and some of the rest preferred to see.

THEY CAME,
THEY SAW,
THEY PAINTED

M any factors shaped the creation of art centers in the Southwest, especially Taos. There were the technological changes taking place in publishing which would soon reduce the jobs available to illustrators. There was the expansion of the railroad, the coming of Fred Harvey, and the desire to increase passenger use of the AT&SF Railroad into areas such as the Grand Canyon. And all the odd twists and turns of fate would ultimately focus on Taos and the art colony that was slowly forming.

Yet in the beginning only two men truly took the time to understand this violent, untamed land for what it was, before the changes brought by eastern settlers and an eastern life-style. Bert Phillips and Joseph Henry Sharp were the only two among the ultimate members of the Taos Society who took the time to truly learn the land and the broad range of people—Mexicans, Indians, and Anglos—who originally settled the area.

It was Phillips who ensured that Taos would retain its appeal for the artists who followed. He understood and accepted the ways of the Taos Indians, the Hispanic Penitentes, and the other people who settled the area, and he also understood the white man. He knew that eventu-

ally too many visitors, whether artists or tourists, would begin to destroy that which was sacred and beautiful. He also witnessed the growing industrial use of the land, a lumber industry that tended to clear-cut trees so that the land would be barren, erosion could occur, and life forms change. He saw forest fires created through carelessness or because it was a rapid way to clear some of the land, even if it did destroy plants, animals, and grounds that some Indians held sacred.

There were other problems as well. Settlers were traveling through Indian land, being indiscriminately destructive. Often, the whites would graze their sheep on Indian land, polluting the pueblo creek, which was the only source of water. The tension would increase unless water rights could be secured for the Indians.

In 1904, Vernon Bailey, the chief field naturalist for the U.S. Biological Survey, visited Taos. He was one of the most powerful individuals in his field, respected for his knowledge and a friend of both Gifford Pinchot of the U.S. Division of Forestry and President Theodore Roosevelt. He was also a friend of Phillips, who showed him the problems that land abuse was creating for the region.

Phillips had another concern. He had taken the time to learn the religion of the Taos Indians, just as he had learned the ceremonies of the Penitentes. Instead of looking on them as superstitious pagans whose feelings could be ignored, he saw them as individuals whose beliefs should be respected.

For example, Blue Lake, located in the mountains of Taos, was an area endangered by encroaching white men, a fact that was leading to great hostility. For the Indians, Blue Lake was the physical reality of what the Garden of Eden was to the Judeo-Christian heritage. All the people and animals of the world came from Blue Lake, according to the Taos Indians. It was the center of the earth, a most sacred location, as well as one of such beauty that Phillips often used it as a backdrop for his paintings. As he explained, "The Indians worship all things beautiful.... It is not the passive appreciation that is the frequent reaction to beauty of many white people. It is an integral part of their being. Their religion revolves around the rhythm

and life of nature. Their love of beauty is born of knowledge as well as of what we call superstition."

Among the superstitions were those related to the deer. The Taos Indians needed to justify their taking of a life, which they did with reluctance, because in Pueblo lore both the animal people and the Pueblo spoke the same language when life began in Blue Lake. The Deer People explained their position in life, that they had been sent by the Great Father for use as food and to meet other needs— clothing, tent making, and so forth.

The Great Father, in his wisdom, had given the Deer People a spirit to protect them from harm. Thus, before the Pueblo Indians could kill the Deer People, they had to first go to a medicine man who would give them a charm to make them invisible to the spirit. In addition, the Deer People taught the early Pueblo a special dance to perform every two years. Once they performed the Deer Dance and received their charm, each time they were able to shoot a deer with an arrow or, later, a gun, they could feel secure in the knowledge that the killing had sacred approval.

Because of Phillips's efforts, Blue Lake was given to the Indians forever in 1906. The Kit Carson Reserve was established that same year. Then, two years later, the Kit Carson was merged with the Jemez National Forest and Taos Forest Preserve, the entire area becoming known as the Carson National Forest.

It was during the period that Phillips was initiating so much on behalf of the Indians that he also suffered more on their account than he realized. Respecting the people and wanting to record them authentically, he frequently painted them in their homes. These were dimly lit by firelight, and it was a strain to see his models.

Perhaps if the Indians had been more like the models Phillips had in New York, the problem would not have been so great. He would have taken regular breaks to go outside in the sunlight. He discovered, however, that the Indians had developed the patience to sit for hours without moving at all. He learned to take advantage of this, turning out far more work in a day than he had ever considered in New York. He also found that the extremely low light levels under which he was working were damaging his eyes. The

strain appeared to be causing him to lose his sight.

Faced with possible blindness, and convinced that a change in activity might save him, Phillips abandoned painting almost entirely for the next four years. Instead, he became the first ranger in the Taos Forest Preserve.

Phillips faced what could have been a tragedy as a blessing for his art. Not only did his eyes heal but the time in the forest also increased his sensitivity as an artist. As he later explained,

> As I rode the mountain and canyon trails the value and beauty of the forest grew upon me, at night in the moonlight, in storms, fires, under winter snows, springtime, summer greens, autumn yellows. [There were] always new messages of beauty to find, some so subtle that they were long hidden My worry that my art would suffer by long absence from daily practice began to lessen as I felt the need to memorize these messages of beauty, like lyrical and symphonic music coming to my mind through my eyes rather than my ears. When the forests began to express spiritual messages and my eyes were healed after four years, I knew the time had come to resign as Forest Ranger and I did; then back to my easel. I realized what value the forest had been [in] opening my eyes and heart. My real mission in art began and my best works were produced, which brought success, for which I feel very humble.

His Indian friends were sensitive to the problem that had caused him to stop painting. They viewed his work as magic and were delighted to re-create their homes in his studio. They took a corner of the studio and added a platform raised two feet above the floor to bring it closer to Phillips's eye level. Then they added a drum, a couch against the wall such as they used in their home, pieces of pottery, a buffalo robe on the floor, a conical-shaped fireplace that they used, a window with vertical wooden bars, and similar touches. In essence, they brought their homes to where there was light, since it was not possible to have

Phillips bring light into their homes.

Other artists were beginning to drift in and out of Taos, only to return for ever longer stays. Blumenschein was coming every summer, though he was having difficulty convincing his wife and daughter to join him permanently. And Joseph Sharp, the most experienced Taos resident after Phillips, was finally admitting to himself that the West was where he wanted to live and work.

Sharp's dream was to record contemporary Indian life. He was aware that changes were occurring which would ultimately destroy the various Indian nations as they had existed for centuries. Most Indians were on reservations. Intermarriage among tribes and intermarriage between whites, blacks, or Hispanics and Indians was taking place. The customs, the religion, even the physical appearance of the people would not last.

Sharp's first trip West was made in 1883 when he was 24. He was fascinated with the area, exciting both his fellow students in the Académie Julian when he went to Paris, and his wife, Addie Byram, whom he married in 1892. He used Cincinnati as his base, working both as an instructor at the Art Academy of Cincinnati and as a portrait artist for wealthy individuals in the area.

Cincinnati was important because it was located along the railroad at a time when railroad executives were giving artists free passes to travel west to paint. The railroad executives had not yet thought about using paintings as direct advertising vehicles, a decision that would ultimately allow for the success of Taos. But during this period at the end of the nineteenth century, railroad officials felt they could increase passenger business by making the public aware of the more remote regions to which they traveled. Artists selling through galleries and artists on assignment for magazines and newspapers were given free rides to anywhere in the West the trains traveled. The indirect publicity was perceived to be a way to get people curious about seeing such sights for themselves.

Just as Blumenschein and Phillips had learned about the West from Sharp, Sharp gained additional knowledge from fellow Cincinnati artist Henry Farny. Farny was a longtime witness to Indian history. His specialty was the

daily life of the Plains Indians, and he was old enough to have seen their daily activities during the period between the major Indian wars and the establishment of reservations. He had been present for the pounding of the spike that linked the East and the West when the first transcontinental railway track was laid in 1869. And his paintings were inspirational to Sharp, who thought Farny might prove to be his mentor, guiding him into a career that would enable him to pursue the art he loved.

Farny was neither a mentor nor particularly nice to the younger man who so respected his work. The truth appeared to be that he did not want the competition. Farny and the Plains Indians paintings were synonymous. He did not relish the idea of a young upstart invading his established territory. As Sharp mentioned in his unpublished biography, "Farny...dissuaded me by telling of hardships, dangers and made me feel I didn't exactly have a right to paint Indians—after a couple of years or so when he saw I was determined to go west, he gave me books on Pueblo Indians & particularly the Penitentes of New Mexico & wanted me to take that up!"

Sharp was too young and naive to realize he was being influenced by a man who was jealous. The year after his marriage he went to the Taos Pueblo to view the Indians, then traveled to the neighboring Spanish-American villages. He had obtained a commission from *Harper's Weekly*, working both as an artist and a writer. He produced the painting *The Harvest Dance of the Pueblo Indians of New Mexico* for the magazine, describing the ritual in fascinating detail for the October 14 issue.

Sharp had a strong commercial sense when planning his work as well as an ongoing awareness of the historical importance of what he was producing. One of the few times he publicly discussed his historical awareness was in an interview for the May 1926 issue of *El Palacio*. He stated, "In past years I have seen so many things and made studies that probably no other living artist ever saw, such as the Tobacco Dance, Graves, Burials, etc., that if I do not paint them no one ever will."

Sharp took excellent notes on what he saw. He was concerned not only with the accuracy of his paintings but also

with understanding what he was seeing. Many of his pictures had the same models repeating poses and settings fitting the most popular type of art of the day, which is why they have occasionally been suspect. However, the accuracy of his descriptions perfectly matched independent eyewitness accounts. Thus, his writing, which often accompanied his painting commissions for magazines, was considered an invaluable source of firsthand information about a people who were dying.

Sharp planned his life around this historical awareness as well. His first trip to the Taos Pueblo had been overwhelmingly stimulating. He sensed that he would be returning again and again for many years to come, though whether he considered moving permanently with his bride was never known. What mattered was that he realized that even with the growing number of white men—artists, business people, and adventurers alike—moving into Taos, the Pueblo Indians would continue practicing their old ways in unspoiled country. Indians in other locations were not so fortunate, especially those in the Montana region. As he explained, "I went north because I realized that Taos would last longer."

Montana was a perfect place to begin his serious work. The territory was just ten years into statehood and General George Armstrong Custer's Battle of the Little Big Horn had been fought only twenty-five years earlier. More important, Sharp's interests in the territory and the culture of the Indians were shared with President Theodore Roosevelt, a man who would become familiar with Sharp's works.

It was 1899 when Sharp established his first studio on the land known as the Custer Battlefield. He followed the long tradition of the early photojournalists such as Matthew Brady and Timothy O'Sullivan, who had used massive wagons as studios on wheels. The photographers needed their wagons to mix chemicals, because the large glass plates used to record the Civil War as well as the emerging West had to be chemically coated within seconds of being inserted in the cameras. Then they were exposed for several minutes before being developed on the spot.

An artist did not have the same problems but needed almost as much space to work. Sharp described his equipment thus: "I had a sheep and cattle herders commissary wagon—took everything out except stove. Put in sky and side lights. 6x12 outside and could stand or sit to paint. Haul it to different localities and get several canvases each place. Painted night and moonlight also—good big lantern behind me. Generally worked outside until cold froze the paint, then in and fired up."

This was a good time to befriend the Indians in the area. Their recent history was painful. In 1876, they had triumphed over white aggression at the Battle of the Little Big Horn. And in 1890, Sitting Bull died and the Sioux Indians were defeated at Wounded Knee. Thus the Indians Sharp painted were often a part of those historic events and provided him with an intense understanding of the Indians' view of history.

Sharp concentrated on the Sioux and Crow Indians, the last tribes to maintain tradition in the Plains Indian lands. He submitted work to the Paris Exposition of 1900 and had two paintings accepted. The publicity generated by the work at the Paris Exposition led to a display of his work in Washington, D.C. There it was spotted by an anthropologist on the staff of the Smithsonian Institution, Henry Holmes, who recognized the accuracy of the portraits. He, too, understood that the faces being recorded were among the last of those who were racially pure. He purchased eleven of the paintings for the Smithsonian, work that Theodore Roosevelt went to see.

Roosevelt was a longtime naturalist who felt that he had recovered from the frail health of his childhood through life in the West. He wanted others to share the dying land, yet knew that whenever large numbers of people visited a land, they also brought changes that destroyed the purity they had traveled to see. He decided that the federal government should support Sharp's work, ordering the Indian Commission to build and furnish living quarters and a studio for Sharp.

The exact location was a decision left to the artist, who enlisted the aid of a friend, Samuel Guilford Reynolds, the Indian agent to the Crows. Together they agreed that the

cabin would be placed on the Crow reservation, within three miles of Custer Battlefield.

Sharp later wrote of the unusual effort,

> *The cabin was built by prison labor—mostly young men for minor offense and girls. . . . Very large living room and balcony one end. Bed room & kitchen added. Architecture and work superintended by the carpenter, agent and myself. Large fire place, andirons, crane and bean pot. Burlington R.R. gave me carload of discarded old oak & oil soaked ties. Two-man saw when I could get help (not many came 2nd time) otherwise one-man hacksaw. Some hard as iron—good winter exercise—made fine backlogs & fire kept all night. Toasted apples on string hung from high mantel. Walls partly covered with painted skins, row of war shields & buffalo skulls around top. Many pronged Elk horn candelabra. Roycraft Mission oak furniture, Navajo rugs. Agency and other people came to house warming. Men all wanted to know what was in the simmering bean pot, and not a lady asked. Franz Hals our fox terrier kept things going. "Them was the days!"*

The reference to the bean pot was a facetious allusion to another aspect of Sharp's reputation. He would eat anything that was presented to him, feeling it wrong to question another culture's cuisine. He once mentioned having eaten boiled dog meat in an Indian camp where such a dish was considered a good meal. He joined without hesitation, later explaining, "If it did not kill them, it won't kill me."

The work Sharp was able to complete resulted in a sale that enabled him to permanently leave teaching in Cincinnati. Phoebe Apperson Hearst, the mother of William Randolph Hearst, bought eighty of Sharp's paintings of Indian life in Taos and on the Plains, though ironically these contain some of his least accurate work. Most were painted during two trips: one to the plains where the weather was so bad that little could be accomplished, and

117

the other to Taos, where the season was so unusually mild that he was able to do more work than usual. Since he wanted more paintings of the Plains Indians, he decided to use Pueblo Indian faces, sometimes modifying the features according to his voluminous notes on the Plains Indian faces, sometimes not. The paintings were more accurate than the illustrations Phoebe Hearst's son had commissioned for the early Spanish-American War coverage, but not all of it was his best work.

The sale included the stipulation that he would paint fifteen more portraits for her for each of the next five years, though the total sale eventually amounted to only fifteen paintings. They were all donated to the Museum of Anthropology of the University of California.

The Montana work alone was monumental, involving over 200 portraits. He concentrated on the survivors and victors from the Battle of the Little Big Horn as well as women, children, braves, and chiefs who were full-blooded but not associated with that notorious event. He also interviewed them while working, making notes that were sometimes historically revealing and sometimes important only because of what they revealed about how the person wanted to go down in history.

For example, the portrait of the Crow Indian named Curly which hangs in the Museum of Anthropology at the University of California, Berkeley, was described by Sharp in a letter: "I have just succeeded in getting a portrait of Curly, Custer's famous scout, and the only one to escape that well-known battle. I have been after him for three years, but he was harder to land than a salmon on a trout hook. He is a man of fine physique, but very morose and taciturn. It is difficult to get him into conversation and he will not talk of the battle."

The reason that Curly did not talk of the battle was because he was not there. He was the man who recognized that Custer was facing more opposition than anticipated. He then did what later proved to be a sensible act of self-preservation: he "escaped" by running away before the battle started. He did not see combat. However, he frequently represented himself as the only survivor of the battle, a falsehood Sharp did not realize.

Sharp did accurately describe the Crow Indian White Swan as "Reno's scout in Custer battle, wounded many times, picked up on battlefield two days after, deaf and dumb from strike of war club on forehead. A good artist in Indian picture writing, jolly, good natured and general favorite. A full brother though direct opposite in character of Curly, Custer's scout."

Part of Sharp's skill came from his deafness. He could not talk with people the way others did, a fact that made him a curiosity among the Indians. In their view, all white men were talkative. They were also boisterous, disrespectful.

Sharp, by contrast, was an observer. He had to use his other senses to learn of the world around him. He was much like Phillips in his ability to accept all races and people. But he went even further than his young friend, collecting artifacts, learning the legends, folklore, and symbols of each tribe, training himself to see subtle differences, and working in their midst throughout the year. There were times when he could be found making sketches during weather that reached thirty degrees below zero. He became an accepted part of their lives and culture.

Sharp's closeness with the Indians and the frequency of his writing left a legacy that shows a man with highly ambivalent feelings despite his seeming love for the people. For example, in April 1899, he wrote an article for the publication *Brush and Pencil* in which he commented about the problems with the Indians who posed for him:

> *As a model the Indian is not a great success. After various tribulations to get him to pose, it is impossible to make him unbend. If it is his first attempt he will invariably take pose of majestic and often ludicrous stiffness. Having used much persuasion, time and patience in breaking one in, he soon becomes indifferent, often gets too familiar, goes on strike for more pay, or stays away altogether; so at times one is tempted to take Dooley's advice, "give him 10 dollars, let him go off and drink himself to death."*

His comments of March 1900 about a painting called

The Chant which he created in Taos showed that he had
mellowed somewhat: "The Indian is a slave to superstition,
and never dances and sings for pleasure or pastime. There
is a hidden meaning to all his movements, and he sacredly
obeys the ceremonial teaching of war, the chase, visits,
prayers and feasts. I have witnessed these chants and
dances of the Pueblo Indian many times, and they always
display a deep religious sentiment and are characterized
by great dignity and seriousness."

Sharp proved himself a protector of the Indians when
the federal government decided in 1901 to make them fol-
low certain standards, among which was the regulation
requiring Indians to cut their hair short, a rule that vio-
lated their customs and did not make any difference in
terms of their dealing with American society. Sharp wrote
to the Office of Indian Affairs of the Department of the
Interior on January 18, 1902:

> *I am an artist—have been going to the Indians
> for nine years. The Smithsonian purchased eleven
> of my Indian portraits last year and Mrs. Phoebe
> Hearst has just lately purchased my whole collec-
> tion for the University of California. I want to ask
> you not to be too strict in the enforcing of the new
> rule about* short hair, *particularly with the older
> men. It would be the greatest sacrifice you could
> have them make. On the death of near relatives or
> other great sorrows they often sacrifice fingers. . .
> but only on rare occasions is their grief so great
> that they cut their hair, and this is the greatest sac-
> rifice they can make. . . . It is too much as tho you
> yourself were forced to renounce your religion and
> love, and hopes for the future.*

Sharp received the following response from the Indian
Commission three days after his letter was sent:

> *The "order" as some have been pleased to call
> it, that eminated [sic] from this office, instructing
> the Agents to insist upon Indians wearing short
> hair and doing away with the painting of their*

*faces, has been misunderstood. I can assure you
that there is no disposition on my part to do any-
thing arbitrary in this matter, and it was far from
my intention to use drastic measures in connec-
tion with the so-called "order"—in fact it was no
"order" at all. It was simply a letter written by me
to some of the agents urging them to use moral
suasion upon the Indians so as to induce them to
adopt civilized ways as soon as possible.*

The Plains Indians were changing rapidly. Most of the
pure-blooded Indians were dying or were unwilling to pose.
Many were moving to other areas. The domination of the
land by the white man was also destroying what Sharp
had seen as natural. It was time for him to change where
he worked, to move to Taos for new opportunities.

In 1909, Sharp turned to Taos as a more permanent
location for his work. Having a sense of history and humor,
he selected the most incongruous location he could find.
It was directly across the street from where frontiersman
Kit Carson had lived and in a once-disreputable part of the
community. The living quarters had previously been a
rowdy dance hall. The studio was in a Penitente chapel, the
walls and overhead beams blood-splattered from the prac-
tice of self-flagellation. Later he would build himself a stu-
dio, turning the still bloodstained chapel into a storeroom.

Sharp took permanent residency in 1912. His wife of
twenty-one years died the following year. The death was
traumatic but not unexpected. They were both overworked
and did not take care of themselves. Sharp's legendary
willingness to eat anything he encountered meant he rare-
ly had a sensible diet.

They were persuaded to get medical exams in 1910—
reluctantly, even though it was evident that Addie Sharp
was increasingly experiencing what he called "nervous
spells" as well as periodically having altitude sickness. The
latter would prove serious. Sufferers frequently are unable
to eat and usually cannot metabolize what they do con-
sume. They lose weight, have a number of symptoms, and,
ultimately, may die.

Addie Sharp became so ill that she was delighted to go

to La Jolla, California, for treatment. In a letter to his early patron, Mrs. Hearst, Sharp commented,

> *While every indication showed Mrs. Sharp to be holding her own and improving, it drifted to Melancholia... [and in August I] put her in Dr. Bishop's private sanitarium in South Pasadena.... She was anxious and willing to go, and only regretted the separation for my sake, as we had never been away from each other but a day or two in eighteen years. She soon began to respond to the treatment, isolation and quiet home life—Dr. Bishop and wife living there.... I am not allowed to see her or communicate direct.... I realize it is for the best.... Her mind lingers in a few of the sweet things of the past, but for so long has been mostly regrets.*

Later in the letter he admits to his own problems. There is also a foreshadowing of a relationship to come. He wrote,

> *We have had her favorite sister [Louise] with us this trip, or we should have had a sorry time of it. She is not taking care of me, preparing my "soft diet," etc.*
>
> *I guess I neglected myself, and for months only got a small amount of sleep, and soon after getting here had a mild attack of appendicitis so one doctor said, but the specialist who treats me now says it is ulcers of colon. No walk, no ride, no work, and only a little reading and writing. It is a sort of refined torture to be quiet after beginning to realize the freedom from bondage.*
>
> *I think the climax has been reached with both of us, tho I know I have to undergo a goodly number of weeks treatment and quiet. I have a very great deal of hope, some courage and patience, and pray for the strength to carry the burden through, which the hope of getting my sweetheart back makes lighter.*

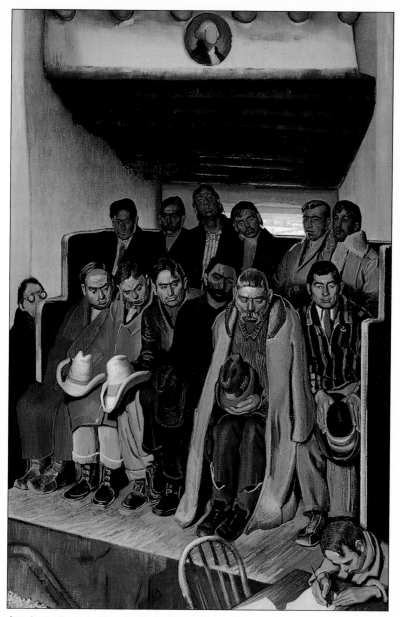

Jury for the Trial of a Sheepherder for Murder, Ernest Blumenschein, 1936 (Courtesy of Fenn Galleries, Santa Fe, New Mexico)

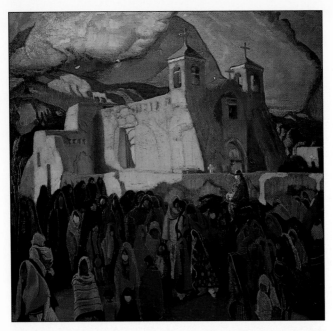

Church at Ranchos de Taos in the Evening, Ernest Blumenschein, 1929
(Courtesy of Fenn Galleries, Santa Fe, New Mexico)

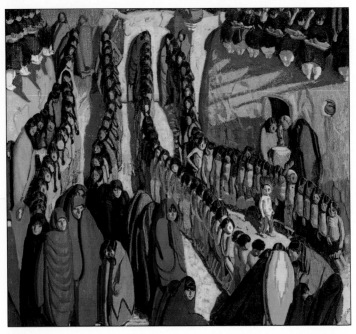

Dance at Taos, Ernest Blumenschein, 1923 (Courtesy of Fenn Galleries, Santa Fe,
New Mexico)

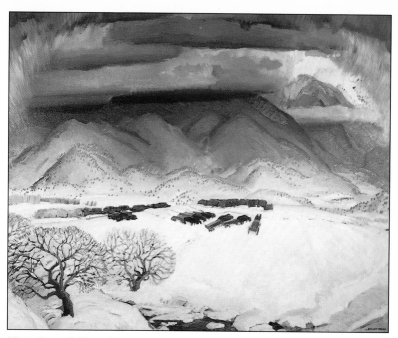

Winter Funeral, Victor Higgins, ca. 1930 (Courtesy of Fenn Galleries, Santa Fe, New Mexico)

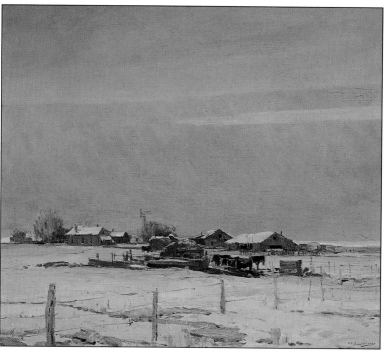

Winter in the Panhandle, Oscar Berninghaus, ca. 1930 (Courtesy of Fenn Galleries, Santa Fe, New Mexico)

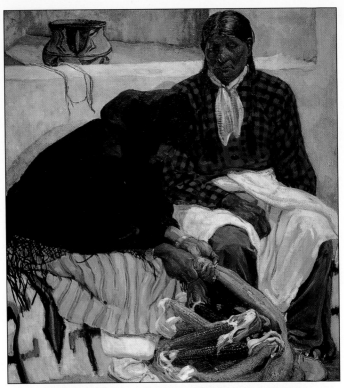

The Taos Farmers, Catherine Critcher, ca. 1928 (Courtesy of Fenn Galleries, Santa Fe, New Mexico)

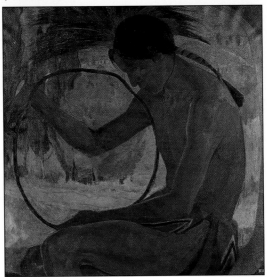

Taos Hoop Dancer, Catherine Critcher, ca. 1928 (Courtesy of Fenn Galleries, Santa Fe, New Mexico)

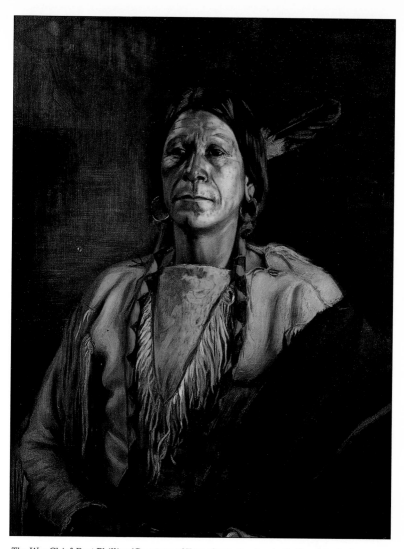

The War Chief, Bert Phillips (Courtesy of Fenn Galleries, Santa Fe, New Mexico)

Aspen Forest, Bert Phillips (Courtesy of Fenn Galleries, Santa Fe, New Mexico)

Oferta Para San Equipula, Walter Ufer, 1918 (Courtesy of Fenn Galleries, Santa Fe, New Mexico)

Winter Evening in the Big Horn Mountains, Joseph H. Sharp, 1920 (Courtesy of Fenn Galleries, Santa Fe, New Mexico)

Old Chief's Query, Joseph H. Sharp, ca. 1925 (Courtesy of Fenn Galleries, Santa Fe, New Mexico)

The Blanket, Eanger Irving Couse, 1929, reproduced on the 1929 AT&SF railroad calendar (Courtesy of Fenn Galleries, Santa Fe, New Mexico)

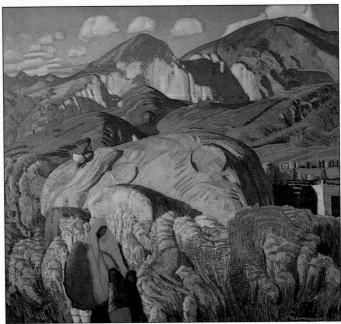

Haystack, Taos, Ernest Blumenschein, 1925-1930 (Courtesy of Fenn Galleries, Santa Fe, New Mexico)

Sharp became seriously depressed, planning to give away his collection of Indian artifacts. Some would go to a museum or university, others would be sold. He started to recover just as it became obvious to everyone but himself that his wife was going to die. His sales increased and plans were made for the permanent relocation to Taos. He thought that Addie was improving in the sanitarium and that she would join him directly. Instead, he discovered that she had become exceedingly frail. They traveled by train only as far as Albuquerque where she had to be hospitalized for pneumonia. He had Louise come down from Taos to help where she could, but Addie died on April 4, 1913.

Sharp and Addie's sister, Louise, were both grief-stricken and began traveling together, talking, sharing in the loss, and gradually working through the process of recovery. In so doing, they fell in love and married in March 1915. Their relationship lasted happily for forty years. They traveled extensively throughout Europe, South America, and Asia, or they stayed at home, recording the Pueblo Indians. Sharp did little traveling among the Plains Indians, instead creating his paintings using Taos models such as Jerry Mirabel wearing the clothing of the Plains Indians but having the braids of the Taos Indians. He even forced one model, White Weasel, to wear a Crow Indian hat. White Weasel hated the idea, suspecting that there might even be some problems for him when he did it. But he eventually dressed as requested, scowling fiercely in the painting.

Oscar Edmund Berninghaus and Eanger Irving Couse

Two other artists were early arrivals in Taos, though they were less influential in the early establishment of the Taos Society of Artists. These men came from quite different backgrounds.

Berninghaus was the odd man among the first of the Taos artists. He had never been to Paris, knew of such places as the Académie Julian only secondhand, and had

little interest in seeing Europe or even the inside of an art school. He was self-taught, his idea of intense study being a trip to an area that he found colorful where he could practice painting until the light was too low.

Part of this attitude came from his childhood. His father, Edmund, was a lithograph salesman when Oscar was born on October 2, 1874. The family was of German descent and lived in the working-class, German-American neighborhoods of St. Louis, Missouri.

Selling lithographs enabled the family to live decently, with just enough extra money so that Oscar could have the paper and pencils needed to practice copying the lithographs his father used as samples. He was fascinated by the pretty pictures, trying to reproduce them until he felt himself reasonably skilled. Then he would go down to the Mississippi River where fur traders and others traveling West on the Missouri River, ten miles above, often came to sell. He would sit among them, sketching and listening to stories of life among the Indians. Some of the stories were true, some were lies, but all of them caught the imagination of the young artist-to-be.

Although Oscar was not familiar with the magazine field and knew little of illustrating, he did understand that the local newspapers ran drawings related to the news. While still a boy he pronounced himself a news sketch artist, racing to the scene of whatever he thought might be newsworthy, making a drawing, then taking it to the two local papers. Most of the work was not very good or of no value. Occasionally, however, the editor bought the work, paying a token fee and publishing it. It was a small start, but the sales came just often enough to excite him. He knew that art would be his career.

Oscar's early education ended at 16. He had had enough of the public school system and went to work as an errand boy for Compton and Sons, a lithograph company, where he hoped to learn the business. This first employer did not take him seriously, so in 1893, he moved to the Woodward and Tiernan Printing Companies where he hired on as an apprentice. It would prove to be the best formal art training he would receive, and, in fact, it was excellent. The company was one of the largest printers in the

United States. The employees were talented, and Oscar was able to learn design, color, draftsmanship, and the need to be sensitive to detail.

For a while, Oscar thought he might like art school, so he took three semesters of evening courses at the School of Fine Arts of Washington University in St. Louis. However, he found that formal education was not the way he learned best. Once he learned the fundamentals, his idea of training was to practice them over and over again until he had a mastery, then increase personal drawing and composition challenges. It was much as he had done as a young boy.

This time his developing skills brought more tangible results and led to real work as a commercial artist, his first important free-lance commission coming in 1899 when he was hired by the Denver and Rio Grande Railroad to illustrate a travel pamphlet with watercolors. The railroad provided him with the passes needed to travel throughout Colorado and New Mexico, where he stopped frequently to sketch and paint until he had produced all that they would need.

The plan was a foreshadowing of the work he and the other Taos artists would eventually be handling for the AT&SF. The idea was that if the public could be shown the beauties of the mountains, the rugged mining camps, the lakes and rivers, they would want to visit. Some would stay on the train, sightseeing from major stop to major stop. Others would take time to leave the train and go camping amidst the beauty all around. And still others would relocate to the West, expanding the commercial base of what was primarily wilderness land.

The pamphlet was a one-time idea, and there is no record of how successful the results were for the railroad. But there is a record of how that trip changed Oscar's life. More than fifty years later, he reminisced about the experience in a letter:

> _It was while traveling around the mining camps through Colorado as the guest of the Denver and Rio Grande Railroad that I came upon the then little town of Alamosa, Colorado, where I_

boarded a narrow gauge freight train (affection-
ately known as the Chili Line) bound for Santa Fe,
New Mexico. This was in 1899.

For reasons unknown to me the little train
would stop every few miles, perhaps to cool down
the axle, take in fuel and water or to remove some
fallen boulder from the mountain side. Anyway
whatever it was this gave me pleasant opportunity
to make sketches of such objects as sagebrush,
piñon trees, rock formations, adobe shacks in the
little Mexican villages along the line, and animal
life such as burros and others of which there were
plenty.

The train crew, taking an interest in me and
what I was doing, suggested I might ride the top of
the freight car that I may better see the country as
we rolled along, but not before I was securely
strapped to the brakeman's iron guard rail that
ran atop each car, standard equipment of the day.
[What he did not say in the letter was just how he
rode the top of the car. First a chair was securely
roped to the catwalk. Then Berninghaus was tied
to the chair.]

It was a beautiful bright sunny day in May;
the warmth of the sun was warmth to the soul and
body in this high altitude of northern New Mexico.

As we stopped and passed Servilleta, a station
now gone, the brakeman pointed out a certain
mountain lying toward the East; this he called
Taos Mountain and told me of a little Mexican vil-
lage of the same name and the Indian Pueblo
lying at the foot of it. That it was one of the oldest
towns in the United States [he knew] and gave me
some of its history, describing it all so vividly that
I started on a twenty-five mile wagon trek over
what was comparatively a goat trail. After a hard
journey I arrived in Taos late in the afternoon, the
sun casting its glowing color over the hills that
gave the Sangre de Cristo mountains their name.

I found it all as the brakeman had described
it and more so, a barren plaza with hitching rail

around it, covered wagons of home seekers, cow and Indian ponies hitched to it. A few merchants and too many saloons made up the business section; there were comparatively few Anglos, some of these had mining interests, some were health seekers, and some perhaps fugitives from justice, as Taos might well be a good hide-out place at the time. I found one artist, with whom I soon became acquainted. It was Bert Phillips. He came in 1898, liked it so well he hung his hat on a peg and there it has remained ever since.

I stayed here but a week, became infected with the Taos germ and promised myself a longer stay the following year. This I did each year, longer and longer, then six months here and six months in St. Louis, my home town.

That first trip to Taos lasted only a week, and the community would not be his permanent home until 1925, but it changed his life. He was fascinated by the variety of subjects and realized for the first time that he might be able to spend his life painting subjects of interest to him instead of handling commercial accounts. He liked Phillips's independence and decided to teach himself how to work in all media, including oils, which he had rarely tried in the past.

Berninghaus was able to teach himself to paint so expertly because of his attitude toward the profession. While others felt painters had to always be looking for the final painting in nature, he thought differently: "The painter must first see the picture as paint, as color, and as form—not as a landscape or a figure. He must see with an inner eye, then paint with feeling, not with seeing. The layman generally does not understand this."

There were few artists interested in Indians in St. Louis, so Oscar quickly became famous for his work. J. C. Strauss, a local photographer, commissioned him to paint an Indian who had just taken a scalp, using the painting in his studio. He also helped illustrate the _St. Louis Westliche Post_ when it had an anniversary issue. And by 1900, Berninghaus had his first one-man show at the Frank Healey Galleries. These were primarily exercises in commercial art—

sketches, drawings, and advertisements, all of which were extremely well received.

This early work also revealed the way Berninghaus's fine art would ultimately develop. He had been successful in advertising because he believed that the illustration should be self-explanatory. There should be few words needed to convey the message.

Berninghaus returned to Taos in 1900, this time staying several weeks to seriously begin painting the Indians. His work was reproduced by the *St. Louis Sunday Star* newspaper after he returned, the editor announcing that the 26-year-old artist "ranks among the foremost of the Indian painters of this country." The praise was rather premature.

Berninghaus returned to marry Emelia Miller, the daughter of a manufacturer. As with Sharp, the marriage would end in tragedy. They were extremely close and delighted in their children, Charles, born in 1902, and Dorothy, born three years later. They all enjoyed traveling to New Mexico every summer until Emelia became ill. By 1910, it was obvious that she was too sick to travel to Taos. She died three years later. Berninghaus was fortunate that his children shared his pleasures, and the three happily made the annual six-month pilgrimage to the Taos Pueblo. As he explained in an interview with the St. Louis *Republic* that year,

> This is a splendid country for an artist because there are more varieties of atmosphere here than I have found in any other place. Up in the hills one can get the right setting for old trapping pictures. There are many varieties of sage and cactus for background, according to the elevation you choose. The Taos Indians are a splendid type; in fact, the best I have ever seen, and if one wants to paint Mexican pictures, he can get a background near Taos, just as picturesque as any spot in Old Mexico.

Eanger Irving Couse followed the classic training program of study in the United States and abroad, but among his first "canvases" were the largest used by any of the

early Taos artists—the sides of houses and barns. He painted buildings until he was seventeen years old and had saved enough money to be able to afford to go to art school.

M. E. Couse owned a hardware store in Saginaw, Michigan, where he worked to support his wife and three children. Irving, born on September 3, 1866, loved to draw as a child, though he was barely an average student in the public school system.

Couse, like Sharp, grew up among Indians. The Ojibwa dominated the Great Lakes region, acting as fur traders to other tribes. They were the wholesalers, in modern terms, supplying both the Hurons, who then sold to the French, and the Iroquois, suppliers to the British. The Ojibwa still hunted, fished, and cultivated crops, living in tepees in settlements within walking distance of his home. Thus he was not only able to hear stories of Indian life and history but to witness them firsthand.

Couse was an oddity among the men who would eventually find their way to Taos. He loved the color and the life of the Indians, but he did not personally care about them. They were vehicles for his paintings. He painted Indians the way others painted flowers or fruit. They were objects to be placed in interesting positions, almost always squatting, kneeling, or sitting, utilizing various implements.

Formal training for Couse began in the National Academy of Design in New York. He learned quickly, winning prizes and developing as a fine artist to such a degree that when he returned home after two years, he was able to support himself as an artist. He painted, taught a few students, and saved his money for travel to Europe where he wanted to continue his studies.

It was 1886 when Couse journeyed to Paris for study at the Académie Julian and École des Beaux-Arts. His primary instructor was Adolphe Bouguereau, one of the finest technicians and draftsmen of the nineteenth century, the man who would have the greatest influence on his work. Couse won the highest honors offered by the Académie Julian and was also accepted in the Salon where, in 1887, he won a prize for _Flower of the Prison_. This

was a painting that showed a wretched, gray-bearded prisoner on a step being offered a rose by a little girl.

Couse fell in love while in Paris. The woman was Virginia Walker, an art student raised on an isolated Oregon ranch. She had previously studied in Chicago, Philadelphia, and New York, although little is known of her ambitions and achievements. Unlike Mary Greene, who married Blumenschein, Virginia had neither prominence in the art world nor a driving ambition that conflicted with society's norms. The couple married secretly in 1889, terrified that Bouguereau might discover the relationship, since he was hostile to married students. They were able to hide the truth from him, Virginia continuing to paint for the next two years. However, when they returned to the United States, she felt that she must give up any thought of a career and act as helpmate, supporter, and critic for her husband. It was a role with which she was quite comfortable, and they lived happily together for the next forty years.

The Couses went from studies in Paris to living in Estaples, a fishing village on the Brittany coast where they both painted. Then they returned to Oregon to meet Virginia's family. It was during this period that Couse began painting Indians, a subject that proved a dual problem for him.

The first problem came because of the Indians he chose. He used such tribes as the Klikitat, Umatilla, and Yakima, most of whom had never seen an artist. They decided that there was a chance that the act of having your portrait painted was bad medicine. Your body would weaken and then you would die, all during the course of the painting.

Couse seemed like a nice man, no direct threat to them, but perhaps he did not understand the potency of the magic with which he was working. They decided to find out by establishing a sacrifice of their own. They selected an aged woman who was ordered to pose for Couse.

The woman was terrified. She sat (sitting and squatting were the primary activities of almost every Indian in every painting Couse would complete over the years) and covered her eyes in terror. She thought the end would come at any moment for her, and she did not want to witness it.

However, in what many felt was a miraculous achievement, the painting was completed and the woman walked away, as healthy as she had been when he started. There was no bad magic. A likeness did not mean death. Delighted with the attention, the other Indians agreed to pose.

Couse left the region with a good selection of paintings with which to finance his new marital status. He placed them for sale; and no one came to buy. The problem was that the times were wrong for nice paintings of peaceful Indians. The Wounded Knee battle had taken place the year before. White Americans either wanted to hear nothing about Indians or they were interested in paintings that would show bloody battles and triumphant troopers.

The Brittany coast paintings proved to be the means for survival, an unexpected windfall for Couse. The Manhattan Photogravure Company thought the public might delight in owning reproductions of two of his works— *Bringing Home the Flock* and *Evening Promenade on the Dyke*. The company was correct, and the Couses returned to France.

Irving Couse would ultimately prove to be the most commercial minded of all the Taos artists, including Ernest Blumenschein, who developed a series of highly successful marketing programs. Couse painted what the public would buy. He declared his return to France as his "sheep period." For three years, the couple alternated between Estaples, where their son, Kibbey, was born in 1895, and Paris.

Couse produced just two types of paintings during this time. One type was pastoral—paintings featuring shepherds and their flocks, the fishing village, and anything else he was certain people would enjoy seeing hanging on their walls as reproductions. The other paintings were copies of the great masters made in Paris. He followed the traditional student's exercise of duplicating the great works found in museums. But while the average student discarded such work, seeing it as no more than a training exercise, Couse proudly saved his canvases, hanging the paintings in his dining room after he moved to Taos.

The Walkers let their daughter, grandson, and son-in-law live on their ranch after the Couses returned to the

United States in 1897. For two years, he produced primarily the types of pastoral scenes he had made in France, as well as periodic studies of the Klikitat Indians. He chose to paint them with an ethnological accuracy that was among the best to be seen, a habit he dropped after 1903.

But the main money came from painting for the public. Did you live in Portland and want your portrait painted? Contact Couse. Did you want a pleasant scene to hang on your wall? See Couse. He wanted to paint and apparently did not care what. Art created to order regardless of the client's taste was as satisfying for him as anything he might be inclined to paint if he had an independent source of income. He was a skilled pragmatist with none of the longings of men such as Phillips.

Although the family began taking trips both to the East and to Paris over the next couple of years, Couse's work earning greater recognition in important competitions, it was not until 1902 that he finally gained success for his paintings of Indian subjects. He won the First Hallgarten Prize for *A Great Day, A Peace Pipe,* and *Firelight*, all Indian subjects. He also was elected an Associate in the National Academy of Design. He was thirty-six years old and soon to be hailed "one of the foremost American artists" (*The Art Review* of 1904).

Couse decided that he would like to do more paintings of Indians. But he lacked the patience and understanding necessary to make the Oregon Indians he had known comfortable with him. He also hated the wet weather for which Oregon was notorious.

Back in 1896, Couse had met Blumenschein, Phillips, and Sharp in Paris. They had talked of Taos, an area that was mentioned again by Sharp when he and Couse were reunited abroad in 1900. Sharp also mentioned how willing the Indians of the Taos Pueblo were to pose for an artist, an important consideration for Couse.

The Couse family had visited Taos briefly in 1902, and they found the land to be exactly as described to them. Only the trip was unpleasant. They took a narrow gauge train from Denver to Tres Piedras, arriving on June 4. There they were housed at John Dunn's Bridge, a traveler's

way station where they spent the night before Dunn took them by stage to Taos.

Dunn had no interest in fancy travel. The hotel that was provided was extremely unpleasant. The rooms had few walls, and none was completely private. Instead they were small cubicles divided from each other with thick layers of cheesecloth hung from the ceiling.

To add to the problems, the Taos mountains could be unseasonably cold, regardless of how warm it might be elsewhere in New Mexico. When the stage arrived on June 6, the pueblo was in the midst of a blizzard. However, when the driving snow ceased to be a problem, Couse was enchanted by the great beauty. He immediately rented a studio that overlooked the valley on one side and Taos Mountain on the other. He painted until late in the year and then returned to his New York studio, from which he made most of his sales.

Couse did not consider making Taos his home right away. In 1903, he was in the midst of the Hopi Reservation, sketching the daily life and activities such as the Flute and Snake ceremonies. All the paintings made at that time were extremely accurate in their depiction of various activities, as were paintings made several years later from his notes and sketches at the time. But once he began spending almost all of his time away from New York in Taos, he sold what was commercial and fit his sense of order. His Indians would kneel, sit, or squat. They did little else.

It would be several years before Couse decided to become a year-round resident of Taos. But by 1910 he had purchased his own building and was considered one of the five founding leaders of the Taos art colony. It was also in the year of that commitment that the business of art for the Taos residents would begin to change.

Chapter VIII

Blumenschein Takes Charge

The connection between the railroad and the world of art existed in a relatively crude form for several years. At first, the AT&SF supplied artists with free passes to travel their line. This practice apparently was without restrictions and was used by men regardless of talent or ability. As a result, William H. Simpson, general advertising agent (director of advertising) for the AT&SF, decided to halt the practice. Instead, he arranged to look at paintings produced by artists who rode the Santa Fe, buying at least one such painting if he liked it, the price guaranteed to cover the cost of travel. The explanation was made in a letter to Blumenschein written on October 12, 1910, in response to a request for a pass made the week before. After expressing pleasure in Blumenschein's continued interest in the Southwest, Simpson explained,

> We do not issue any more advertising passes, but will be glad to buy a picture from you occasionally and pay cash for it to help out railroad fare. On future trips please take receipts for railroad fare, as a matter of reference.
>
> After you get back to New York if you have anything which you think we could use in our adver-

*tising, please hand it to our New York agent, Mr. G.
C. Dillard, 377 Broadway, and he will send it here
[Chicago] for inspection. In doing so let us know
what the price is on each painting. Our art fund is
not a large one and we cannot afford to pay art
dealers' prices; but I know you will be reasonable
on that score.*

Simpson made the decision both as a businessman
and as an art lover. He had a personal collection of paint-
ings of the Southwest and was also known for his poetry
about the area. He wanted not only to sustain an impor-
tant business venture for the railroad but also to ensure
that only the best work was being subsidized in any man-
ner. He did not realize that his actions, coming at the time
when illustration commissions would soon be reduced,
would come to ensure the financial survival of the drug-
store cowboys and others who eventually formed the Taos
Society of Artists.

The letters between Simpson and Blumenschein con-
tinued in a friendly manner for a few months. Blumy, as he
was called by his friends, wanted Simpson to see a paint-
ing of the Lionel Barrymore family that was being
exhibited in Chicago, and Simpson spoke of meeting with
the artist either in Taos or New York should the opportu-
nity arrive. However, by June 1911, the relationship was
being changed by Simpson, a fact that would ensure the
success of the Taos artists.

Simpson had discovered that the American public was
delighted with images of the West. Paintings were encour-
aging people to take the train for pleasure, still a new expe-
rience. Fred Harvey had revolutionized train travel, yet the
memory of the bad years lingered in the minds of the pub-
lic. They needed ways to become excited about the West,
and Simpson felt the paintings would help.

Actually, Simpson was not the pioneer in linking the
Santa Fe operations with Indians of the Southwest. As
early as 1884, Fred Harvey used Indian crafts to decorate
his restaurant in Holbrook, Arizona, just outside the
Grand Canyon. He also painted the interiors in the bright
colors common to both the Indians and the land. The red

rocks of Sedona, Arizona, the richness of the blues, pinks, and reds of the evening sky, and all the other colors found in the West were quite unfamiliar to the eastern families who were the primary customers. The radical changes proved exciting to visitors.

In 1899, Herman Schweizer was ordered by Harvey to buy work from the Navajo. These included blankets and silverwork of a quality that could only be found in eastern museums. The Navajo long had had silver workers, but their trading was limited. Schweizer had them custom make creations for him, greatly boosting their income. Then he moved to other areas of Arizona, purchasing baskets from the Pima and Papago.

In 1902, Harvey created the Fred Harvey Indian Department as part of the Santa Fe Railroad operations. Indian work was used as decoration and also sold to the public. People began taking intricately designed jewelry, blankets, pottery, and other items back with them to the East, generating a demand for such merchandise. Some people deliberately went West to buy it from the Harvey facilities. Others arranged for large purchases, then began offering it for resale. As a result, almost everything used by the Harvey operation increased in value through the 1950s, when prices stabilized slightly. Since then Navajo silver and other craft work have been in growing demand in Europe as well as the eastern United States. Some of the early blankets and rugs are worth many thousands of dollars despite being purchased for very little money at the time.

Simpson recognized the true value of the paintings, both at the time and for their potential. He decided to ensure a steady stream of work at the lowest possible price. He also wanted to dictate the type of paintings that would be made so that they could be used for promotion.

The genius or deviousness of the plan, depending on your point of view, was exceptional. If he commissioned a painting for advertising, there would be a set price and a guaranteed purchase. If he told an artist the type of painting in which he was interested, pleaded low budget, then said he would look at whatever was produced for possible purchase, he was under no contractual obligation. He

could refuse work he did not like and purchase work for which a budget had been established. Sometimes the cost would be the same as with an advertising artist. At other times he could save money. Either way, there was no risk.

Typical of the subtle manipulation was a letter to Blumenschein dated June 8, 1911, in which Simpson explained,

> *On looking over what is left of our small art fund, find it will be impossible to spend more than $400. No doubt you can give me something worth while for that amount. Prefer an Indian subject with Taos Pueblo in the ground, if such a thing feasible. Such a picture would have an advertising value apart from its art quality.*
>
> *It is my recollection you wanted an advance payment on the picture. The management lately has adopted a new rule in such matters and for the present I can only pay when the work is done. Presume this will make no difference so long as you have the order.*
>
> *Trust you will be able to go west this summer. Should you conclude to locate there permanently, same as Mr. Couse and other artists, I think we can buy a larger canvas, and pay for it in yearly installments.*

The correspondence that ensued showed the manner in which business was being conducted. Money was always carefully negotiated. The painting that Simpson purchased from Blumenschein for $400 was paid for in two installments, $100 being paid the day the painting was delivered and the remainder a few days later. Simpson also made a point of showing Blumenschein that the cost of his train ride had been under $100, leaving him with a nice profit. The fact that there were other expenses was barely mentioned. He also avoided the issue of paying for the artist's time. Both men knew that the Taos artists needed whatever income they could get to pursue their dream of working full-time from Taos. Thus the railroad was determined to exploit them as best as it could, knowing that they would always back off in a confrontation.

For example, the Fred Harvey office in Kansas City, Missouri, arranged for the paintings to be reproduced in two books, one containing paintings of the Southwest in general and the other containing paintings of the Indians. They also made postcards from the paintings, all of which they sold for profit.

The technology of the times was such that only paintings were desirable. A practical color film had not been developed for photography. James Clerk Maxwell had developed the theory of color photography in 1855 and made a demonstration of the concept in 1861, but it was not until 1930 that true color photography existed. Thus, in a letter dated September 11, 1911, Simpson was advised by a representative of the Harvey operations,

> *I would prefer, if possible, to use all paintings in this album instead of photographs, but we cannot get a sufficiently representative lot of pictures [of Indians]. I think there are several other pictures in the several Santa Fe offices that you might consider allowing us to reproduce in the album in question. Are there any other pictures in the general offices in Chicago owned by any of the officials or others that you think we could get permission to reproduce? I am quite sure you will be very much pleased with the reproduction in colors.*
>
> *The first edition of this album will be ten thousand, and I think it will be one of the biggest sellers we have ever had on the Santa Fe, and I want it to be in every way first-class. Anyone whose picture is reproduced in this album will not regret it as the album will be high-class in every way.*

Later it was stated, "The better we make the album, the better an advertisement it will be." What went unstated because it was of no concern to the railroad was that the artists would receive no additional money. For one relatively low fee based on limited funds to acquire art for decorations, the same paintings were being used for advertising, a department that had a separate budget.

By 1912, Simpson was becoming skilled in manipulat-

ing the Taos artists. He was using the pictures the com-
pany purchased for special displays. Offices had mini-art
galleries of the work, some framed and mounted on easels,
others used on walls. People stopping by in cities such as
Chicago and St. Louis would be enticed by the beauty of
the Southwest. In addition, postcards were made from the
paintings as further marketing tools.

Blumenschein, having a sense of the value of the work
to the railroad, yet afraid to cut off a major source of
income for the artists, kept pushing Simpson for larger
sums of money. Gradually his efforts proved successful,
though Simpson still had the upper hand. For example, the
price for a painting went from $400 to $700 but was spread
over a three-year period. At times the $700 figure was
reduced by $100 because, according to internal memos, it
was easier to figure one-third payments for the $600 total.

The money was paid annually, though Simpson at
times would commiserate with the artists' needs by offer-
ing immediate payment, providing the artist would take a
10 percent cut. He also provided the general subject mat-
ter he desired or a primary artistic element, such as "In-
dian pueblo background."

The relationship with the railroad was important to the
Taos artists because it provided them with a continuing
source of money to meet their needs. Blumenschein was
preparing for the day when he, too, would live full-time in
that world, but in the meantime, he had a family back in
New York and had to continue his illustrating to have an
adequate income for an urban environment.

Most of the artists ate their meals at the Columbia
Hotel, which provided them with twenty-one meals per
week for just $3.50, a fraction of what even the Fred Harvey
feasts would cost. The hotel owner was willing to yield to
every taste, despite the fact that he barely made a profit
from his charges. He often made individual orders for the
men, knowing that they could not agree on a single meal
even though large quantities of the same item would have
been less expensive.

The artists caused other problems for the hotel as well.
Watermelon was the standard dessert each evening. They
would eat the watermelon to the rind, being careful not to

break its horseshoe shape. Then they would pitch the rinds at the metal crossbars on the ceiling, scoring points if they could hoop it through to the other side.

To make matters worse, most were in arrears of even the cheap meal charges. They would demand and receive credit to such a degree that the owner frequently had to wonder if he could pay his own bills. When payment was made, it was sometimes in the form of a painting that had no commercial value locally. The hotel owner had no way to sell the work in the East, so he had something that was pretty, yet could do no more to help his debt than a contemporary print from Woolworth's.

Blumenschein was a member of the artists' group known as the Salmagundi Club in New York. Painters gathered there to discuss their work, their problems, and their goals. He realized that a similar organization might be developed among the artists of the Southwest to make formal sales to the railroad. He commented to Simpson,

> *I've thought several times in the last year that the thing to do was form an organization of the painters who find their subjects in that region. We must talk it over next winter and perhaps something may evolve, resulting of course in annual exhibitions that could tour the country to the advantage of both artists and the Santa Fe Railroad.*
>
> *At any rate the production is growing and we shall see some bully paintings from this talented group.*

Blumenschein did just that the following year. Berninghaus, Couse, Phillips, and Sharp joined with Blumenschein in forming "the group." The men were extremely enthusiastic, because they were watching other artists become financially successful through their association with Simpson and his changed approach to marketing their works. In 1910, a number of major artists, including Elliot Dangerfield, Thomas Moran, Dewitt Parshall, and Edward Potthost had their paintings exhibited by the AT&SF. The men gained exposure and commissions, then were given the bonus of a trip to the Grand Canyon, accompanied by

their wives, all expenses paid.

The following year, the same artists agreed to let the railroad exhibit their works throughout the United States, in city after city serviced by the railroad. A major new buyer's market was opened for the artists, and the railroad enjoyed dramatically increased passenger business. Everyone prospered. Everyone was happy.

By 1913, the third year of the exhibit, Couse managed to participate even though the rest of "the group" was not formally involved as yet.

"The group" became more formalized by the first part of 1913, meeting once a month in the Berninghaus studio, regardless of who was present in Taos at the time. They critiqued each other's work, and Blumenschein reported on his business contacts with Simpson.

There were other problems by 1913, including the fact that the marriage between Mary and Ernest Blumenschein was falling apart. She had led an extremely happy life as a successful artist and sophisticate in major cities such as Paris and New York. Instead of taking her for who she was, Blumenschein had proven himself to be a dominating chauvinist who wanted a wife to be housewife, mother, and caretaker of the family home while he went around the country painting. This would not have been a problem had he encouraged her to have her own career. But he did not, and she subjugated her interests to his. Even worse, when his "Bill" (Helen) showed an inclination to become a painter, he insisted that there could not be three artists in the family.

Taos was another sore point between them. She was willing to tolerate the rustic setting provided Helen could get an adequate education and the land was safe. She had read Phillips's early letters and knew of the violence of the past. She had no intention of exposing herself or her daughter to such danger.

Blumenschein was too weak a man to live in the manner Phillips had and did not request that the family move there permanently until after the community had become peaceful. But he thought it would be humorous to lie to his wife, scaring her with stories of marauding bands of In-

dians and Mexicans. He told her of harsh weather, of dust storms and flash floods that were forever threatening his life. He painted a picture of bandits who seemed always poised, ready to rape, loot, and pillage at a moment's notice. Even Phillips, who had truly encountered the rigors of the old West, had never experienced half the tales Blumenschein shared with Mary. And she believed them. He was intensely lonely, yet his idea of a humorous way to tease Mary was driving them farther apart.

He did not tell her that Taos was becoming so civilized that it had two baseball teams, the Greys, for which Blumenschein played shortstop, and the Maroons. They met every Sunday on an empty lot, Blumy participating until 1924, when he turned 50 and developed leg injuries that forced him to stop. Sadly for him, that decision followed his best year—a season during which he batted .417 and played right field, according to a newspaper clipping from that period.

The other "adventure" he enjoyed when Mary was in New York was fly-fishing for trout in the Rio Grande. Most of the locals had not been serious fishermen and had not carefully studied the fish in the water. They assumed that the Rio Grande contained only carp and suckers, so when Blumenschein showed up with four- and five-pound trout, refusing to tell where he found them, they thought he had a secret "watering hole" somewhere. Once they learned the truth about the river, it became the standard fishing spot for all the enthusiasts.

Blumenschein took his paints with him when fishing, combining work and pleasure. Later landscapes were often based on the sketches he made along the river. Yet these civilized, pastoral pleasures were all kept secret from Mary. Blumenschein never experienced the rugged life that Phillips had enjoyed—nor did he want to—but he certainly wanted Mary to think that he had.

Blumenschein was asking too much of Mary and their daughter, who had been a sickly child the first few years following her birth. They had left Paris by mutual agreement when Mary was pregnant. New York had been a compromise they both respected.

Then Blumenschein demanded that Mary sacrifice her

life for his, which was unnecessary. Her commissions were so lucrative that they could easily have afforded help for their home, allowing both artists to pursue their careers. Yet the truth was that Mary was the superior artist and Blumenschein was insecure, never satisfied with his paintings, always tinkering until deadline. It was not unusual for him to destroy canvases, and he routinely painted over older paintings, trying to improve them. He could not handle what he perceived to be the competition within his own home, especially after Mary began receiving commissions for illustrations, the one area where Blumenschein had felt himself successful in his own right.

Suddenly Blumenschein wanted Mary to give up the sophistication of Manhattan for a primitive land where each day seemed like a fight for survival. They were still living in New York as their permanent home, Blumenschein only summering in Taos. She did not mind the separation. However, she also did not want to go where there were few whites, no culture, and constant violence from both man and nature. Or so was the picture her husband painted in his letters.

New York was comfortable. During the winter, Blumenschein was teaching at the New York Art Students League on Tuesdays and Fridays. He was gaining portraiture commissions. He was gaining magazine assignments and experimenting with impressionist techniques of lighting. He was growing in skill, respected in society, and tolerated in his absences each summer. Mary wanted him to leave well enough alone.

In 1913, Blumenschein finally persuaded Mary to bring Helen and come to Taos for the summer. Unfortunately, his timing could not have been worse. A diphtheria epidemic had struck the community, and many of the wells were polluted. Food was in short supply, and the desert winds were hot, humid, and filled with choking dust.

Perhaps had Blumenschein not been trying to impress his wife with his manhood prior to that first visit, she would have been more receptive to the idea that the situation was an aberration. But the dire living conditions just reinforced the image he had planted in her mind while trying to impress her with his struggles as an artist of the Southwest.

Approximately 150 artists and writers lived in Santa Fe and Taos. The area was growing rapidly and, though isolated, was developing more into small-town America than rugged West. However, as with many communities outside the major cities, indoor plumbing was nonexistent, electricity was not available, and telephone service could not be found. The streets were muddy after a rain, dusty during a dry spell, and a constant source of throat irritation.

All of the problems were not unlike the conditions found in other rural communities. Mary had not known the routine hardships of heartland America, however, and had no interest in adapting herself to any more of them than necessary.

Not that the visit was all bad. Mary loved the raw beauty of the land, of mountains bearing color she had never before witnessed, of skies quite different from any she had seen in the East. The mixed cultures resulted in radically different clothing and facial features, all of which were exciting for an artist. She could understand the appeal for a painter, but she felt she was not allowed to paint and resented the constant stimulus that only her husband was permitted to enjoy.

Mary agreed to adapt to Taos, but only to the extent necessary. Nights would be illuminated by candle power. Bodily functions would be handled outdoors, and proper physical hygiene would require much careful preparation and extensive work to heat the water, especially on cold days. And she would accept that the Indians and Mexicans seemed peaceful when riding through town and would probably not scalp and murder her and Helen. However, she would not dress as the locals did. She wore white gloves and a black velvet band around her neck. And each day at 4 o'clock, proper tea time, she would prepare the afternoon libation. Ernest Blumenschein could remove the lady from sophistication, but he could not remove the sophisticate from his wife.

Oddly, the more Blumenschein tried to make his wife adapt to the rugged life-style of Taos, the more he enjoyed "civilizing" the region to his personal taste. His interest in tennis intensified in Taos, where courts were constructed for the first time and he became an award-winning player.

He also was a master bridge player, so competitive and hostile to others that he could not keep partners. No one could tolerate his constant criticism.

BUCK DUNTON

Other artists were discovering Taos as Blumenschein was both developing business arrangements with the AT&SF and helping his family relocate permanently. One of these was W. Herbert "Buck" Dunton, who joined the five main-stays of Taos in 1915.

Buck Dunton, the true prodigy among the Taos Society of Artists, was born on August 28, 1878, to William Henry and Anna Katherine Pillsbury Dunton of Augusta, Maine. William Dunton was a professional photographer, one of the earliest connected with a newspaper, though most of his photographs were produced separately from his job with the Kennebec *Journal*.

Dunton was drawing with a pencil before he could feed himself and writing stories to illustrate almost from the time he learned the alphabet. His mother bought him bound books of blank paper that he filled with both sketches and writing.

Probably because of his father's work, Buck understood the business of art and, while still a child, began selling freehand drawings to newspapers in Lewiston and Bangor, Maine, as well as to the Boston *Sunday Globe*. By age 14, he was the writer/illustrator of a column for the New York-based *Recreation* magazine. Then, at 16, he quit school to become a free-lance artist for newspapers and magazines.

Unlike the Taos Society of Artists members, Dunton had no interest in the period when Indians ruled the American West. He was fascinated by the transition period when white cattlemen moved onto land either shared with the Indians or forcibly taken from them. These cattlemen were, in turn, forced out of the area by urbanization, ultimately establishing ranches that did not have the same visual interest or history.

Dunton's childhood was quite different from those of the other artists. His roaming the land and delighting in

the outdoors was similar to Phillips's experience, yet unlike Phillips, he was frequently in the company of his grandfather and other adults. The combination of being a prodigy as a commercial artist and his exposure to older men and women made him more mature than others his age. He later wrote of those years in a story entitled "Two Boys and a Gun."

Dunton explained that he spent the first seven years on his mother's family farm. Then his grandfather sold the place and he went to live on a larger farm north of Newport Junction. The land belonged to his great-grandmother, whose husband had died and who no longer could manage without help. There he would know the kind of childhood only possible with an extended family, with the older men taking an active part in raising the youngest children.

It was a quaint, pretty place in which she lived. Sitting back from the road, the house with its ell and long, low shed stretched back to the huge barn where the swallows glided in and out from beneath the eaves. A half dozen pine trees stood like grim sentinels fronting the house, and in summer a tremendous flower garden blazed in a riot of color from the front porch to the road. Behind the buildings was the orchard and flanking them spread the fields through which the land led to the pasture and the woods. The life on a New England farm of that day seems quaint to us now, but this place was, even then, more primitive than that from which we had just come. The big kitchen, its floor with its downard slant, its wooden sink, the huge fireplace and spacious 'buttery' savored of earlier days. The living room with its rag carpet and oval, home-made rugs, its hair-cloth sofa, hassocks and rockers, gave forth an air of comfort and good cheer, but the parlor, which was only opened on rare occasions, was a musty place. Here everything was arranged in severe precision. The family Bible had lain for years on the mahogany center table, and the album on its shelf beneath. Samplers, worked by those long dead, hung over

the doors, while from the walls musty portraits looked down in solemn dignity. A tall grandfather clock ticked measuredly in the front hall where the long winding stairway led to the bedchambers above. Oh! the comfort of those great four-posters with their feather beds in which we sunk on winter nights beneath the coarse, heavy blankets and crazy quilts. And those nights were cold and the bedrooms as chill as the blasts outside—for did not the water often freeze in the Delft pitcher on the commode?—yet by the use of warming pans or a hot soapstone wrapped in flannel we were warm enough.

The family lived off the land, raising everything they needed and selling the rest. Unlike many such farms, the older men and women were able to handle the bulk of the chores, giving Buck Dunton the chance to go "hunting" with a bow, blunt arrows, and an imagination that turned his weapon into a muzzle-loading rifle. He hunted "orioles and king birds which paid scant heed to my clumsy stalking." But once the family had a few months to settle into their new life, his grandfather took him in hand and taught him to shoot a "real" gun as well as to fish in the nearby pond.

Dunton and his grandfather became inseparable companions, fishing, tramping through the woods, and hunting the different game in season. He attended the country school, where he learned to read and write but little else. A male teacher was always sent to run the school, although the location was so undesirable that the teacher was invariably incompetent and disliked. As soon as the first heavy snow hit the area, the older, bigger boys would ambush the teacher each day, pushing him into snowdrifts and letting him know he was unwelcome. After a few weeks at most the man would quit, the children would return to the farms, and the search for a new teacher would begin again.

Once Buck finished the equivalent of elementary school, he was sent to the city for higher education. He hated it, as did the other children in the community, but it

was their only choice. However, he delighted in returning home to his grandfather, who gradually taught him to buy his own powder and shot, to make bullets, and to hunt alone. By the time he was in high school, he and his friends would spend much of their free time in the marshes and bogs, hunting ducks, camping, and swimming.

Dunton was unusual in other ways. While the other members of the Taos Society were either drugstore cowboys who moved West or individuals who saw the West as an area to explore, camping out like Boy Scouts with palettes, Dunton chose to learn the West from experts. He had been reading the stories of pioneer adventurers—authentic stories, not the dime novels that fed the imaginations of the other artists. When he eventually went West, it was not to become some fantasy hero but rather to obtain jobs from those who knew what they were doing. Not long after his eighteenth birthday, for example, Dunton became the assistant to an impoverished bear hunter. The man was highly skilled but unable to afford such basic tools as a dog pack for running the bears to ground. Instead, the man, aided by Buck, would track the bears on foot, sometimes finding one to shoot, other times wandering for days, hearing the bears, seeing the number of tracks increase as a pair were joined by others, yet never being able to move close enough for the kill.

In Montana, where Dunton did most of his work as a big game hunter, he learned to draw animals through a method that he later felt was destructive. First, he would observe the animal in the wild, sketching it from every angle he could. Then, when either he had made all the sketches he needed or when the animal looked as though it might move out of shooting range, he would shoot it.

If conditions were ideal, as they were in the mountains for several months of the year, the corpse would freeze where it dropped while Dunton studied it closely. He would experiment with duplicating the color and texture of the fur. Then he would isolate areas of the anatomy, drawing the ears, the eyes, the hooves, and all the other parts of everything from a cow to a mountain lion.

Once the exterior of the body had been thoroughly studied and sketched, Dunton would begin dissecting it.

The skin would be removed, then layer after layer of the flesh would be closely scrutinized. What did the muscles look like? What about the bone structure?

Later, Dunton would laugh at the way he handled himself. He carried revolvers and rifles, finely honed knives, and enough bullets to, as he put it, "exterminate all the game in the Rockies." Although his actions were destructive and his concerns self-centered, the more time he spent in the West, the more he came to understand the changes taking place. Hunters, trappers, and others were leaving man-made items behind when they left. Animals were slaughtered for uses other than survival, endangering the way of life of the Indians, who wasted nothing.

Gradually Dunton became a conservationist, opposing wilderness experiences that endangered the land or needlessly took the lives of the animals. In just a few short years, the experiences he had had at 18 could not be duplicated by other young men, because the wilderness had been damaged by thoughtless white men. He accepted his past, changed his ways, and worked for the passage of game laws that would end hunting for the sake of shooting a living creature.

But such change came later in life. The young Buck was eager to learn the West from the men who came after the Indians. In addition to following bear and taking art training through animal slaughter, Buck worked on a cattle ranch and took other jobs that enabled him to know, firsthand, the life of the cowboy.

Dunton spent some fifteen years, from 1896 through 1911, traveling throughout the American and Canadian West. He critiqued his own work to the best of his ability, then took courses from the Boston Cowles Art School and New York's Art Students League as well as from individual artists who accepted an occasional student.

The first four western paintings Dunton sold while a teenager were to a publishing company that paid him $75.00 for the work. This led him to other assignments for other companies. Some of his work was typical for the business—creating a visual image to go along with a poem or short story. Other work relied on his knowledge of the West, of living off the land, and of hunting and fishing.

These images appeared in magazines such as *Recreation, The Amateur Sportsman,* and *The National Sportsman.* Then he took a job illustrating the work of an East Coast dentist whose fantasy stories of the American West were both serialized in magazines and published in books. The dentist was Zane Grey, and at the beginning of the new century, Dunton's art and his name were often as well known as the writer whose work he illustrated. His images were in all the important magazines—*The Saturday Evening Post, Cosmopolitan, Collier's, McClure's, Harper's Weekly,* and *The Woman's Home Companion.* He also was employed by major book publishing companies.

The first five TSA members were keen observers of western life. Phillips attended the Penitente ceremonies. Sharp observed both rituals and daily life. But Dunton was unique in that he was both an observer of and a participant in what went on around him, later reflecting on the eccentric manners and customs he and his friends had enjoyed.

For example, outside observers of the cowboy tended to glorify the horse. These were men who came from the East where industrialization made them sensitive to the importance of basic tools. In a factory, the most money would be spent on the most crucial equipment, which, in their minds, they translated into the horses being ridden by the cowboys. Their pictures often showed cowboys who seemed impoverished riding astride expensive, quality animals. But Dunton's work was different because he understood that "in my day no cowhand wore any cheap finery, and angora chaps were either black or white—not orange, lemon yellow, etc., such as is affected today in the show business. I've paid as much as $40.00 for a bit. In fact, I've *literally*—many times—'put $500 on a $15 horse.' That's just what my old outfit cost me—saddle with 'taps,' Navajo blanket, head stall, bit, spurs, chaps, 6 gun, etc."

Dunton's attitude toward women was quite different from that of his fellow artists, especially Blumenschein. He delighted in the women of the West, respected them, recognized the physical burdens they shouldered by living in so rugged an area. They were neither weak nor objects of rid-

icule but equal to the men when necessary and romantically gentle at other times.

It is unclear whether Dunton had an affair with Lillian Barron, his most frequently used model for his paintings of white women in the West. Born in Brooklyn, New York, Barron later moved to the West, where she lived for many years. She had the large bust, thin waist, and long, attractive legs that reminded people of the women made famous by Charles Dana Gibson. However, Buck painted her astride a bronco, standing alone in the fading daylight, and in related settings. His work featuring her won numerous awards and extensive publicity, especially in 1914 when one of his Lillian Barron paintings, *The Lonely Vigil*, was displayed by the National Academy of Design.

At 22, Dunton married Nellie Hartley of Waltham, Massachusetts, then moved with her to New York, then to Ridgewood, New Jersey, and finally to Taos. She seemed delighted with the East and had no interest in her husband's wanderings. She was not enthusiastic about living on cattle ranches and tracking bear. She certainly was not inclined to accompany him into Mexico around 1910 when the revolution against the Díaz government was taking place. Instead, she led her life, taking care of their children, Vivian (born 1907) and Ivan (born 1912), and he led his. Then, in 1920, both of them accepting the fact that the relationship was long over—and Nellie, probably jealous of women such as Barron who seemed to get as much publicity as his paintings—they divorced.

Dunton felt that his wife could not handle being married to a free-lance artist who might be very rich or very poor but never knew what his income would be over time. He later commented, "Nellie cared nothing about art. She couldn't face the lean years with me. All she wanted was the bin full of coal and the larder well stocked."

It was 1911 when Dunton first met Blumenschein at the Salmagundi Club, where they became good friends. Then, after studying Blumenschein's work, Dunton decided to take a course from his fellow artist at the Art Students League the following year. It was there that they began discussing the West and Dunton was invited to visit Taos.

He was looking for a change. His marriage was falling

apart, and he had come to hate illustration. He had been accepting every commission he could obtain, working so intensely that he was constantly tired, though financially well off. He had also become well enough known that he could live anywhere he chose, his name selling his work for him. The idea of traveling to Taos to see what life there might be like intrigued him.

Dunton, like the men who preceded him, was delighted with Taos. He arrived in June 1912 and was immediately accepted by the other five artists and invited to form what became the Taos Society of Artists. Buck Dunton became the resident cowboy artist of Taos, though he spent a part of each year back East. He was the man who had lived the life the rest had only heard about. He had been a cowboy in the American West and a vaquero in Mexico. He also collected saddles, bridles, swords, and other equipment related to both the cowboy life and the cavalry. Each year, the Stetson Hat Company sent him a new hat with his name spelled out in gold in the sweatband.

Dunton found happiness, but not with his wife. They divorced, and she moved to Santa Fe and opened a curio shop. After his death, she moved back to Taos to live in the large home that he willed to her and their children.

Dunton's greatest appreciation of women, both in his writing and on canvas, came from those he encountered at the gathering known as Frontier Days held in Cheyenne, Wyoming. This was a combination county fair, rodeo, historic celebration, and excuse for a giant party among whites and Indians. The first Squaw Race he ever saw was never forgotten, probably because the winner was a woman whose name was Mrs. Silk Underwear. But his disappointment in the Ladies' Relay Race, a competition among women bronco riders, revealed the respect Buck had for the courage and skill of the women in the West.

A bronco race was one of the most difficult events for men and women, requiring the greatest skill and horsemanship. The horses were captured still wild and unridden. On the ranches, the women would leap astride the animals and ride them until the horses calmed down and allowed themselves to be controlled. The horses would leap in the air, buck, drop to the ground, and do anything they

could to rid themselves of the rider, and the women would stay on their backs for so long as it took to calm the animal or until they were thrown to the ground. It was extremely dangerous work: a rider could be killed if he or she made a mistake.

The race was meant to duplicate the skills of the ranchers. However, to add to the skill demanded of the riders, not only would they have to stay mounted but they also would have to show fast enough mastery of the animals to move them around a preset course.

What bothered Dunton was the use of hobbled stirrups attached like a belt while the animal was in a holding pen, ready to be released into the ring. The stirrups gave the women a better chance to stay astride the horses than they would have riding bareback, a chauvinist action reflecting the race organizers' refusal to treat the women as equals. Dunton said, "There are plenty of girls in the cow country who can ride broncos and 'ride 'em slick' —that is without hobbles."

Buck Dunton was more than a legend in his own mind. Friends of his delighted in creating stories about his exploits, most of which were as outrageous as the image he had of himself. In one instance, a story was published by a friend, the small pamphlet made to look like the popular dime novels of the day. The cover had a crude picture of the bust of a masked man in a cowboy hat. The title was _Buck Dunton & The Desperado_. Below the bust was, "A Ballad Written by Spud Johnson on the Very Day the Shooting Occurred & when all of the FACTS were Fresh & VARIED With an Unbelievably-lifelike Portrait of Buck by L. MOZLEY" (Loren Mozley). And below that was the price, "TEN CENTS THE COPY."

Inside, the poem read,

BUCK DUNTON & THE DESPERADO— A BALLAD

The road was long, the road was white,
 The new moon showed a crescent;
It was the night Buck Dunton's plight
 Was far from pleasant.

For Buck was on his way to town
　To raise his doctors' bills,
And 'though he felt like lying down,
　He staggered o'er the hills.

A frightful groan burst from his lips,
　Most pitiful to hear;
He leaned and rested with his hips
　Against a tree in fear:

For he was nigh unto Death's Door,
　His pain was keen and vital;
He stood there in the road and swore
　By his most cherished title,

Which was the proudest ever won
　By artist pale or tan,
For he was christened by John Dunn
　As "The Cowboy Painter Man."

He swore he would relinquish pay
　And even give up painting,
If God would take his pain away
　And keep his heart from fainting.

He scarce had spoke, when out the night
　A bold bad man stepped spryly.
"Hands up!" he said, "And don't show fight;
　This ain't no bloody baile!"

Always a gentleman and true,
　Buck Dunton raised his hat;
But when the man said "Goddamn you!"
　Buck Dunton raised his gat.

"Gimme your money, or I'll shoot!"
　The man spoke not in fun,
For he was out for golden loot,
　And didn't see Buck's gun.

Buck groaned again, but took his aim
　Straight at the bandit's heart;
And 'though he staggered and was lame,
　He knew his hero part.

Buck shot him once, he shot him twice,
 He said, "You dirty toad!"
The bandit fell and wriggled thrice,
 Then laid there in the road.

A rancher nearby heard the fray;
 He rescued Dunton quick,
And took them both to Santa Fe,
 For Herbert sure was sick.

As for the villain, he was too,
 With a bullet in his mug.
The prison doctor pulled him through,
 But left him in the jug.

Now Buck lies quiet in his cot
 At old St Vincent San.
They operated. —And we've still got
 Our Cowboy Painter Man!

Again, unlike the other members of the TSA, Buck was not interested in the local Indians and Spanish settlements. His first studio was right downtown, but he would spend days or weeks camping miles from Taos, creating paintings of cowboys on the open range and of life in the West. The few Indian paintings he made were romanticized images about which he was not particularly enthusiastic. He felt that he had perhaps twenty-five years to capture the transition from Indian land to white settlements, so he worked as quickly and intensely as he could.

The paintings he did create which related to Indians had detailed stories behind the conception. Typical of these was *The Buffalo Signal* exhibited at the Art Institute of Chicago in 1915, then, four years later, at the Pennsylvania Academy of Fine Arts. He wrote an article to explain what the painting was about:

> *This canvas is "laid" anywhere between 1830 and 1860. Note that the bucks are armed with bows, arrows and shields, save one who possesses a flint-lock.*
>
> *The Indians represented are "Crows." On occa-*

sions of an impending battle or such an important event as an annual buffalo hunt, the "plains" or "horse" tribes (such as Crows, Sioux, Blackfeet, Cheyennes, Utes, etc.) strip to breechclout and moccasins—even stripping their ponies down to 'jaw rope' before going into a fight or buffalo running.

. . . In the canvas represented—"The Buffalo Signal"—the moment illustrated represents a group of young, restless Crow bucks, who have ridden ahead of the village, not unlike scouts, paused on the crest of a sagebrush hill gazing into the little valley beyond, where they behold the first buffalo sighted—a few perhaps, but the "fringe" of the herd. The Buck on the sorrel horse (an American horse, not an Indian pony, captured or run off in a surprise attack before dawn on some Cavalry or Dragoon command, or the mount of some unfortunate cavalryman killed in battle), has removed from beneath him an elk skin blanket and is signalling (wigwagging) with it (a signal agreed upon) to the traveling village that the buffalo have been sighted. Another Indian is seen half turned on his horse—pouring powder from his horn into the "pan" of his rifle (priming it) preparatory to "running" the buffalo. The balance of the group—their gaze is riveted on the buffalo, below and beyond them.

More typical of Dunton's work was his painting of the elderly Zenith Curtis, a man who lived on the Niles Ranch a few miles from Taos. Curtis and Dunton were friends who both longed for the old days of the West when Zenith had been a part of the massive ranches and extensive cattle drives. Buck decided to paint this friend who was living history, choosing a late afternoon sun that was rich in rose and violet. The painting shows Curtis astride his horse, looking over a herd of cattle in the valley, the mountains in the background. It was large and impressive and almost sold for what was then a small fortune. He considered it one of his most important works.

Dunton liked to joke about the Curtis painting, entitled *The Cattle Buyer,* because a patron died trying to buy it. *The Cattle Buyer* was on display in the Don Fernando Hotel in Taos. Despite Blumenschein's attempts to create the image of a Taos with danger on every street corner, the Don Fernando was internationally known, a frequent home for kings, queens, and other visiting heads of state. In addition, there was a major art gallery on the mezzanine floor where many artists went to sell their work.

The Cattle Buyer was displayed at the head of the stairs, in full view of everyone, a fact that annoyed the other artists and delighted Dunton. Although the members of the TSA supposedly worked together, they were all constantly on the alert for a wealthy patron. Each of them wanted to be the first to know what influential person might be staying as a guest; each would arrange to intercept the person, taking him to his studio to try and sell only his own work.

When Dunton wasn't working, he would frequently drop by the hotel to watch for a wealthy Texas buyer. He dressed like a cowboy, always conveying the image of a simple man of the people who happened to paint. He thought it was expected of him, going so far as to wear rather elaborate western wear under his painter's smock, removing the smock when someone knocked at his door.

The wealthy Texas buyer actually appeared, fell in love with the painting, and arranged to have dinner with Dunton at the Don Fernando to buy it. The Texan asked the price. Dunton informed him that it was $20,000, and the Texan was delighted that he would not have to pay more. The fact that, at the time, the price was approximately six years' income for the average working man in America meant nothing to the Texan, and Dunton knew he had made his biggest sale ever.

Dunton wanted to grab the money and run, but he did not feel that that would be right for his image. Instead, he magnanimously suggested that the Texan put away his checkbook and not bother with so petty a detail as cash until the morning when the painting would be removed from the wall and delivered to the buyer's hotel room.

Buck failed to understand that the Texan had a serious

heart condition. Taos had great beauty, but it also had great altitude. It was 7,000 feet above sea level, a height where the air is thinner and normal activities are more difficult. Some people adapt. Some people are never comfortable. And some people develop one problem or another as a result of the thin air. Among these problems are heart attacks, which this man promptly suffered in his sleep. His corpse was found the next morning, and Dunton was out the $20,000 that would have been charged against the estate had he accepted the check as the man desired him to do.

Taos became the Duntons' permanent home in spring 1915, the year the first meeting of the TSA took place in the home of T. P. Martin, a local doctor. This was before the gallery was built in the Don Fernando Hotel, so the primary interest was in gaining traveling exhibitions of the work the men were producing. By the following year's meeting, arrangements had been made for TSA members to display their work on the Taos plaza. Later they would extend invitation rights to other artists they respected, such as Victor Higgins and Walter Ufer, men who would not become members of the TSA until a few years later.

And so, with Dunton, Blumenschein, Sharp, Berninghaus, Phillips, and Couse, the Society was complete for the first couple of years. Bits and pieces of the by-laws have been quoted over the years, by Helen Blumenschein, among others, and these are now in the Santa Fe Museum of Fine Arts Archives. The Constitution stated, in part, "This Society is formed for educational purposes, to develop a high standard of art among its members, and to aid in the diffusion of taste for art in general. To promote and stimulate the practical expressions of art—to preserve and promote the native art. . . .To facilitate bringing before the public through exhibitions and other means, tangible results of the work of its members—to promote, maintain and preserve high standards of excellence in painting, and to encourage sculpture, architecture, applied arts, music, literature, ethnology and archaeology, solely as it pertains to New Mexico and the states adjoining."

Yet with all the noble-sounding statements, the truth was that the TSA was organized to make money for its

members. What none of them expected was that by 1917, their main concern would be creating paintings to be used for machine-gun target practice.

DON'T SHOOT 'TILL YOU SEE THEIR CERULEAN BLUE

I t was the war to end all wars. The Huns (Germans) were trying to dominate the world, and the United States was joining with Britain and France to restore peace and sanity throughout the globe. And even the artists busily painting the West, too old to go to war, felt they had to get involved.

The Great War had been a way of life in Europe since 1915, although Americans held it in disdain. One of the most popular songs of that year was "I Didn't Raise My Boy to be a Soldier." Europeans had the right to die in their own territory without the United States becoming involved, although there was the unspoken hint that if we ever should become involved, "watch out!"

In truth, America was involved with the war as early as July 24, 1915, when the U.S. Secret Service obtained a briefcase from Dr. Heinrich Albert, a German agent operating in the United States. He had a $28 million budget to finance sabotage against the United States as well as propaganda efforts meant to make Americans pro-German. The orders seemed contradictory, but then this was not a war for which anyone was truly ready.

On April 2, 1917, President Woodrow Wilson announced that the United States was in a state of war against Ger-

many. "We have no selfish ends to serve. We desire no con-
quest, no dominion. We seek no indemnities . . . no material
compensation."

We also had no army. There were 208,304 soldiers in the
service, all of them undertrained and inexperienced. There
were also 130 pilots to fly 55 airplanes that were barely fit
for flying, even by the crude standards of those early days
of aviation. New infantry recruits grabbed broomsticks or
tree branches that they whittled into roughly shaped
"guns," practicing marching and fighting with their
weapons, "shooting" imaginary bullets until France and
Britain could sell the army ammunition and rifles could be
acquired. The cavalry had an easier time. They took bar-
rels, mounted them on sticks, then "rode" off into the sun-
set, much like little boys astride rocking horses racing over
the hills and valleys of their imaginations.

Those early days of America's involvement took on a
surreal image. On Sundays, the main streets of large cities
were filled with horse-drawn automobiles in an effort to
conserve gasoline. Whale meat was used in place of beef.
Mondays were designated as a day when coal would not be
used for heating. Victory gardens were planted every-
where, and even elderly men and women began taking fit-
ness lessons, learning to shoot whatever weapons became
available and generally preparing to defend the nation
against invasion.

Not that anyone had to worry. There were too many
women involved with groups such as the American
Women's League for Self-Defense running around the
countryside for any self-respecting Hun to invade our soil.
Yet strangely, in what seems a parody of real violence,
Americans pulled together in a manner at once united and
intensely vicious. People began looking for spies every-
where, often taking violent action against anyone who
seemed to be dangerous. The Committee on Public Infor-
mation, for example, commissioned posters that stated,

SPIES AND LIES

German agents are everywhere, eager to gather
scraps of news about our men, our ships, our mun-
itions. It is still possible to get such information

through to Germany, where thousands of these fragments—often individually harmless—are patiently pieced together into a whole which spells death to American soldiers and danger to American homes. . . .

Do not become a tool of the Hun by passing on the malicious, disheartening rumors which he so eagerly sows. Remember he asks no better service than to have you spread his lies of disasters to our soldiers and sailors, gross scandals in the Red Cross, cruelties, neglect and wholesale executions in our camps, drunkenness and vice in the Expeditionary Force, and other tales certain to disturb American patriots and to bring anxiety and grief to American parents.

And do not wait until you catch someone putting a bomb under a factory. Report the man who spreads pessimistic stories, divulges—or seeks—confidential military information, cries for peace, or belittles our efforts to win the war.

Send the names of such persons, even if they are in uniform, to the Department of Justice, Washington. Give all the details you can, with names of witnesses if possible—show the Hun that we can beat him at his own game of collecting scattered information and putting it to work. The fact that you made the report will not become public. . . .

It was a matter of national pride to prove yourself "100 percent American." Stereotypes abounded, and racism seemed to dominate the land. Jews were seen as revolutionaries without patriotic feelings for any country. Anyone with an obviously European name was suspect. The movie industry depicted Germans as torturers, sadists, and rapists of children. Pretzels were banned in Cincinnati because they were of German origin, and no one caught German measles during that period. Instead, they suffered from liberty measles.

Artists felt they had to contribute to the cause. Charles Dana Gibson turned his attention to the creation of post-

ers meant to nurture America's fighting spirit and sense of selfless sacrifice. Newspaper articles circulated about other artists who went to work in war plants, using their trained eyes for such tasks as inspecting gas mask parts.

And in Taos, Ernest Blumenschein felt that the Taos Society of Artists should do their part—by creating paintings for target practice called range finders. The targets were used to train recruits indoors in the rudiments of rifle and machine-gun fire, and later to instruct the soldiers in tactics and strategy. It was an effort with which he was already involved through his New York connection with the Salmagundi Club.

Blumenschein's involvement with the war effort actually began much earlier. It seems to have started as a result of a combination of desires—to help his country and to gain broader personal recognition. He supplied drawings for a newspaper called *The War Saver* published by the National War Savings Committee, a division of the U.S. Treasury Department. The newspaper was meant to encourage the public to save everything necessary for the war effort, from money and fuel to food, labor, and materials. Blumenschein provided pictures meant to support this effort.

M. L. Blumenthal, head of the committee, wrote on July 27, 1918, "It will be of real assistance if you will incorporate in your illustrations, drawings of the different posters for War Savings Stamps, Food, Fuel, etc. etc. wherever an opportunity offers; as, for instance, in your outdoor scenes, in pictures of club interiors, public meeting places and wherever else pictures of posters would fit naturally."

The series of paintings begun by members of the Salmagundi Club were nonspecific scenics called "range finder paintings." Blumenschein acted as coordinator of the effort, taking the issue to Taos as well.

In a form letter dated September 16, 1918, Blumenschein explained the situation to the members of various art clubs that might participate:

You have no doubt heard of the "range finder"
pictures which the Salmagundi Club artists are

163

providing for the army.

These paintings are used in the army camps for the instruction of the machine gun and musketry departments and have proved to be such a great help that we want your club of artists to get interested in this patriotic work. I have been appointed Special Representative of the War Service Committee of the Salmagundi Club—a sort of promoter—as I have had practical experience this summer in Taos in arranging for and directing the painting of about twenty "Range finders". I write of this experience to assist you in organizing, if your club should be generous enough with its talents to help our soldiers.

Our Taos artists were sluggish in the matter of giving time for a work not then recognized as so very essential, and after three months had passed with only one picture turned in, we carried out the following scheme:

We secured a large studio for two weeks; then wrote a personal letter to each painter asking him to pledge himself to work for two half-days a week for two weeks, either at this studio or at his own. A definite date was set by which all pictures must be completed. We provided house paint and decorative oil colors, turpentine, eight stretchers, a cheap cotton canvas and four or five easels. We had at hand a number of newspaper supplements and magazines containing photos of French landscapes.

The artists were not all enthusiastic but half of our colony volunteered for the painting and were allotted their working days. Once the work was begun it proved pleasant and interesting. Things sailed along nicely, and at the end of two weeks we had nearly twenty canvases, some of them excellent paintings. They were all thinly painted, but well defined in detail in the middle distance.

The range finder paintings were sent to Camp Cody and Camp Funston. The artists were not sure the paintings

were really of much practical use, but eventually all doubts were dispelled by the following letter dated September 10, 1918, from Camp Funston headquarters:

> *My dear Sir:*
> *I have today received the following official statement from Capt. Bert C. Calvin who is in command of the 28th Machine Gun Battalion at Camp Funston:*
> *It is absolutely essential that machine gun organizations be furnished these landscape paintings as they are very necessary in target designation, etc., and machine gun units cannot afford to be without them. They are necessary for proper instruction of men. It is recommended that all machine gun organizations be furnished with same as soon as practicable.*
> *I know this will be interesting to you and to members of your organization.*
> *Sincerely,*
> *(Signed) R. A. OSMUN*
> *Capt. Coast Artillery Corps,*
> *Aide de Camp*

General Leonard Wood also wrote to Blumenschein, saying his machine gunners were "very keen" on the range finders and that the artists' efforts had not been in vain. This artist involvement was not unique. British artists had participated in a similar effort, and Americans had originally attempted to use lithographs. The decision to use painters was one developed by Mrs. H. Van Buren Magonigle, the chairman of the Woman's Branch of the Art War-Relief, who was familiar with the British endeavor. As reporter William Forrest wrote in the New York *Evening Post,*

> *How well they succeeded can best be judged by the pictures themselves. They have delighted the officers and the men who have seen them, and it is predicted that they will play a very important part in the training of our soldiers in the rudiments of war.*

They will be used in teaching the men to observe closely the country in which they are fighting, as range-finding charts or landscape targets, and in working out problems of offense and defense. They visualize accurately great sections of country such as the American troops will be called upon to fight in. The need of such charts or pictures is due to the fact that many of the training-camps are situated in flat country which offers no opportunity to study terrane [sic] such as that over which the troops will fight in France.

A majority of the men have never been taught to observe the conformations of the land, and it is very difficult to instruct them by means of the ordinary military map. Recently a non-commissioned officer's class was taken into a room in which a picture similar to those we have just contributed was hung, and the men were told to study the picture carefully, as they were to be questioned on it later. Then they were taken into another room and one of the men was asked what was the most distinctive thing in the foreground of the picture. "The sky," he replied.

After they have been taught to pick out the distinctive features of the landscape they are given problems to work out in defense and offense, using the pictures instead of maps. They are instructed how to take up positions in order to ward off an attack from a certain point, how to pick out the open spaces over which attacking troops will have to advance, and how to find the range of those open spaces. To the machine gunners especially this training is of great value.

The men are put to work on problems in offense also. The pictures are much more realistic than maps, on which the hills and valleys are simply indicated by contour lines, and the men take to them more readily.

The pictures will be used for subtarget practice by the machine gunners. This sort of practice is

*especially important in the training of machine
gunners, as their accuracy in judging ranges is of
utmost importance in stopping enemy attacks.*

The quality of the work was high, and the servicemen
delighted in the paintings, requesting that they be hung in
the mess halls when they were not used for classroom exer-
cises or being shot by the machine gunners.

Blumenschein ultimately became overzealous in his
work for the military, alienating friends in the art world. He
wrote a letter to the *American Art News* in which he criti-
cized the TSA for not embracing more enthusiastically the
range finder painting project. The letter was completely
improper, because there was intense participation by all
the artists. Because of his insecurities and tendencies to
endlessly overpaint his own work, Blumenschein routinely
produced fewer paintings for exhibition than the others.
When he added the war work and his own range finders,
the result was that the TSA traveling exhibition for 1918
contained only one Blumenschein painting. There were
none others to be had, though his fellow members all had
two or more because they tended to work faster and use
their time more effectively. Blumenschein's *Portrait of Albe-
dia* was popular, but his jealousy of the others caused him
to charge that their personal productivity was the result of
being less patriotic than he was.

When the war ended on November 11, 1918, the issue of
the range finders was moot. Yet the letter he had written
left Blumenschein with bad relationships with his fellow
artists. And it would be several months before they fully
accepted him again as a friend.

Despite the problems with the TSA members, the end
of the war marked what were probably the happiest years
of Blumenschein's life. He was respected for his volunteer
efforts on behalf of the military. His work was selling well.
And he was enjoying his tennis, bridge, afternoon tea, and
baseball in the midst of the "primitive" life of the Taos
Pueblo.

TAOS SOCIETY OF ARTISTS—THE LAST OF THE GOOD YEARS

In the last years of the war and immediately after, the Taos Society of Artists enjoyed increased financial success and popular recognition. In 1916 they exhibited in Boulder, Colorado, and Santa Fe and Las Vegas, New Mexico. Secretary Bert Phillips also noted in the annual report for that year that "both the Denver & Rio Grande and the Santa Fe Railway systems have extensively advertised the work of our members and I believe some appreciation of their efforts are due the officials who are responsible for this valuable assistance."

But there were problems amidst the success. Phillips went on to note, "The growing reputation of the Society and the increasing demands for its usefulness at home and abroad should encourage us to realize that no effort is wasted which we can employ to its advancement; I would like to say right here in connection with this that I feel that we are not all pulling together as well as we should; that there seems to be an apathy among the members and a feeling that the Secretary must supply the initiative."

In the secretary's report for 1917, Phillips provided an overview of the war years and prospects for the future:

Looking back over the three years since the Taos Society of Artists was organized we are greatly encouraged by the success already achieved in spite of the fact that a great world war has raged during that time and that our own country has been taking part in it for over a year.

Our two circuit exhibitions now united at Colorado Springs have visited the cities of New York, Boston, Chicago, St. Louis, Des Moines, Denver, Santa Fe, Los Angeles, Pasadena & Salt Lake City.

Our pictures have met with no little appreciation from thousands of people and a great deal of advertising matter has been printed and circulated until it would be difficult to find a person in the whole country making any pretention to being posted in art matters who has not heard of Taos and the "Taos Artists." Several sales have been made in the exhibition and we feel that had the world been at peace the number would have been more than doubled so we look forward to the time when a very substantial reward will be the outcome of our efforts to keep the name of the organization before the public. In the year before us our efforts may be attended with greater difficulties but that is all the more reason why we should put forth our best endeavors.

But there were some other concerns during the war years and immediately after. The primary one was financial. Galleries in Santa Fe were publishing the prices of the paintings, prices that then became public knowledge. Among those learning the income of the artists were the Indians, who suddenly had a different understanding of the business of art. Instead of being helpful to some nice white men engaged in a rather odd profession, they suddenly saw themselves as valuable parts of a profitable enterprise. They wanted their share.

Irving Couse was the president of the Taos Society of Artists in 1917 and sent a letter to one of the gallery owners, explaining the problem:

> *A clipping from the Santa Fe N. Mexican was sent me containing an article on the coming exhibition of the Taos Soc. of Artists in which values & prices of certain of the paintings were published.*
>
> *During the past couple of years, we at Taos have been experiencing difficulties in getting models owing to the belief among the Indians that we get huge prices for our pictures in which they should at least get half. The established rate for models is 25 cts per hour which is more than twice as much as the Indians can make in other work. My models last summer told me that there was scarcely a painter at the Pueblo but what the question was brought up & we are fearful lest the indians be prohibited from posing for the artists. I firmly believe they get their ideas from the indians who can read english & from similar articles to the above mentioned. Last summer our secretary Mr. Phillips was instructed by our society to write you a letter requesting you where possible to avoid having prices published. I do not know if you received such a letter. If not & providing the articles emanate from your office I hope you will see the wisdom of our request as I firmly believe that unless these impressions are nipped in the bud the whole future of the St. Fe Taos Art movement will be seriously handicapped & that the artist will be compelled to go elsewhere for models.*

Couse was especially nervous because he had already experienced one "revolt" by an Indian whom he had been commissioned to paint. This occurred years earlier, in 1908, when the Detroit Museum asked him to paint the Chippewa chief, Shappanagons. Couse would not get any money if he did not paint the chief, and the chief knew the economics of the business well enough to recognize that he had control over the relationship with Couse. As Couse later explained, Shappanagons "is a shrewd old fellow and a great character out there. At first he was unwilling to pose. Then he heard how much I was to get for his portrait and he offered to pose if I would give him half. Finally we

compromised on five dollars a sitting. I wanted him without his shirt. That he refused to do. It was not modest and would make the young ladies ashamed. So he wears his own costume, which includes the banded leggins that are a feature of his tribe."

The other major event of the time was the arrival of Robert Evien of Santa Fe. He was a pioneer cinematographer who during 1918 made a film of each of the TSA artists at work. A copy of the film was given to the TSA instead of payment, the artists using the film to accompany their exhibitions and increase interest in their work. This was so successful that requests for exhibitions came from more cities than they could handle in the course of a year.

During this period, Blumenschein finally gained the economic freedom he had long been seeking—not from his own work but from his wife's good fortune. Mary Blumenschein's mother died in 1917, leaving her daughter with both a cash inheritance and a brownstone house in Brooklyn. The couple immediately moved out of their apartment into the house where they would stay for the next two years.

Money no longer being critical to maintain basic living expenses, Blumenschein began spending an increasing amount of time in Taos. He was anxious for Mary and Helen to join him, but Mary was extremely reluctant. Their interests were radically different, and each had difficulty convincing the other of their personal needs.

At one point Blumenschein wrote to his wife:

> _I really can't understand why people want to live so many months a year in houses and cities. This great western country is so inspiring, makes your thoughts along large lines, and your life full of joy. You are living, sharing a thankful existence with all of nature, while out-of-doors in the deserts and mountains under a great sky. There is no gloom.... I've always thought of you and wished for you to share my happiness of this fascinating out-of-doors in a great country. You haven't yet shared these with me in many years; still I go on,_

*associating you with my hopes and pleasure.
"C'est droll, L'amour!" But I don't seem able to
avoid it, so I'll go on hoping, and one day it may
come true that you can be congenial with my
great joys. "Je t'adore toujours."*

Mary understood what Blumenschein was trying to tell
her. However, she felt that Helen would be deprived by leav-
ing the cultural stimulation of the East. She wrote, "I
appreciate the regret with which you leave Taos, 'Ville
d'Amour' with its nature and lack of responsibility. But
Helen and I get a lot out of the East. You will find her much
improved, I think. The change—the training of her mind,
and the food do much for her. One realizes it more each
year, and that added to her life will be quite wonderful."

Blumenschein seemed to realize that the strain
between himself and Mary was quite serious. He would not
leave Taos or alter his life-style for his wife, yet he did not
want to lose her. He expressed sensitivity to her past frus-
trations and began encouraging her to paint once again.
He seemed to feel that if she did the work that had once
made her so happy, work for which she was suited by tem-
perament, talent, and training, she might regain some of
the happiness she had lost. More important, he might be
able to convince her that Taos was the better place for her
to work.

His letters also reflect more emotion concerning Mary
than he had expressed in the past. He wrote,

*I evidently have to be away from you to really
appreciate what a grand sweetheart you are. You
sure are bathed in glory! It's not a false impression
either, for it sort of epitomized all your splendid
values that have been sown during our thirteen
years of life together. You've been pretty fine. . . . In
fact, I have suspicion that I might have been
improved on in many delicate situations that
required a less primitive nature than my crude
one. . . and here I am still threshing out the chaff
from the wheat, in the effort to find out "wasze-
matterwisme"! You really should have married a*

> *great big fine noble gent with great dignity, finesse,
> and fine linen . . . but as you didn't, I have had the
> agreeable pleasure of being your husband. . . .*
>
> *You've been a good consistent character—the
> kind a fellow respects. . . . You've added to the dig-
> nity of my name by your capable artwork; you've
> decorated the home with a "charmante petite
> fille"; you are the class of lady a man is always
> proud to show off as "his'n"; and you are a pleas-
> ing sight for the eye to rest upon. And I love you; for
> what you've been and what you are.*

The letter was almost a caricature of Blumenschein, a
man who had traveled the world and been far better edu-
cated than his impression of a cowboy artist seems to give.
He was never so simple as he tried to appear, which he did
probably in an effort to talk like "the boys" of Taos, though
Buck Dunton was the only real cowboy among them. Still,
despite a writing style that is far removed from the more
sophisticated writing of his youth, the effort to express
emotions in words was a major one for Blumenschein, and
Mary realized it. Her response is filled with emotion: "Life
is worth living to have such a good message from my hus-
band. It made me young, beautiful, talented, and every-
thing desirable all at once. I sat and beamed until Helen
wanted to know what I was smiling about. In fact I kept on
dreaming all day. . . . I am so glad you are mine and I am
yours."

Blumenschein's efforts to have his family move perma-
nently to Taos succeeded in 1919. The letters served as a
second courtship for the couple. There were hints of the
closeness that had brought them together in Paris, and
Mary was willing to make a sacrifice to again be the cou-
ple they had started out to be.

There were a few restrictions, though. She would sell
the brownstone she had inherited only if he would buy a
real house for the family in Taos. He readily agreed, then
tried to entice her to come immediately, though she
wanted to wait until June to put her affairs in order.

Blumenschein argued with what proved to be an un-
changeable decision. He wanted her to come down because

he would buy a car, the first the couple had ever owned, and take them on an automobile camping trip, a new craze sweeping the country as more and more people bought cars. He would show them New Mexico and Arizona as he had come to know them, certain that they would love the experience. Unfortunately, no change was possible, and Blumenschein was on his own until June.

The car was purchased from the Ford Motor Company in March 1919. Blumenschein spared no expense, adding so many modifications that the price increased by 50 percent, and the car company, delighted with so expensive a sale, sent a man to both deliver the car and teach Blumenschein how to drive it.

Among the modifications was the addition of a large box hinged to the rear to hold clothing for camping. The seats were cut, then hinged so that they could be used for sleeping when it was raining. In essence, he created a custom camper and holding facility for his artist's equipment, naming the vehicle "Michelangelo" and spending $728 for the privilege. Too excited to wait for Mary and Helen to try his new toy, Blumenschein and Bert Phillips took a camping trip to northern Arizona's Painted Desert.

Yet even in the joy of renewed love between Blumenschein and Mary, there was a hint of the attitude that kept an undercurrent of tension in the family. To Mary he wrote, "I love you to distraction—at times, and normally at times." But in an April 4 postcard to "Bill Blumenschein," he reminded his ten-year-old daughter, Helen, that when the family went on a trip together after their arrival, "I want a boy this summer." He signed her card, "With love, Ernest," and those who knew the child felt that those last weeks in New York would also mark the end of the greatest happiness she would know as a child.

The house Blumenschein purchased was actually bought in stages. The nine-room structure on Ledoux Street was owned by several people, including Buck Dunton, who sold Blumenschein his four rooms. It was a well-built structure first constructed in 1797 and considered a historic landmark. In addition to Dunton, the occupants included a salesman who sold liquor to the Indians, a handyman named Epimenio Tenorio, and a family named

Cocas about whom little was known. Each time someone died or moved away, Blumenschein bought their section until, twelve years later, the entire structure was his. At that point he remodeled, moving a fireplace, knocking out doors, adding two bathrooms and a kitchen, and studios for both Mary and Helen.

The house was both magnificent and a nightmare. The entire Taos Valley formed their southern exposure, a view uninterrupted by any development. Mary furnished the home with materials gathered both in Europe and the East, as well as pieces obtained from Henry Sharp and some of the Hispanic craftsmen who made furniture from local woods such as white pine. However, the lack of electricity, plumbing, and telephones was a problem. Helen was keenly aware of the difference between the comfortable New York brownstone and her frequent trips to her Taos home's outhouse when the temperature dropped to minus 10 degrees F.

Bathing during the cold weather months was generally a weekly experience. Only one family owned an indoor bathtub, though some of the homes had portable generators so they could have electricity. However, the artists paid 50 cents each once a week to rent a single room at the Don Fernando Hotel where plumbing was considered a necessity for the guests. Then each artist and every member of their families would take turns throughout the day, luxuriating in the bathtub filled with hot water.

There were other adjustments for Mary and Helen. The roof of the house had to be kept clear of snow to avoid leaks that would put out the fires in the fireplaces. Then, in the spring, the snow would thaw and the road would turn to mud. Pavement was not a consideration until the 1930s.

Life was not all bad, though. Helen later wrote a small book entitled _Recuerdos_ in which she said of the better aspects of Taos living:

> _The church bell awakened us at 6:30 a.m. everyday and kept us informed of marriages and deaths. Once a week, Mr. Struck of Ranchos de Taos, four miles away, came to our door in his buggy laden with fresh vegetables and, in the fall,_

melons and apples. Milk was delivered from a brand new dairy from the Prettner's, meat came from the corner butcher, tough as could be. Fresh spring water was carried in an old barrel from the Taos Canyon and hauled in a decrepit wagon by Mr. Leatherman. Our well water, pulled up twenty feet by hand in a bucket, turned out to be sanitary, but we weren't sure then.

Who can forget the hunting and fishing 'in the good old days'? Wild turkeys in large flocks, fishing for cutthroats in any one of the six rivers flowing into the valley.

Twenty-five was the daily limit! Cottontail rabbits for a weekly stew, or, if fried, they were even better than chicken. Wild plum jelly from our local bushes, not to mention some wild raspberries in August, if you knew where to go. Deer could be found anywhere but most of the Spanish-Americans preferred their own lamb and beef raised in their pastures. Politics and fiestas were the entertainment of most of the natives. Going to church was a way of life for the 99% Catholic majority. We felt with our hearts in those days. People, animals, nature, your family were all important. Your many primos [cousins] were always dropping by. Families were interrelated in this small community isolated for so many centuries by the mountains and the Rio del Norte. It created friction, too. I do not want to leave you with the feeling that everything was idyllic—it wasn't. Everyone had to be self-sufficient, and that was not easy in a climate that went to extremes of drought and cold. In the twenties, the nearest train was only 25 miles away, but what a ride to get to it!

The latter comment about the train had to do with the man who represented the only link with the railroad stop—Long John Dunn. He owned a buckboard and mules, taking passengers from Santa Fe to Taos and back. He had been working since before the turn of the century, at first driving the rig 75 miles each way. Later, when the railroad

route went to Tres Piedras, the trip to Santa Fe was reduced by two-thirds. Yet the road was so bad, including a slow, rather dangerous descent into the Rio Grande Gorge to the halfway house owned by Dunn, that it took two days to travel that 25 miles.

Dunn had a gallows humor about the trip. He was accustomed to it, his rig well trained, his wagon held together as well as possible. Yet when everyone, including himself, was nervously watching as the wagon moved along the road, the wheels literally inches from the dangerous cliff edge, he would comment, "In winter, when the ice is on, the road is really dangerous."

The arrival of the Model-T Ford made the trip faster, but it could not improve the quality of the roads or the potential for danger that they offered. One visitor, Sarah Olden, commented about the modern ride in the new Ford:

> The roads. . .were worse than usual on account of the washouts caused by the unusual and enormous downpours of rain. . . .Sometimes we were dashed swiftly along through deep sand and ruts; again we were bumped high and low over rough shoulders of rock, especially as we wound out and in and down and up through the Rio Grande Canyon. Here we were plunged into sudden gullies, or went coasting along "the ragged edge of nothing," or were dragged. . .up precipitous ascents which almost caused the engine to puff and blow its last. We felt that at any moment we might be rushing backward with terrific force and dashing over the straight walls of yellow and black basalt into eternity below. In spite of it all there was the glory of the mighty gorge, through which, hundreds of feet beneath us, the yellow river was splatter-dashing and foaming on its bewildering way.

Dunn also used a Model-T, but he found that there was a serious problem with it. The gasoline tank was in front of the car, which created balance and handling problems when driving up the steep gorge. He frequently had to turn the car around and drive up the hill in reverse. This so ter-

rified the passengers that most of them got out and walked behind or ahead of Dunn until he had negotiated this most dangerous of segments of the trip.

Although Mary and Helen made Taos their permanent home beginning in 1919, Mary was determined that their daughter's education would not suffer by the isolation. She insisted on returning to New York each fall until Helen was through with her education.

Blumenschein was furious. He did not care about "Bill's" going to some fancy school. His wife had agreed to make Taos her home and he had purchased a house in which she could live. The idea that Helen could not gain the basics in Taos was ridiculous. He did not care about the opportunities of the East. He wanted to live in Taos, and a wife should do whatever her husband wanted.

The longer the separations took place, the more stubborn Blumenschein became and the more the closeness they had started to rediscover was shattered. The precarious relationship was being destroyed, most of their acquaintances now seeing Blumenschein as the primary cause of the problems.

WALTER UFER AND VICTOR HIGGINS

It was while the conflict was taking place between Blumenschein and his wife that two more artists were added to the membership of the Taos Society—Walter Ufer and Victor Higgins. They were radically different from each other: Higgins was typical of most of the members of the TSA, while Ufer brought the first hint of social conscience to the area. Yet the differences were oddly appropriate in this postwar period. The relationships among the members of the TSA were changing radically, and the addition of two men so opposite in personality seemed appropriate.

There was a truth about the Taos Pueblo, a truth no one wanted to address until Walter Ufer discovered the area. It was not a place of historic importance, not in the manner that Blumenschein liked to romanticize. It was not a more accurate reflection of early Native American life than other parts of the country. It was a prison for the Indians, a created world where life could be lived only within the

confines allowed by the white man. The freedom that had been a part of the native tradition for centuries had been cut off. The people were servants, forced to adapt to the most menial aspects of a world they had never desired.

Ufer loved the land and sensed what once had been. The Taos Valley was "God's country!" The richness of the land made it an artist's paradise. But only a white artist. And only at the expense of the Indians and Spanish Americans who had been forced to change their ways in order for men like himself to move freely.

Ufer arrived in Taos in 1914. He had never before been to the area, yet unlike the pioneers among the TSA members, he had the ability to distance himself from his emotions. He looked beyond the excitement of a new world to conquer on canvas and began studying the culture of the people. He saw that the Indians were living in two distinctly different ways in the Pueblo and the village. He also discovered that the natural course of their lives had, for centuries, involved only two concerns—the seasons for growing corn and the reciting of prayers to ensure the continuing good health of those who lived there. They were people educated in the land, the seasons, the necessities of survival. They were not prepared for the urban life-style that confronted them when the white man dominated New Mexico.

Couse had expressed concern about the prices for the paintings being reported in the press, since he was trying to keep the modeling fees for Indians at 25 cents an hour. He was concerned with keeping the cost of painting as low as possible to assure a substantial profit for the artists. But the action was exploitative, a fact of which Ufer was keenly aware.

Ufer also understood that the assimilation of the Indian was more in the fantasy of the white man than in reality. For example, the natives in Taos were Catholic, having been exposed to Spanish missionaries for 300 years. Yet instead of understanding the religion and then embracing it as the answer to spiritual longing, they took those portions that were magical and incorporated them into their history. Taken without the historic and theological understanding of those who studied Bible and human history,

179

the basic story presented by the Catholic missionaries seemed similar to their own teachings. Here was a God who came to earth as a man, performed magical healings, then rose into heaven because efforts to kill him were futile. The story was similar to the pagan teachings of Sun Worshipers. Thus, the ceremonies were a mix of Catholic teachings, the Eagle Dance, the Corn Dance, and other traditional parts of their culture.

The paintings Ufer created primarily showed the results of the impact of the white man on the Indian. Instead of painting the charming images so in demand by collectors and businesses like the Santa Fe Railroad, he showed the Indians as servants for the whites. He painted the Indians as auto mechanics (*Bob Abbott and His Assistant*), waiters and waitresses (*Luncheon at Lone Locust*), and as poverty-stricken people barely able to have enough to eat (*In the Land of Mañana* and *Hunger*). He had the social conscience of an anarchist, joined the International Workers of the World, and was a follower of Trotsky. He was the only member of the TSA to walk a picket line and to be jailed in New Mexico for being part of a protest.

Ufer was more than a rebel, though. He lived his activism in ways that made even Phillips seem to be just an observer of life. For example, when the Taos Pueblo was stricken with an influenza epidemic, which was causing many thousands of deaths throughout the United States, only Dr. T. P. Martin, Phillips's brother-in-law, initially fought to save lives. Both Ufer and his wife joined in and worked literally to exhaustion.

Harriet Andrews of the Kansas City *Post* wrote one of the best descriptions of Ufer in her article "Society of a Mud Salon," which appeared on February 13, 1916.

> *We saw him first painting in the alley. He had three models posing for him, but then, as always, he was willing to stop and talk, using his brush to gesture with. You would know he was an artist merely by the shape of his hands, supple, expressive hands, and that he was an outdoor artist by their color, the right one tanned, the left bleached all except the thumb, which was brown to the base,*

where it had been thrust through the palette.

He catapulted in to see us one night and stayed till nearly 12 o'clock and after that, he came nearly every evening. We talked and talked, war, politics, life and art in Dresden and Munich and Paris, the brush work of Sargent and Story and James Montgomery Flagg, the comparative literary merits of B. Shaw and H. G. Wells. He is vivid, emphatic, dramatic, characterizing and settling a disputed question once and for all merely by uplifted eyelids and expressive lips, annihilating an argument with one denunciatory gesture, holding his head with both hands to keep it from bursting with the explosion of what he is about to say. We loved to have him talk of his student days in Dresden. . . . His poverty stories were delicious. . . .

"I did not like to eat the crusts of breads," he told us reminiscently. "But I had to learn to be saving. I had a tin box, and I put all my crusts into that. As long as I had money, the crusts stayed there and moulded. Sometimes the mould would be half an inch thick before I took them out. When all my money was gone, I would cut off the mould and soak the crusts in boiling water and eat them. But more than once, I went as much as four days without food."

He worked. How he must have worked to learn to paint the way he does now. He respects work for its own sake and detests insincere dabblers in art. He came back to America sure of his own ability and full of ideals and young enthusiasm. But his ideals received a severe jolt. . . . He is wonderfully and truly American, and yet it was at this point in his story, when he came to the art attitude of our country, that he held his head in both hands. "They go along, and they go along, the American people, and they never see the writing and painting fellows right among them. Then all of a sudden somebody wakes up and says, 'Why there's So and So. He has a European reputation. Let's give him something to do over here.' And then maybe

one of the Armours speaks up and says 'All right.
Let's let him paint a little sausage.' But that is only
on general grounds, and in the heat of argument,
when he is apt to exclaim furiously to his oppo-
nent, "What you need is a European trip and you
need it damn quick!"

Our German anarchist does know a lot of
things beside his art, and he's such fun when he
talks! His delineation of a member of a lady's art
committee planting a ribbon on a prize picture
was irresistible.

"Oh, isn't that swe-e-et," and walks, in the
mincing gaits of corsets and tight shoes, to a spot
on the wall, murmurs over it and pins an imagi-
nary ribbon to it with an admiring and officious
dab. He thinks he doesn't approve of women. . . .
And yet, he is so proud of his wife, he cannot say
enough about her.

Ufer was a product of many influences. He was born on
July 22, 1876, the second of five children born to Peter and
Alvina Manseer Ufer. The family was German, having
emigrated from Cologne in 1875, ultimately settling in
Louisville, Kentucky, where Peter worked as a gunsmith.
Peter Ufer was a master craftsman who had been success-
ful in Cologne but wanted his family to have more oppor-
tunities than he felt existed in Germany. He had relatives
in Louisville, dictating his choice of where to live, but he
found that he could not make enough money to support
the family.

The degree of poverty the family faced was evident in
the way Walter was treated. He was a sickly child who, if
pressured too hard, was not expected to survive. Yet as one
of the older children, tradition warranted his going to work
while still a small boy. His health would have resulted in
his being excused from such duty, yet the family simply
could not make ends meet if he did not work. They were
willing to do what so many immigrant families throughout
the nation had to do. They would sacrifice one of their chil-
dren for the good of the others. As a result, Ufer lit gas
lamps and sold newspapers while still in grammar school.

The reasoning was that if he was not strong enough to survive, at least he would help feed the family in his last days. And if he lived, then he would not have been needlessly pampered. Obviously, he did survive, though his health was permanently damaged.

Ufer drew pictures from the time he was a small boy. He would sometimes take a break from lighting the gas lamps to sit on the curb across from the Pennedennis Club of Louisville, sketching on whatever scraps of paper he had with him. One of the club members saw the child, was intrigued, and took him to Woolworth's where he bought him some watercolors and a pad of paper.

Ufer was also encouraged at school. He delighted in telling how his principal, W. O. Cross, caught him making sketches of his classmates on the flyleaves of his books. Cross ordered him to the blackboard where he proceeded to produce a credible likeness of the principal. Then he explained that he wanted to be an artist when he grew up, a fact that the principal encouraged. Cross made certain that whenever drawing needed to be done for any teacher's lessons, Ufer was the one who assisted.

Ufer had none of the natural talent of Buck Dunton. He needed lessons and wanted them at an early age. His family allowed him to hold back a small percentage of the money he earned so that he could afford to take advantage of art lessons offered to children on Sunday mornings. The teacher showed him the basics of drawing both from plaster casts and from life, teaching him about shadow and form. In addition, his father taught him the art skills he had learned as an engraver.

Peter Ufer shared something else with his son—an endless tirade about social injustice. The American government was too conservative for his taste. Ufer was aware of the intense poverty of immigrants, the bigotry, the wealth of potential that was not being nurtured by the government. Much of what he said made sense to the boy and, as he grew older, he became, in effect, a disciple of his father's teachings.

Ufer may not have been a prodigy, but he was determined to succeed. He took an apprenticeship with a lithography firm when he was about to enter high school. He

thought that he would have a chance to advance his art skills, but the firm was one of the biggest in the city and could not take a chance with an underskilled boy. They made him a gofer who did whatever unskilled or semi-skilled task needed to be handled. It was a depressing period because his art education had effectively been placed on hold.

The World's Columbian Exposition was held in Chicago when Ufer was 17 years old. He attended because the Exposition included a gallery of art where he was able to see museum-quality paintings and sculpture for the first time in his life. The experience made him even more determined to get better training.

The opportunity for change became a reality sooner than he expected. Ufer had befriended the head designer at the lithography firm, Johan Jergens, a man who understood Walter's frustrations. He also recognized that the youth had talent that should be better trained. When Jergens, a native of Hamburg, Germany, was given the opportunity to buy his own lithography firm back in that city, he quit Louisville and offered Walter a chance to work for him. Walter would still be an apprentice, though he would have more opportunity for learning because there were fewer people available for the skilled work. And to sweeten the offer, Walter would be able to attend the Royal Applied Art School.

Walter arrived in Hamburg in 1893. He worked and studied for a year, then spent the next two years traveling, working, and studying. Finally, he settled in Dresden, enrolling in the Royal Academy of Fine Arts while working as a lithographer. There he was happy, participating in the student life, the political discussions, generally coming to be seen as a part of the young intellectuals.

The Dresden existence was a Bohemian one that Ufer loved. He might have made Europe his new home had his mother not pleaded with him to return to Louisville in 1898. But that return was frustrating. He called Louisville "slow and easygoing. . .a dull tobacco and whisky town. It wasn't a city in the true sense of the word. . . .You went to a drug store and you found the finest set of bums that you ever saw in your life. A nation of drug store bums and loafers—

and the only nation in the world that produces them. . . . A nation of tobacco and gum chewers—gracious, what a future."

Ufer had the arrogance of youth, seeing things only in terms of absolutes. Everything was either black or white, with no room for shadings of gray. Yet much of America deserved his wrath so long as his focus was on the impoverished immigrant. The family from Europe often lived in conditions of horror. Social workers and "muckrakers" would soon document everything from overcrowded conditions, high infant mortality rates, and rampant disease to jobs so dangerous that people were routinely killed through unsafe practices. Incest and domestic violence were serious problems. The meat processing industry was a place where men routinely were killed, their bodies frequently falling into vats where it was impossible to remove them, a fact that resulted in some food containing human parts ground into the meat.

There were other problems as well. Ufer had been a major artist in a small community of artists. In the United States, he was no longer a genius on the cutting edge of new technique. His work was viewed as being either "too modern" or "too rough and unfinished," according to the critics. Unable to sell through galleries, he took a job in the art department of the newspaper, the Louisville *Courier.*

Ufer moved to Chicago in 1900. He had $15.00 in his pocket and a job as a designer for an engraving firm. At night he attended the J. Francis Smith School, an American branch of the Académie Julian. That affiliation enabled him to compete with the Paris students in their monthly competitions. His work was shipped by boat, along with that of other pupils studying at the Smith School, and taken as equal with the work done in Paris. His efforts were so unusually good that he won every monthly prize given that year, ultimately being given a gold medal and the offer of a chance to study abroad. However, Ufer would have to pay his own way, and he lacked the money. Instead he accepted a position as an instructor for the Smith School in 1904.

It is not known how good a teacher Walter Ufer might have been, but he did make an impression on one of his

pupils, Mary Monrad Frederiksen, a girl raised in Copenhagen, Denmark. Their relationship was the most progressive and seemingly mutually respectful of all the members of the TSA. He informed Mary that he loved her, that he wanted her to be an independent person leading her own life. Whatever she wanted to do was fine with him, and if they ultimately found that they could not get along together, they should part. He was comfortable with a commitment to marriage. He was comfortable with divorce. But he was not comfortable with the idea of a woman subjugating her identity to the man she married. He was the most progressive and enlightened of all the members of the Taos Society, and he was the only one to both marry an artist and have a truly successful relationship.

Marriage forced Ufer to decide on priorities. He had trouble maintaining his finances and would be poor most of his life, a condition he grew to accept. But he regularly tried to be a good provider, especially after marrying. He immediately took the job as advertising manager for Armour and Company, free-lancing on the side. He painted portraits for extra income, then did personal fine art work for what he hoped would become a gallery following. Most of this personal work involved figure studies and nudes, though they seemed to not have been particularly successful for him.

In 1911, the Ufers felt that they had saved enough money to go abroad to study. They traveled to Germany as well as France, Italy, Sweden, Denmark, and North Africa. They both studied and painted, each developing unique skills. Mary was the historian of the two, her expertise being strongest in art history.

Upon his return, Walter had a chance to exhibit his European paintings, seven crateloads in all, in Chicago. The couple had used all their money and only could afford passage for one crate. Mary stayed with her mother in Copenhagen where she planned to live until Walter could get a new job to support them. The exhibition of his work was a step toward that end.

The exhibition brought Ufer a new experience. Chicago Mayor Carter H. Harrison, Jr., and several business associates, in conjunction with the Santa Fe Railroad, sponsored

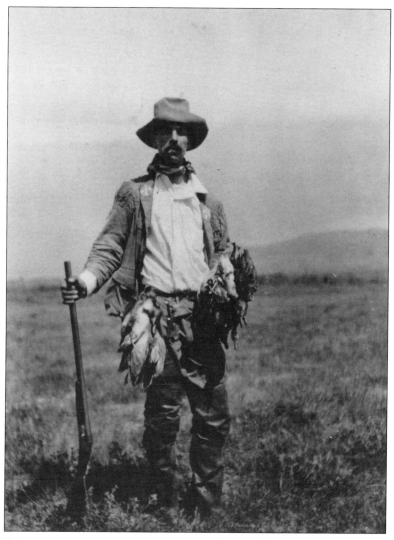

Herbert "Buck" Dunton, ca. 1921 (Courtesy of Fenn Galleries, Santa Fe, New Mexico)

Ernest Blumenschein, Oscar Berninghaus, Eanger Irving Couse (Courtesy of Fenn Galleries, Santa Fe, New Mexico)

Rural Free Delivery, mural by Kenneth Adams, located in the post office, Goodland, Kansas (Courtesy of Fenn Galleries, Santa Fe, New Mexico)

Amizetto, New Mexico, Eanger Irving Couse (Courtesy of Fenn Galleries, Santa Fe, New Mexico)

Waiting, Eanger Irving Couse (Courtesy of Fenn Galleries, Santa Fe, New Mexico)

E. Martin Hennings (Courtesy of Fenn Galleries, Santa Fe, New Mexico)

Shelling Corn, Joseph H. Sharp (Courtesy of Fenn Galleries, Santa Fe, New Mexico)

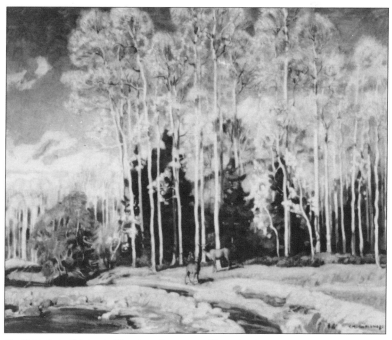

The Waterhole, E. Martin Hennings (Courtesy of Fenn Galleries, Santa Fe, New Mexico)

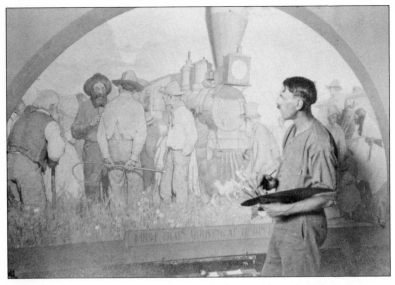

Herbert "Buck" Dunton at work on a mural in the Missouri State Capitol, ca. 1924 (Courtesy of Fenn Galleries, Santa Fe, New Mexico)

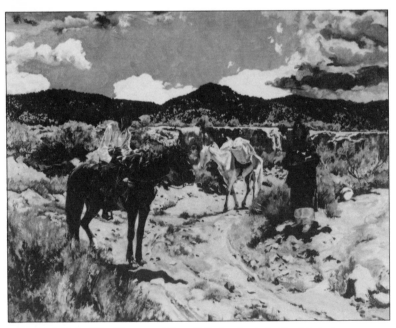

Desert Trail, Walter Ufer (Courtesy of Fenn Galleries, Santa Fe, New Mexico)

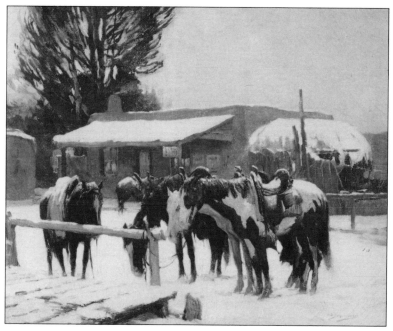

Forgotten, Oscar Berninghaus (Courtesy of Fenn Galleries, Santa Fe, New Mexico)

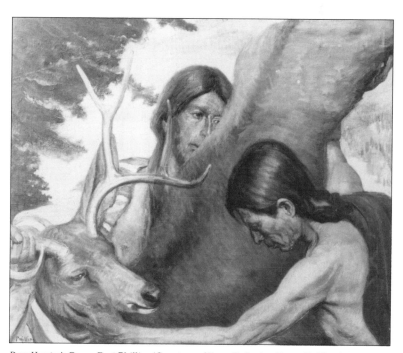

Deer Hunter's Camp, Bert Phillips (Courtesy of Fenn Galleries, Santa Fe, New Mexico)

Chief Shappanagons, Eanger Irving Couse (Courtesy of Fenn Galleries, Santa Fe, New Mexico)

Ufer as one of the artists who would travel without charge to Taos to paint. Several years later, in January 1933, in an article Ina Cassidy wrote for *New Mexico Magazine*, "Art and Artists of New Mexico," he was quoted as follows:

> *Carter Harrison sent me [to Taos]. He had been out here, loved the country and advised me to come. He did more than advise me, he made it possible for me to come and stay by buying my work and persuading his friends to buy. He just told them they had to. And they did. . . . Carter Harrison has done more for American art, for Taos art, New Mexico art, than any other man I know. He has always been a "booster" and a buyer which is the best kind of a "booster," and has made it possible for a number of outstanding American artists to succeed.*

Ufer made that first trip in 1914. He made what he felt was the most important observation that could be made about the West: it was the place where American art would come into its own. Prior to that time, he felt that only Europe originated important work. Certainly, the old masters were all from Europe, and even the new concepts, such as impressionism, were coming from France, Germany, Italy, and similar locations.

In 1928, as a foreword to the catalog published in connection with an exhibition of his paintings, Ufer wrote,

> *I believe that if America gets a National Art it will come more from the Southwest than from the Atlantic Board. Because we are really different from Europeans, and the farther away from European influence, the better for us. We already have too much of Indian blood within our veins to be classed with Europeans, though we are a white race. They are a mixture over there, but we are a different mixture. The strong beauty that the Southwest holds, connected with what the early Spaniard found here when he conquered these people, is what holds us out here rather than*

painting fishing smacks in the east or the Pacific slope.

Gradually, and with the Indian here, I believe we can give much to American Art in the future. The Southwest has gradually gained—though it is still wild—by taking within its fold the Artist. I mean by this every kind of artist. The dramatist has come, the writer has come, the sculptor has come, the architect has come,—and the painter discovered it. The musician has also come, and I still maintain that the Great American Opera will be written out here.

The period of separation from Mary was not a happy one. Ufer had discovered Taos, but he was finding other irritations. For example, he hated the shallowness of American women and the men's lack of social conscience. He felt that everyone was chasing money and power rather than what mattered. He felt that he was held in scorn, as were all artists, because they did not work sixteen-hour days in jobs that would make them rich.

Ufer also hated the American culture. He was irate over the new dance craze that was sweeping America in 1913, especially since its influence was so broad. He had become a curmudgeon in his young age, albeit one with a sense of humor. He wrote to Mary,

But understand that the people are not the only ones who get this mania. Horses, dogs and anything that can move gets it. It is nothing unusual to see a horse suddenly go chasing down the street in full gallop—turn a corner—halt—make a few jumps, dance a bit and go chasing like mad again. Or a street car may suddenly fall over—rear up on its hind wheels, dance a few jigs and go madly down the street—the motor man keeping time by clanging on the bell. All of them—everything doing the "latest."

Mary was his best friend. He once wrote to Blumenschein, "Now with the reputation that I have got and

knowing where I stand, if I had money—much of it I mean—I believe that I would be doing something more manly than paint pictures. One has to associate with too many women in this game, for which I do not give one damn. My regret is that I cannot compete with strong men—real towering men. Such a regret is natural too, I would like to be strong like a locomotive—or something like it." Yet the separation from Mary was destroying him. He thought it might be two or three years that they would have to live apart. He had missed the age of illustration, photoengraving taking that role from the artist. Portrait painting had been a trade that sustained artists for centuries, yet the camera and changing times had altered that possibility. He felt that he was creating a product no one wanted, that artists would invariably starve because society had too many false values. He was depressed, frustrated, angry, and desperately missing his wife.

Mary knew she could not stay apart from her husband. He was depressed, drinking too much (he was probably an alcoholic at the time of his death), working, yet not happy. He needed her and she knew it. She used what little money she had left to book passage home, arriving in the United States in January 1914.

Mary reminded Walter of their days of happiness as starving artists in Munich. She wanted the joy of his company, not the riches of people they knew. She also decided to give illustrated lectures on art, starting with Chicago women who regularly gathered for afternoon teas. She knew she could obtain stereopticon views, supplementing them with photographic prints from the Art Institute.

There were other events affecting the couple at the time. Mayor Harrison was more than a man who was able to help Ufer with his Santa Fe trip. Through his brother, William Preston Harrison, and wealthy philanthropist Andreas Wackenreuter, a syndicate was established in which money was pooled for the sole purpose of buying Ufer paintings in quantity. Money would be advanced as needed, the remainder paid on completion of the paintings. Ultimately approximately forty paintings of various sizes were completed during that first trip, the syndicate guaranteeing a purchase of a minimum of eight per year

for each of three years. However, Harrison was critical of the early work, which was similar to that of the members of the TSA in that it captured the past of the Taos Indians. Harrison suggested that Ufer consider the realistic presentation of the Indians, showing them as they are. It was this impetus that led to the unique perspective he would offer, as well as reinforcing his social consciousness.

The next couple of years were tumultuous ones for Ufer. He had a tendency to try to assure financial devastation in the midst of newfound success.

The New Mexican paintings were finding success in areas where such work had seldom, if ever, been displayed. They were used in the Panama-Pacific Exposition in San Francisco, displayed in the Chicago Art Institute, the Louisville Artists League, and elsewhere, generally in the Midwest and on the West Coast. Galleries were interested in his work, and he made inroads in areas that never before had accepted paintings related to the Southwest.

But Ufer argued with the Harrisons and Wackenreuter. Both the mayor and Mary felt that Walter should paint the mayor without charge, the painting ultimately to be part of the city collection of important figures. Not only did they both feel that he should be grateful for the help but it was also made clear that he was only one of many extremely talented people in the city. His arrogance was uncalled for.

Ufer eventually earned a few hundred dollars for the mayor's portrait and the anger of the syndicate that was sponsoring his other projects. They continued supporting him, though, because they did find him special compared with the hundreds of other talented artists in the city. He also had the sense to stop pressuring everyone from time to time, recognizing that he was no longer in advertising where negotiations and signs of temperament were common and even encouraged to a degree.

Ufer was extremely prolific, though most of his renderings were quite small compared to those of most of the western painters. In his early years working in Taos, he seldom painted anything larger than 30"x 30", his concern being with technical perfection rather than panoramic creations.

Ufer was in rather unusual circumstances by 1916. He

had become one of the artists supplying both the Atchison, Topeka, & Santa Fe Railroad and the Fred Harvey Indian Department outlets at their various hotels and gift shops, the latter on consignment. He was sending exhibitions of his work and coordinating exhibitions for both himself and others through groups such as the Palette and Chisel Club of Chicago, which had over 100 members. And he was heading an educational committee that supplied speakers from the arts who were also talking about the politics of various countries. Thus an expert on art in Ireland would also discuss the vicious handling of the Irish under British rule.

The only work Ufer despised when it came to the business of art was the handling of circuit club exhibitions for the Chicago Society of Arts, a group with more than 150 members. Usually the paintings were circulated among various women's clubs in cities throughout the Midwest and elsewhere.

The women's club movement was a powerful one that had begun in the latter part of the nineteenth century. Such groups were both mocked and respected. Sometimes, the groups had ladies who enjoyed tea, pretentious conversation, and the presentation of speakers on topics they had no interest in. At other times, the clubs had members who were political and social activists seriously working for change for the better. When they had speakers concerning art, politics, or other subjects, they were not only well prepared for questions but also turned their interest into social activism.

Ufer tended to see all such club members as ninnies with whom he wanted no connection. At the same time, he worked with such groups without revealing his disdain because both he and the other members of the clubs he represented often gained commissions as a result of these contacts.

The Taos artists liked Ufer, helping him find places to work and stay in Taos as well as helping him gain membership in the Salmagundi Club of New York. He was also winning numerous important awards for his work, starting with the Martin B. Cahn Prize in Chicago for _The Solemn_

Pledge—Taos Indians (1916). Later there would be the first Frank G. Logan Prize (*In the Land of Mañana,* 1917), the Thomas B. Clarke Prize of the National Academy of Design (*Going East,* 1918), the Third Class Medal of the Carnegie Institute (*Suzanna and Her Sisters,* 1920), along with the first Altman Prize, the Isidor Gold Medal, a second Martin B. Cahn Prize, and purchases by the Corcoran Gallery of Art, the Metropolitan Museum of Art, the Gilcrease Institute, the Brooklyn Museum, the Pennsylvania Academy of Fine Art, and others. He was regularly invited to exhibit with the world's most prestigious exhibitions and also became a member of the important art organizations both in the United States and England, where he was elected a fellow of the Royal Society of Artists in London. In 1917, he became a member of the Taos Society of Artists.

The war was taking place when Ufer's paintings *Going East* and *Her Daughter* were shown at the National Academy of Design. The work had already won the Thomas B. Clarke Prize for best figure painting and resulted in the automatic consideration of Ufer as an associate of the NAD. Unfortunately, not only was Ufer of German descent but he was also known to be a political radical at a time when such a distinction was a definite disadvantage. Blumenschein was the one who had to break the news to Ufer about the bigotry that had been spawned by the war. It was 1918 when Blumenschein wrote,

> *At the reception of the N.A.D. there were exciting patriotic speeches by Gibson and Augustus Thomas, urging the artists to more active participation in the war, so that it left the members of the Academy in a touchy mood regarding candidates with German names. Nevertheless I started your paper which must have the names of seven members endorsing you. Couse and I signed it and then we asked a very influential landscape painter. He said he wouldn't sign unless he knew exactly how you stood on the war—whether you were in sympathy with the allies or Germany before America's entrance, where you studied, etc. This sounded extreme—in fact I hadn't thought*

of it—so Couse and I talked it over between us and decided it would be a very risky thing for you to be proposed by me, with my German name, and Couse felt that in case feeling should run so high as to reject you (not on art standing, for I feel sure you would go in on your paintings) it might be fatal to your future chances.

It's a mighty ticklish moment just now, Ufer, and people are just boiling at times. Some of these artists are very narrow. They have refused to take in Kroll and Hayley Lever three straight years in succession, and solely because of their extreme socialistic views. I have stood up for these two men steadily placing myself on record as decidedly with the Radicals. So I know the temper of these N.A.'s. They are not broad—but ultra-conservative. Just like Couse (with no disrespect to the President of the T.S. of A.).

So I'm sorry to have to be so frank, but I really feel that you are taking big _chances to be put up just now._

You might _get in, but if you didn't, it would be goodnight Ufer. So my advice is not to be disturbed over the matter, and to withdraw your name if it should be proposed by someone else. Be happy with your prize and keep on painting good ones. N.A.D. don't amount to anything in this world._

The bigotry that prevented his early admission in the National Academy of Design caused Ufer much pain. In 1920, he finally became an associate of the NAD, and in 1926, he was named Academician. Yet his intense social conscience made him very much aware of the slights he suffered earlier.

Ufer had other problems as well. He became the highest-paid painter of southwestern art in the United States, yet he seemed almost constantly to be in need of money. When he finally was able to set aside some savings, the Depression hit, and he lost his money in the bank failures. As a result, he would paint almost any picture for money

so long as he did not have to stop doing the work he loved.

Regular buyers of Ufer's art would dictate how to paint for the market. His first mentor, Harrison, was probably the greatest abuser. Sometimes he would give precise details of the type of picture he wanted, including the colors. At other times he would insist on changes that distracted from the authenticity of the work. For example, he wanted the Pueblo Indians painted darker than their natural flesh tone because he feared people would not think they were real Indians. He also wanted Ufer to choose colors that would look attractive when displayed under artificial light.

Sometimes Ufer exploded with anger, refusing to play such games with clients. (His studio held a sign that read, "Keep Out! TNT EXPLOSIVE!") At other times, he acquiesced to the demands of anyone who was interested in his work, painting in the manner they desired. Yet always he was a realist, painting the Indians for what they were, including scenes where they stared vacantly into space, a part of the landscape, reflecting the fact that they had become nothing more than a tourist attraction for white people.

And it was this inner sadness that raged within him as well. He drank heavily, the bottle an escape from the pain he saw all around him. His wife provided the only consistent happiness he ever knew.

William Victor Higgins was a radical contrast to Ufer when the two men joined the TSA in 1917. Higgins was seen as a man of many moods, a deep thinker who would withdraw into his thoughts for days, then become the most jovial of speakers, sharing his love of art with large audiences. When he was made a member, he shared his feelings about Taos in an April 15 article in the *Chicago Sun:*

> *There is in the mind of every member of the Taos art colony the knowledge that here is the oldest of American civilizations. The manners and customs and style of architecture are the same today that they were before Christ was born. They offer the painter a subject as full of the fundamen-*

tal qualities of life as did the Holy Land of long ago.

The Taos Indians are a people living in an absolutely natural state, entirely independent of all the world. If the rest of humanity were wiped from the earth, they would go ahead just as they are today, self-supporting, self-reliant, simple and competent. They have dignity in spite of their lack of riches and nobility in spite of their humble mode of living.

Their architecture is the only naturally American architecture in the nation today. All other styles were borrowed from Europe.

Being so completely the product of their surroundings, they give the painter a host of fresh and original ideas.

This strong primitive appeal calls out the side of art that is not derivative; it urges the painter to get his subjects, his coloring, his tone from real life about him, not from the wisdom of the studios.

Coupled with this impressive simplicity, the country makes its inhabitants daring and lovers of the "chance." In the cities men are careful doing what others have done, bound by conventions, ringed round by tradition. The very air of the Taos country, its nearness to big works of nature drives caution from man's brain. He takes a chance. Perhaps this has led the Taos painters to be original and to be so devoted to the country and its people.

There was no sense of the plight of the Indians that so moved Ufer, yet both Higgins and Ufer were able to look on Chicago's Mayor Carter H. Harrison, Jr., as patron. In another of those unusual coincidences, both had first seen Taos in 1914.

Higgins was born on June 28, 1884, in Shelbyville, Indiana. John Tilson and Rose Ellen Dolan Higgins were Americans, second-generation Catholics of Irish descent. Victor was the third of their nine children. The family owned a farm, the children handling an increasingly heavy load of chores as they were able to assume such responsibility.

Young Victor seemed to be irresponsible. He was a dreamer who liked to walk the farm country, observing life, thinking, but never bothering with his schoolwork. He learned the basics, yet nothing excited him until he was nine and encountered a traveling sign painter working on the side of a barn. Such painters roamed the farm country, sometimes doing little more than applying lettering to advertise some product. At other times their decorations were major artistic creations, not much different from the designs van artists would have created for them more than eighty years later.

The sign painter explained the business of art to Victor as best he could. He let him know that there was a creative element to the work as well as basic skills that had to be learned and practiced. He said that painting could be learned in special schools and that the best of the paintings were hung in museums. He also mentioned the Art Institute of Chicago, which had recently been constructed. Then he gave the boy a set of paints and some brushes to use at home. From that moment on, Victor Higgins was an artist.

There were problems, of course. Ellen Higgins was delighted by her son's encounter and respected his enthusiasm. However, she firmly informed him that a nine-year-old boy who had had a single encounter with a traveling sign painter had neither the knowledge nor the skill to paint the family barn. She did let him work inside that barn, doing whatever he liked with the walls.

There is no definite record of what skill he may have had at the start. Years later, his first wife, Sara, was able to see the paintings, because the barn had not yet been destroyed. It was her opinion that they not only showed promise but that there was obvious improvement from section to section, as though the boy completed one work, studied it, then tried to improve its failings with the next.

The Higgins family encouraged their son's love of art. He was obviously never going to be a scholar, and his father could see that the boy only tolerated the farm. More important, John Higgins was sensitive to his son's new love because he had always had a love for the beauty, the color,

and the patterns of life in nature. He had a carefully culti-
vated flower garden and encouraged the children to try
and see the details of the seasons, watching them much as
one would study a painting.

Victor and the other children were paid for handling
their farm chores and were expected to meet their needs
for school supplies, clothing, and anything else from the
pay they received. The family was reasonably prosperous,
and Victor was able to set aside some of his money month
after month and year after year. Finally, at fifteen, he had
enough to travel to Chicago to study art.

The Chicago period was to last ten years. During this
time, he studied at the Art Institute and at the Chicago
Academy of Fine Arts, which eventually invited him to
return as a teacher. Money came from working at what-
ever jobs he could get. He was a professional wood carver,
an interior decorator, took jobs with theaters painting their
scenery, painted murals, acted as an art restorer, and did
anything else in any way related to his field. Sometimes he
was quite good. Sometimes he was simply more skilled
than his customers. But he did what was necessary to gain
all the training he could get in Chicago, then saved his
money for trips to New York and Europe.

Higgins was the true student, unlike other members of
the TSA who held free-lance jobs as commercial artists in
order to pay their way during most of their academic years.
He painted in France at the Académie de la Grande Chau-
miere in Paris, and in Munich he studied with Hans von
Hyedk. He also met Walter Ufer in Munich, the start of
what would prove to be a lifetime friendship.

Higgins knew he needed the training he received but
felt that conversations with friends who were fellow artists
proved more stimulating than the schools. He learned how
others saw painting, how they worked, and what they were
trying to achieve. He felt that such information was of far
greater value to him.

For him, academic training provided only the technical
basics for an artist. Certainly many commercially success-
ful artists learned the basics and nothing more. They
painted in the styles of the old masters, failing to add their
personal vision. He needed to find a way to express himself

in a unique manner that would separate him from the work of those who had come before.

Higgins was in New York in 1913 when the famous Armory Show was held. This was the show that introduced Americans to the latest in European art—the fauvists, the impressionists, and the other innovators of the day. Here, gathered together in one showing, were such pioneers as Picasso, van Gogh, Degas, Goya, Dufy, Toulouse-Lautrec, Delacroix, Matisse, and numerous others. Their visions were shocking to some, fascinating to others. They were little known as yet, their impact still not fully understood, yet they challenged the traditionalists, the academics, the artists who wanted to be safe in what they produced. And they inspired Higgins.

There was something more to Higgins's sense of where he must head as an artist. He questioned what made the Europeans so special, and he realized that they gained their inspiration from the rich diversity of their own countries. American painters regularly went abroad to learn. The innovators stayed home after schooling, trying to sense their native country in a way that would allow their art to emerge from the uniqueness of their own land.

> *Our country is full of young artists who can never outgrow the fact that they are merely following the European herd—just being little Cezannes, Derains, van Goghs, Gauguins, or whom have you . . . they want the courage of their own reactions to the life about them—the secret of the success of those they would imitate. To be outstanding their art should be indigenous; yet they go on and on aping the latest trends, blowing about like a dry leaf before every changing gust.*

It was with such thoughts that Higgins entered paintings in a Chicago art competition attended by the mayor, Carter Harrison. And it was from that show that he, like Ufer, was able to discover New Mexico due to the patronage of the mayor and his friends. They recommended he make the trip, buying enough paintings and guaranteeing enough purchases to enable him to do so. He arrived there

at the end of 1913, took residence the following year, and never left. Three years later he became a member of the TSA and, ultimately, he ran for mayor of Taos, losing by twelve votes.

Sheldon Parsons was a Taos artist, though not a member of the TSA. He immediately welcomed Higgins into his home and introduced him to his daughter, Sara, then fourteen years of age and interested in a career in the arts. She was a happy child, strong willed, raised with the belief that she could be or do anything so long as she applied herself.

Higgins was fascinated with Sara, so different from himself. She was outgoing where he was essentially a loner. She was interested in seeing and recording the countryside, both as a painter and a photographer. He wanted to stay in Taos and come to understand the land and its people, his only wanderings to be the wanderings of the mind that would lead him to explore life in what he hoped would be a unique visual way. He expected a wife to be both lover and servant and was disgusted by the idea of "lady painters." She felt that a career with mutual respect was critical for a woman and her marriage. She also had little interest in money and cared most about pursuing her work, while he, with all his artistic concerns, "simply did not approve of being poor," as she later joked.

The opposites attracted with great intensity, and five years after their initial meeting, they were married. It would prove a time of intense productivity for both of them, yet she was soon feeling stifled. She was growing in ways that did not relate to his approach to life. The marriage did not last as long as the friendship, and the couple divorced approximately four years later.

Higgins began winning awards for his work almost immediately after he arrived in Taos. He became an Associate of the National Academy of Design in 1921 and an Academician in 1931. And when the Museum of Modern Art opened its doors in 1929, he was part of the opening exhibition, "Paintings by Nineteen Living Americans."

Higgins did not want to have the money problems that perpetually plagued Ufer, yet he also did not wish to compromise his work. He was an experimenter who was not afraid to change his style as he both mastered his craft and

learned to see in new ways. His earliest work was quite literal, the standard depiction of the Taos Indians as they went about their daily lives. Then, as the years passed, the almost photographic representation changed to more stylized studies. The people were no longer important design elements. They were representational, a part of scenics where color and form were of vital importance.

"The term *reality* is greatly misunderstood," he explained in an interview quoted in *New Mexico Magazine* of December 1932 ("Art and Artists of New Mexico" by Ina Sizer Cassidy). "It does not mean the ability to copy nature as most people seem to think, it means more than that, the *reality* of being. The difference between the modernistic and the romantic form of art, as I see it, is the architectural basis. The modern painter, and by 'modern' I do not mean exactly the painter who is a distortionist or innovator, but the true modern, *builds* his picture, he does not merely paint it. He has his superstructure, his foundation, just as an architect has for his buildings."

Higgins's work also derived from his inherent competitiveness with other artists. He was determined to be different from those around him, better, able to create and sell more effectively. His style was as radical as the difference between Ufer's downtrodden Indian subjects and the peaceful culture of the past found in the paintings of the other members of TSA. However, he found a way to ensure that he would be financially secure. He did what professional athletes would do in later years. He sold shares in his work.

It was December 31, 1921, when he convinced four Chicago businessmen to establish a special fund for him with the Corn Exchange National Bank. They would each invest $2,400 over a period of two years—$100 per month per man—into an account from which Higgins would make withdrawals as needed. Then, each time Higgins sold a painting, each man would receive 10 percent of the sale price. Thus Higgins would be left with 60 percent of the price, the four men dividing the remaining 40 percent. If Higgins was successful during the next two years, the investors could profit handsomely. If Higgins had lower

sales than anticipated, he would still have a fixed mini-mum income.

The TSA was developing other resources for the group during this period as well. The Missouri Art Commission wanted murals painted at the new capitol building in Jefferson City. Blumenschein, representing himself as well as speaking for the others, obtained the work.

Blumenschein claimed the largest portion of the assignments for himself. He was assigned to fill three lunettes, semicircular spaces above doors and windows in which mural paintings were commonly placed, as well as to produce two full-length (9 ft.) portraits. One was of fron-tier artist George Caleb Bingham and the other of General John J. "Blackjack" Pershing.

Pershing was a temperamental man who wanted to control the painting as he had controlled the military. Nor-mally, this would have been a minor problem for any art-ist, but Pershing was seen as one of the nation's most important individuals. There was talk of his running for the presidency because he was a national hero. He had been the successful commander of the troops in Europe during the Great War. He had also had a career that was legendary in its scope. He had forced Mexican revolution-ary Pancho Villa to return to Mexico after crossing into the United States. He had fought Apaches in the Southwest, and he had been in the Philippines, fighting the Moros.

Pershing had little interest in the portrait at first. Blumenschein contacted him by mail, only to have his let-ters thrown away unread. When contact was made indirectly, the general was more receptive, though insist-ing on first reviewing the artist's past work. Once comfort-able with the style, Pershing announced that he would stand with feet apart, head back, his gloves carried at the waistband.

The committee that hired Blumenschein had other ideas. There was a story that when Pershing reached France, he paid a visit to the grave of Lafayette where he supposedly said, "We are here in recognition of Lafayette's helpful role in the American Revolutionary War." Ulti-mately, there was a compromise for the Senate chamber portrait, the final product more formal than the general

envisioned and less romantic than the committee wanted. And the George Bingham painting, a straightforward assignment, was handled with no difficulty.

The lunettes were different. One was meant to depict the encounter between writer Washington Irving and frontiersman Kit Carson at the Arrow Rock Tavern. The second was a scene at Fort Orleans where a French soldier took an Indian bride, then went to Paris for their honeymoon. The painting depicted their return, surrounded by strong Indians who later killed the officer. And the third was called *Trader, Fort Carondelet*. It depicted a frontiersman trading wool blankets with the Indians.

The three lunettes were completed in the studio Blumenschein had built in the Ledoux Street house after tenant Epimenio Tenorio was gone. The work was far larger than anything in the past, so the room had to be lengthened by ten feet to accommodate it.

Berninghaus prepared three lunettes for the Missouri State Capitol building's main corridor—*Early Lead Mining in Washington County, Old Ste. Genevieve—First Permanent Settlement,* and *Herculaneum—Where Shot Making Was an Industry*. Both Phillips and Dunton were hired to produce murals depicting Indian life, and Couse contributed lunettes. The work brought substantial income to the five TSA members involved with the Jefferson City project.

The work was important for other reasons. The postwar years saw a decrease in financial involvement with the arts. There was a recession in both Europe and the United States, a situation requiring the artists to work in broader areas than they had in the past. After Blumenschein was elected president of the TSA in 1920, with Ufer acting as secretary/treasurer, plans were made to exhibit the members' paintings in ten cities from New York to Honolulu. It was a major undertaking, and it included the work of younger painters of skill from Santa Fe. Yet as enticing as the traveling exhibition was meant to be, only three paintings sold during the run of the circuit. Fortunately, this had changed by 1922; three paintings sold in the first city where the exhibit took place.

There was dissension forming in the ranks of the TSA, the members beginning to question how effective the

organization had become. Magazine commissions were dwindling as photography replaced paintings for many of the illustrations. The railroad was still buying paintings of the West, but the AT&SF policy had slowly changed to where negotiations were made with individual artists who might or might not be members of the Society. Sales from the circuit exhibitions were down, and many of the artists found that they could make more money by arranging for their own deals, their own patrons.

When Blumenschein's term in office ended, Ufer was elected president and Berninghaus took over the secretary/treasurer position. No one thanked Blumenschein for his work. No one praised him for working hard to bring young, non-TSA artists into the exhibitions or for expanding where they were held. This may have been a reaction to the lack of sales, and it may have been a reaction to Blumenschein's ego. Certainly his attitude toward the effort of the TSA members when it came to the painting of range finders just a couple of years earlier was still in their minds. Whatever the case, Blumenschein's bitterness was evident when he later wrote to the members,

> At the recent meeting of the Society at my residence no action was taken thanking me for my services during my two years in office.
>
> The morning after the meeting, I told Mrs. Blumenschein that the Society had passed a resolution thanking her for the pains she had taken to see that there was some refreshment at each meeting during the two years. Of course, no such resolution was passed, but I would not have her think that to be the case.
>
> I was very careful to see that the Society recognized the labors of the secretary, but the entire bunch including the secretary forgot there had been a president.
>
> I have waited two days since the meeting hoping someone might have noticed the error, but as no remark or communication has been made on this subject I do not feel included to be of further service to the organization.

Despite the ill will, Blumenschein was elected to the office of secretary in 1923, that position to take effect the following year. However, Blumenschein explained that he had taken a more active role in another group, the New Mexico Painters, an organization slightly younger than the TSA which had somewhat similar goals for its members, though it was not in competition with the TSA. In fact, other artists, such as Victor Higgins and Walter Ufer, held membership in both groups. However, Blumenschein said he would not have the time to handle both positions, since he was already the secretary for New Mexico Painters.

According to the by-laws of the TSA, by-laws Blumenschein had helped create, refusal to accept an elected position was the equivalent of resignation. As a result, Blumenschein's membership in the Taos Society of Artists was formally terminated in 1923.

There was growing dissension among the members during this period, the society's life greatly threatened by the revolts from within. Shortly before Blumenschein's expulsion, Buck Dunton resigned over a conflict with the members for failing to take his turn as secretary of the organization. They did not take the action seriously until 1924 when they elected him to office and he made it clear that he would not hold any position with the group. From that day forward, he was no longer considered to be a part of the TSA.

Ufer also was in conflict during this period with a petulant, sharp-tongued Blumenschein, a feud that caused him personal pleasure when Blumenschein was removed from the organization he had founded. Blumenschein disliked Ufer's attempts to make his work commercial enough to become quite wealthy. He also resented Ufer maintaining independent ties with dealers.

Several years later, the feud reached a peak when Blumenschein claimed that Ufer and a Philadelphia art dealer, attempting to exploit what they hoped would be the popularity of Indian art following the stock market crash of 1929, produced a series of low-quality landscapes, each featuring an Indian on a horse. The implication was that Ufer rapidly turned out highly commercial work of limited quality. The idea was to mass market original paintings by

a "name" western artist, and the work essentially ruined Ufer's reputation. Yet the truth was that while some of Ufer's work was of low quality during that period, most of his work was both excellent and showed growth in his abilities. This was proven during an exhibition at New York's Babcock Gallery in 1931, an exhibition Blumenschein chose to ignore when making his blanket condemnation of his former friend.

Part of Blumenschein's criticism of his fellow artists resulted from changes in his thinking about his own work. He wanted to grow with the times, and he was aware of the modernist painters being drawn to Taos and Santa Fe. These men and women were experimenting with light and color rather than the realism, historical accuracy, and/or sentimentality of the subject which had been the concern of the members of the TSA. He accused his former friends of turning out "potboilers," paintings that were created for the marketplace.

Blumenschein's arrogance about the artists and his decision to experiment regardless of the marketplace seemed to come from noble values. The truth was that no matter what his feelings, he was able to survive because of his wife's inheritance. Without that steady source of income, he would have done what the others did—experiment with painting at the same time that they were producing images certain to sell to ensure their financial futures.

But Blumenschein was serious about his love for the modernist art movement as typified by Matisse and Picasso. As far back as 1913 he had written about such art and the exhibition in the Armory Show. Then he had befriended a highly social eccentric named Mabel Dodge (later Mabel Dodge Luhan after a wild affair with a local Indian and artist's model named Tony Luhan which ended in their marriage) who visited Taos in 1916 and moved to the community not long afterward. She had long been a supporter of the modernists and encouraged Blumenschein in his endeavors in this area.

Dodge was rich, friendly, and what might be considered a groupie of the avant-garde in art. She lived in Paris for many years, delighting in the expatriates, the students,

and the locals involved with writing, painting, and the other arts. She had been a friend of D. H. Lawrence, painter Nicolai Fechin, and others. Yet her personality was so overpowering that Lawrence, who at first was interested in staying in the same community as Mabel Dodge, ultimately sought refuge on a ranch some distance from Taos.

Andrew Dasburg, considered America's leading avant-garde painter from 1910 through 1935, had achieved both financial and critical success by the time he arrived in Taos in 1917. Prior to that time he had been experimenting with the use of form and space in the manner of Cézanne. He described his approach to seeing in a catalog for the Forum Exhibition of Modern Painters which was produced by the Anderson Galleries of New York in March of 1916. It was a concept that eventually caused Blumenschein to begin to alter his style. Dasburg wrote,

> *In these pictures my intention has been to co-ordinate color and contour into a phantasie of form that will have the power to stimulate one's sense of the aesthetic reality.*
>
> *In my use of color I aim to reinforce the sensation of light and dark, that is to develop the rhythm to and from the eye by placing on canvas the colors which by their depressive or stimulating qualities, approach or recede in accordance with the forms I wish to approach or recede in the rhythmic scheme of the pictures. Thus the movement of the preconceived rhythm is intensified. This is what I mean by co-ordinating color and contour.*
>
> *My conception of rhythm is based on a simple tensional contract [sic] of lines which will give the sense of poise, of balanced masses which in themselves constitute an inter-dependent unity. The other lines—the minor rhythms—are developed from the original lines; they supplement and augment the first simple statement of the rhythm, and are, in turn, a part of the original rhythm, partaking of its character. Like leaves thrown in a stream, the minor rhythms are picked up by the central*

current and carried forward according to the direc-
tion of that current.

I differentiate the aesthetic reality from the
illustrative reality. In the latter it is necessary to
represent nature as a series of recognizable objects.
But in the former, we need only have the sense or
emotion *of objectivity. That is why I eliminate the*
recognizable object. *When the spectator sees in a*
picture a familiar form, he has associative ideas
concerning that form which may be at variance
with the actual relation of the form in the picture:
It becomes a barrier, or point of fixation, standing
between the spectator and the meaning of the
work of art. Therefore, in order to obtain a pure aes-
thetic emotion, based alone on rhythm and form,
I eliminated all those factors which might detract
the eye and interest from the fundamental inten-
tion of the picture.*

Dasburg had great influence on Blumenschein's think-
ing. In addition, Blumenschein was intrigued by the work
of Marsden Hartley, another modernist who was in Taos
during the war years and with whom he became friendly.

Hartley experimented with strong chromatic colors
and new approaches to composition, including one he
called dynamic symmetry. This influence, which affected
both Blumenschein and Higgins, led to Blumenschein's
Storm Clouds at Sunset, a 1920 painting that was his first
attempt at expressionism. The billowing clouds were
painted with rapid, swirling brush strokes along the lines
of van Gogh. He used a dark foreground to contrast with
the deep purple reds of the mountain. Color and mass were
of critical importance, not social accuracy.

Other work followed, such as *Snowscape, Taos Valley,*
and *Superstition. Superstition* was first shown around 1921
when it won the Altman Prize of the National Academy of
Design. It used extensive symbolism along the lines of the
paintings being produced by the members of what was
known as the German expressionist movement. Blumen-
schein later wrote about the painting's symbols in a re-

sponse to a question by art historian Thomas Gilcrease. He said, in part, "A medicine man. . . from a distant tribe swallowed a ribbon to determine whether a patient would live, or die. If the ribbon came out of the medicine man's naval, the patient would live. . . . I tried to paint the Indian friend's feelings—and maybe my own—it grew into this picture, which will be interpreted according to the intelligence of the on-looker."

The actual painting shows how far he had come from focusing strictly on recording the events he saw all around him. There was a medicine man chanting while holding a Santa Clara jar from which two figures are emerging. The figures symbolize Christian and Indian beliefs. In addition, a crucified Jesus is to the right in the painting and an Indian dance mask is in the left. Designs in the background are similar to petroglyphs carved in the rocks where prehistoric Indians once lived. Other signs and symbols represent the complexity of cultural beliefs that are the foundation of superstition. They are meant to reveal the invisible world of the inner self, a concept that was a familiar theme of the German expressionists.

In a rather humorous side note, especially considering the arrogance he would begin displaying two years later, Blumenschein was severely criticized when the painting was displayed at the Grand Central Art Gallery. It was part of a three-man show (with Higgins and Ufer), but the critics singled out *Superstition* and called it a "cheap and tawdry Indian picture."

Ironically, Blumenschein's rejection of the commercial world made him more commercial among collectors. He began doing expressionist work in the form of such paintings as *The Plasterer, New Mexico Peon*, and the Indian dance pictures—*Dance at Taos, Indian Dance*, and *Morning, Noon and Starlight*. One painting, *Sangre de Cristo Mountains*, a large (50" x 60") landscape that won the 1925 Altman prize, also was purchased for $3,000. Other work brought as much or more, though not for every painting. He had moved away from the patronage of businesses such as the railroad and was reaching a new, wealthy audience. He felt so secure within himself that he sacrificed "Michelangelo," his old Ford, and bought the fam-

ily a Cadillac, even then an expensive luxury car symbolic of success.

Blumenschein knew his greatest personal success immediately after his break with the TSA. He made large sums of money and was active as a baseball player until he turned 50, when problems with his legs forced him to give it up. The following year, in 1925, he went back to Brooklyn for surgery on his legs. From then on he limited his athletic activity to tennis, which he enjoyed until the early days of World War II.

Mary Blumenschein was trying to find her own creative outlet now that her relationship with her husband was again strained. She still could not bring herself to work as a painter, so she enrolled in the Pratt Institute, learned silversmithing and jewelry design, and began selling her work in July 1924. She used a direct sales method that predated Avon and Tupperware, having small teas for people who had the money and the interest to buy custom jewelry. She would show the work in those intimate settings, developing a following of buyers.

But Mary's health was not good, and she also had to return to New York for surgery. She began spending more time in Brooklyn each year, taking Helen with her. This actually helped her own career because, from February 7 to February 19, 1927, she had her first major showing of jewelry in the prestigious Grand Central Art Gallery in New York. The exhibit was combined with the showing of 46 paintings by her husband—33 large paintings and 13 small ones. His work was offered for from $3,000 (the price of _Superstition_) to $100 for his small work. Mary displayed what were cataloged as "Nine Articles in Gold and Silver Designed and Executed by Mary Greene Blumenschein."

Mary's work was equally respected in its own right, which is why she was included in what would otherwise have been a one-person exhibit. But she did not have Blumenschein's flamboyance or the past publicity. Thus, the reviews focused strictly on the paintings, discussing the changes from his days as an illustrator when the work was far more straightforward and literal. Helen Appleton Read, a reviewer for the Brooklyn _Daily Eagle_, wrote,

Blumenschein has added the personal emotional quality which no objective treatment could convey, however dramatic the material was to start with. There is an apocalyptic quality to most of the pictures—as if the artist had become so steeped in his subject that it had come to mean something more to him than mere landscapes....

Mr. Blumenschein has... been able to convey with greater conviction, because of the intensity of his own emotional reaction, the spell which this country exerts upon the sensitive and imaginative temperaments.

In addition, critic Royal Crotissoz, a frequent antagonist of Blumenschein's, wrote,

Blumenschein... paints a part of the world which has a highly distinctive physiognomy, abounding in hot color and bathed in a pitiless light.... Mr. Blumenschein, in his latest works, has come closer to a plausible adjustment. His color is strong, and the result is a series of impressions having a quietly rich harmony. Last of all he has gone about his task with a resolution to do more than record the fact, to bring it under the laws of composition. In consequence his canvases have always a pictorial interest, balanced, united, and finally, individualized. A particularly attractive quality in his work is the sense of still vastness which it conveys, the air of places having a sort of primeval grandeur. Some years ago, when I had had occasion to protest against the chromatic wrongness of the Taos school, an editorial editor in a paper there urged me to come out and see for myself what the painters had to deal with. This exhibition inclines me to feel that, if there were a magic carpet around the place, it would be interesting to go.

By 1927, Blumenschein had been given full membership in the National Academy of Design for his contribu-

tions to American art. During this same period, the Grand Central exhibit toured Chicago, Toronto, Buffalo, and Rochester. Then it was pared to twenty paintings, and those were added to a much larger exhibition of paintings by New Mexico artists which traveled throughout the West. The total sales for Blumenschein were extremely large during that period: he netted $12,000 in 1927-28.

Yet the organization Blumenschein had helped create and the friendships that had been so important in those early years were rapidly coming to an end. There would be a few new members of the TSA, and the railroad would continue to support some of the artists for a short while. But the world of the drugstore cowboys, which seemed as though it would last forever, was swiftly changing in ways none of the founding members ever anticipated.

AND THEN
THERE WERE NONE

T here would be three more members of the Taos
Society of Artists before its death by boredom in
1927. One, Kenneth Miller Adams, is frequently
mentioned, although his fame never matched that of most
of the other members. The second, Catharine C. Critcher,
did not fit the pattern at all. The third, Ernest Martin Hen-
nings, was most in agreement with the ways in which the
earliest members of TSA worked and thought.

Martin Hennings, as he preferred to be known, was
another of the discoveries of Carter Harrison, Jr., the
former Chicago mayor, and Oscar Mayer of the meat pack-
ing family. His trip to New Mexico, again with the cooper-
ation of the AT&SF, was in 1917. The journey was under-
written by the guarantee of several purchases of the work
produced in Taos and elsewhere. He was so impressed with
the area that he moved there permanently in 1921, joining
the TSA three years later.

Hennings was born in Penns Grove, New Jersey, on
February 5, 1886, but his family moved to Chicago two
years later. His father, Martin, was a cement finisher who
had come to the United States from Schleswig-Holstein,
Germany. He felt that opportunities would be greater in

Chicago. He also was able to expose Martin to a broader range of experience.

Martin allegedly showed an interest in art early in his life, but there are few references to such an interest before the age of 13. At that time he visited the Art Institute of Chicago and became fascinated with both the paintings and the idea that a school was connected with the Institute. He decided at once that art would be his career and enrolled in the school immediately after high school. He graduated with honors, then returned for additional training, and finally entered the business world in 1906.

Hennings was a realist who wanted to produce fine art but sought commercial jobs so as to have enough money to support himself. By 1912, his fine art was beginning to be respected and he decided to travel to Munich for additional study. He had learned rather fractured German from his parents, but not being skilled in languages, a little German seemed better than no French, and he knew that the city was second only to Paris as a major art center.

Hennings stayed in Germany until the impending war made it critical to leave the country. He returned to Chicago, combining mural work, some commercial assignments, and personal painting. He accepted a job teaching at the Academy of Fine Arts, discovered that he hated teaching, and dropped that "career" after his one-year contract was completed.

Hennings's "discovery" by Harrison in 1917 resulted in his being given a letter of introduction to the director of the Museum of New Mexico. He was to produce eight or ten canvases under the agreement, his trip beginning at the Grand Canyon and ending at Taos. This was to assure that the railroad might also benefit, as Grand Canyon travel was still being heavily encouraged.

The idea of living in an artists' colony appealed to Hennings after his Taos trip. He returned to Chicago, working and traveling to other such colonies, including one in Gloucester, Massachusetts, before settling in Taos in 1921.

Hennings was delighted with landscape work and the beauty of the Indians of the Taos Pueblo. He felt the land to be a constant inspiration and enjoyed the relationships with the artists who preceded him.

The schedule Hennings maintained was meant to further his sales. He spent approximately nine months in Taos and the remainder of his time in Chicago where his work was frequently exhibited and sold. He won several prizes from the Art Institute as well as from the Pennsylvania Academy of Fine Arts and the National Academy of Design during that early period. However, he felt that his most important experience came in 1924 when Marshall Field's department store held an exhibition of his work. Although the paintings were for sale, the exhibition was partially meant to entice new customers into the store. Toward this end, Helen Otte, the assistant art buyer, was involved, and she was at once taken by Hennings. They were married two years later, traveling throughout Europe, painting everywhere.

The young couple delighted in their adventures. The Moslems refused to allow the painting of a face, feeling that such a likeness was sacrilegious. This forced Hennings to sketch secretly in some areas. He held the canvas under his arms at times, working surreptitiously. On the French Riviera, almost everyone seemed to be willing to be subjects, so Martin would set up his easel, Helen obtained food at the local market, then lunch would be prepared by cooking it over a can of sterno.

The return to Taos was a comfortable one despite the primitive nature of the city. Burt Harwood, one of the early artists in the community, had created a cultural center, complete with apartments, on Ledoux Street. The location, called the Harwood Foundation, became their home until they saved enough money to buy a house.

If there is a way to distinguish Hennings's work from that of the artists who came before him, it is his combining of the human figure with the landscape in quite different ways.

Landscape plays so important a part of my work, and subjects of sage, mountain and sky. Nothing thrills me more, when in the fall, the aspen and cottonwoods are in color and with the sunlight playing across them — all the poetry and drama, all the moods and changes of nature are

*there to inspire one to greater accomplishment
from year to year.*

*In figure subjects I think I find my greatest
inspiration—subjects which you have grown to
know from experience and subjects which the
imagination brings forth....A painting is a great
adventure-thinking over a subject, making all
sorts of pencil sketches, designing, comparing,
organizing, planning its color, the lighting, until
you are sure it has everything you want for a
strong and effective painting—then you go to work
on your canvas, with your models, and this will
call for all the ability and craftsmanship which
the years of work have given you, plus all the spe-
cial effort you are capable of in order to have a con-
summative and significant piece of art realized.*

Hennings refused to join in the discussions of the differ-
ent styles of painting that were becoming of concern to
Blumenschein and some of the others. Labels and styles
meant nothing to him. He felt that a painting was either
good or bad. He also felt that all paintings, no matter what
their style, must combine quality design, draftsmanship,
form, and rhythm in order to succeed. If they did, the
artist's personal style would determine all else, not some
label such as fauvism, or cubism, or modernism.

Blumenschein felt that Hennings was the finest artist
in Taos, both in and out of the TSA. They each tried to
strive for perfection, but where Blumenschein was neu-
rotic to the point where he seldom was satisfied with any-
thing he did, Hennings seemed to strive to do the best of
which he was capable, complete the work, and go on to the
next.

Helen Hennings, the couple's only child, was born on
October 14, 1930, in Santa Fe, where they had gone to be
certain they could have medical care. The child should
have been a severe financial burden on the couple since
the Depression was hurting all the artists. But Hennings,
like a few of the others in the TSA, had prudently set
money aside during the good times and had no problems.
He was also one of the last of the TSA members to work for

the AT&SF, selling his first painting to them in 1925. He was commissioned to do nine in all for their private collection, though one additional commission came quite by chance many years later.

It was 1955, and one of the officials of the railroad saw an Indian portrait done by Hennings hanging in Valley National Bank in Arizona. The railroad wanted to have some paintings of the Navajo Indians and asked him to do one. As a result, the couple found themselves traveling to Ganado, Arizona, that September, living for six weeks in a hogan on the Trading Post grounds.

The painting that was created was one of a Navajo mother with a baby in a cradleboard. The baby had fallen asleep during the work so Martin painted the child that way, not realizing that the beliefs of the Navajo were quite different from those of the more familiar (to him) tribes of New Mexico.

The idea of painting was unfamiliar to the Navajo, so a large number of family members had gathered to watch the painting of the woman and her child. They stayed just close enough to see what was happening but not so close that they could view the painting. Once he was done and they stepped forward to look, they were horrified. According to their beliefs, the closed eyes meant that the baby was dead, an omen of disaster for the family. Martin immediately repainted the eyes so that they would be open. Then the much-relieved family went back to their daily activities.

Critcher is seldom mentioned as a member of the TSA despite the fact that she was elected to active membership in 1924 when she was 56 years old. Although raised in wealth, her family owning an estate in Virginia, she was not a woman of means as an adult. Her income came primarily from portrait painting and teaching; neither profession was particularly lucrative.

The railroad was no longer a money machine for most of the members of the TSA, though Couse, who notified Critcher of her acceptance, was on a long-term arrangement with the Atchison, Topeka, & Santa Fe. He had become advertising general agent Simpson's "pet" by 1923, the two of them collaborating on the work produced for an an-

nual calendar. Simpson would suggest the type of illustration he wanted, and Couse would produce it. Couse painted twenty-three calendar images between 1923 and 1936, and in the fifty years the railroad used paintings for their calendars, more than half included purchases made from Couse's work over the years. His arrangement ended only with his death in 1936.

Critcher was the least commercial of the TSA members. She had a wanderlust, a desire to teach, and a sense of her artistry as being that of a portrait painter, not a recorder of the Indians of the Southwest. Her work sold and sold well at times. Her subjects ranged from President Woodrow Wilson to Senator Harry F. Byrd to now nameless Gloucester fishermen. She also exhibited extensively; for example, at the Corcoran Gallery of Art, the Carnegie Institute, the Women's University Club in Washington, D.C., the Richmond Academy of Art, the Brice Museum in Stamford, Connecticut, and numerous other galleries. The Southern States Art League awarded her its Portrait Prize for *Indian Grandmother* in 1929, and the Witte Memorial Museum in San Antonio, Texas, gave her its $500 Purchase Award that same year. Previously, Alex Simpson, Jr., justice of the Pennsylvania Supreme Court, purchased *Indian Chief* specifically as a gift for the Philadelphia Museum of Art.

Yet Critcher never looked on her Indian paintings as income, only the commissioned portraits. In fact, most of the Indian paintings, though widely displayed and offered for sale in such locations as the Taos Village Gallery, were eventually given away to family members.

Her other major source of income came from teaching. She had always loved art and rejected traditional education roles in favor of study at the Cooper Union in New York. She was a medalist there, then left after a year to study in Washington at the Corcoran School of Art, where she won the Gold Medal for her work. Her education complete, she first returned to Virginia where her father, John Critcher, had become prominent in politics. He was a cavalry officer for the Confederate Army, then a judge who was removed from office in 1869 because he was considered to have committed the crime of bearing arms against

the United States during the Civil War. However, the following year, the hostility toward former Confederates was reduced enough so that he was able to serve a term in the U.S. Congress. He had arranged for his daughter to be tutored by a governess and was pleased with her decision to pursue art. His connections also helped her begin her career as a painter of portraits of the most prominent among the Virginia families.

John Critcher died in 1901, the same year that Catharine gained her first statewide recognition. She had painted the portrait of John Singleton Mosby, one of the most respected or hated Confederate soldiers, depending on the politics of the viewer. Mosby was not only a guerrilla fighter but also he established a private company called "Mosby's Raiders." His efforts were considered an important part of the rebellion, and the portrait she painted was presented to the University of Virginia.

Catharine made the obligatory trip to Europe to study in 1904, but by then she was 30 years old and so well established that she paid for her courses at the Académie Julian by opening, a year after her arrival, the Cours Critcher. This was not a school in competition with the Académie Julian, where she was still a student. Instead, it was a program of a type that she realized she had needed on arriving and could not get. It was meant for students who lacked familiarity with the French language and had trouble adjusting to the French way of teaching art.

"I opened a class in art, employing two Frenchmen— artists, as my assistants," she was quoted as saying in an interview in the *Jefferson Republican* published on December 23, 1948. "They spoke very little English and I acted as their interpreter and conducted the class. I made a living at this for four years during the winter and in the summer I supplemented my income by conducting tours of Americans visiting Europe." Although the school thrived and certainly drew students from other courses, she was still able to win the First Honor Student award at the Académie Julian and have a painting selected for the Paris Salon.

Critcher returned to the United States to teach at the Corcoran Art School in July 1909 for a salary of $450 per year. This was raised by slightly less than a dollar a week

after five years of successful teaching, a fact that forced her to handle as many portrait commissions as possible. She also realized that it would be far more profitable to have her own school, which she eventually opened in 1919. It was called the Critcher School of Painting and remained in business for twenty-one years.

At first, the school offered those courses she could teach—portraiture, composition, drawing, still life, and figure painting. She charged $20.00 per month per student. Then, after three years in St. Mathews Alley, where she also had her own studio, she joined with sculptor Carla Hill, moved to Connecticut Avenue, and renamed the school the Critcher-Hill Art School. She also helped found the Washington Arts Club and began winning awards for her portraiture.

In 1920 Catharine made her first trip to Taos and other cities in New Mexico. She was not working as an illustrator or taking advantage of the railroad as the others had done. She was simply excited by the chance to paint new types of faces—Spanish and Indian instead of just the Europeans and Americans with whom she had established her reputation.

The Taos experience was different in many ways. She did not view herself on a mission to record the past or present Indian life, nor was she a modernist trying to experiment with color and form. She did use some standard techniques everyone seemed to try at least once—the Indian astride a horse with a colorful blanket as a design element. But she dropped this idea quickly, concentrating instead on the character of each subject. Her images have intense faces, and she seems to be striving to show the character within.

Catharine lived where she could, not being offered the friendship that male artists were accorded. In the interview with the _Jefferson Republican_, she reminisced about one less than pleasant experience when she lived with a woman who proved to be emotionally disturbed. "She was a devoted friend, but she turned on me—slept with a loaded pistol under her pillow every night, carried it with her whenever we went in the car, wouldn't eat any of the food I had prepared and would leave the room whenever I

entered. I don't know why I wasn't afraid of her, but I wasn't. I later learned that she had been in sanitariums several times before and later some of her family came for her and placed her in one again."

Catharine avoided such circumstances during her subsequent trips to the Southwest when she painted both the Taos Pueblo natives and the Hopi Indians. She exhibited the work, lectured, and opened specialized schools such as the Red Rock Art Camp near Saltville, Virginia, which she ran in 1935 in conjunction with Margaret Munn.

The membership in the TSA was greatly appreciated, but Catharine was a misfit. Her concerns were not sales in the sense of the other artists. Money was not her primary goal, nor was she interested in perpetuating interest in the Southwest culture. She did not care if the Taos paintings attracted people to the West. She was simply a teacher and portrait painter whose brilliance and well-established credentials caused the members of the TSA to feel they would benefit by her election. They did not.

Kenneth Adams was the youngest of the men to join the TSA. He was born on August 6, 1897, and was just 30 years old when the society ceased to exist. He also was the only one to see active military service of a sort, having been drafted in September 1918. He served his entire time at Camp Funston, Kansas.

Adams was a womanizer who seemed to see his career both as a way to do the work he loved and as a way to meet women who would take off their clothing for him. He discovered art in the Kansas school system, where such work was stressed as intensely as learning to read and write. He excelled in watercolor painting and drawing and was encouraged to go to the Art Institute of Chicago on graduating from high school in 1916. There he found the type of training the other artists had earlier found in New York. The school was excellent and the museum had developed important collections of art. There were also dedicated art patrons, such as Carter Harrison, who had previously helped early members of the TSA when he was mayor of that city.

After being discharged from the army, Adams went to New York to study at the Art Students League and to view

the art at the various museums. He was introduced to the work of Andrew Dasburg and was fascinated by the style, just as Blumenschein was being changed by the same work.

Adams discovered that Dasburg ran a summer school for the Art Students League. The program was held at Woodstock in Ulster County, New York, and Adams not only enrolled but was one of the students who was given responsibility for taking care of aspects of the program. To his delight, Adams was placed in charge of the models, an appointment that was similar to an alley cat being asked to take charge of a group of mice. The randy Adams delighted in all of the women, then focused in on one who was in his "care." The joke around the school was that Adams was so concerned about his responsibility to the model that he made certain he visited her every night. And to be certain he did not disturb other students while handling his "arduous task," Adams climbed the side of the building and sneaked across the roof to get to her room.

After two years in New York, Adams felt that it was time to go to Paris. This was the Paris that Mary Blumenschein knew and loved, the center for the world's culture between the wars, a land where everything new and different in the arts seemed to originate.

From July 1921 until his departure two years later, Adams had what seemed to him to be the most exciting time of his life. Many of the women wore black as they mourned their dead, though many others were willing to put the losses of the war behind them as they developed new relationships. Paris was both a city that had survived and a city that was enjoying rebirth. Some buildings withstood the ravages of war, and others were being rebuilt. Yet the art had survived, the intellectuals had flocked to the city, and everywhere there was an energy that excited him.

Adams studied at the Académie Ranson and taught himself at the Louvre. He was intrigued by the modernists as well as the Mexican muralists who had begun to receive international attention. Where the other members of the TSA were taught traditional painting and then chose, in some instances, to adapt to the new styles of art, Adams's education was primarily in what, for his predecessors, had

been experimental. In fact, when something in life excited him to such a degree that he felt moved to paint it exactly, such as certain types of landscapes, he considered himself incapable of doing it justice.

Adams returned to the United States in 1923 and heard from Dasburg that the ideal place to work was Santa Fe. He arrived there several months later but could find no place to live. The community was experiencing a period of growth that exceeded the availability of affordable housing. However, Dasburg had a friend in Ufer and gave his former pupil a letter of introduction to the artist in Taos. Once Adams reached the community, he never looked back.

It was easier for Adams than it had been for the earlier members. He was the new kid on the block and young enough to be the son of most of them, including Catharine Critcher. They did not view him as competition, nor did they see him as an equal. Instead, they played the role of mentor, teaching him the land, the people, and their approach to art. He learned how to gain Indian models and how to make friends with the natives. Then, after he had been seasoned for a couple of years, they made him a member of the TSA in 1926.

Adams understood the importance of the TSA even though he was never really a part of their pioneering efforts. He became reflective in the 1950s, writing for the *New Mexico Quarterly*, explaining that the society had "stimulated the art of painting so effectively that today New Mexico has more resident artists per capita than any state in the Union. Its several members in the course of their lives have found themselves allied with the anthropologists, archaeologists and ethnologists in many a battle for the preservation of the native arts, national monuments, historic architecture, and the independence of the Indian. Many workers in the fields of the applied arts, architecture, sculpture, music and literature are grateful for the encouragement they have received from these men. Their contribution as unwitting publicists, perhaps, has been worth millions of dollars to the state and the surrounding area. Certainly no other professional group has contributed so much to the Southwest."

Adams delighted in his new world. He followed the men who came before him at first, his earliest work more traditional in style than his later paintings as he tried to understand the people and their culture. He also immediately became involved with the widow Hilda Brann Boulton, an extremely attractive young woman who was delighted with him.

Always the womanizer, the intensity of the relationship with Boulton was no match for the sexual energy he felt when Liane Hall, a visitor from Connecticut, came to Taos in 1927. He essentially abandoned Hilda to escort Liane around the community, then went to New York the following year to be present when he had a one-man show at the Ferargil Gallery. Once there he sent Liane an invitation to come down from her home, and the relationship intensified. They were married on October 29, 1928, immediately sailing for Paris.

Liane Adams had spent considerable time in Paris and knew it at least as well as her new husband. She also had more money than he did, paying for a studio where they could live for a while.

For Liane, the honeymoon seemed the ideal time for prolonged painting and lovemaking. She seemed to picture her husband turning out masterpieces, inspired by their shared passion for one another. Instead, he took a true vacation, delighting in going to clubs and generally playing the role of the wealthy American, a role for which neither of them had adequate funds. Little or no painting was accomplished, nor, apparently, had he ever intended to do any. He was relaxing for the first time in many years, and his bride hated that previously unseen side of him. They were divorced in Santa Fe the following June. Liane filed, using "nonsupport" as her reason for seeking the end of the marriage.

Hilda Brann Boulton was delighted with the end of the marriage. She did not care about Adams's character flaws. She just cared about having him as her husband.

Tragically, Adams received an unexpected comeuppance in this second marriage. Hilda developed tuberculosis, one of the most serious illnesses of the day and one that required almost constant nursing care. Taos was too

far from any medical facilities to allow for relief, so Adams had to tend to his wife himself. Either out of anger for his running off with Liane or because of her fear concerning her illness, Hilda became extremely demanding, expecting him by her bedside whenever he wasn't working nearby. Outside callers were discouraged by her, effectively isolating the couple.

The onset of the Depression caused even greater problems. All sales were down, and with the extra pressure of lost painting time because of Hilda, the Adamses often lacked adequate food. The couple was too proud to admit to the problem, but Buck Dunton and some of the other artists found a way to help. They would periodically find themselves with "extra" deer, fish, fruit, and vegetables that they shared with Adams.

Some of the financial burden was eased when the University of New Mexico opened a Field School in Taos in 1929 and hired Adams to teach. Four years later, he taught a fall semester in Albuquerque, though the pay was so bad that he applied for a job with the Works Progress Administration Federal Arts Project. He was hired immediately for $42.50 a week, more than enough to support himself and his wife.

Adams was finally free to paint full-time. His work required, among other things, that he provide plans and sketches for murals for public buildings. Among these were ones commissioned for use in Goodland, Kansas, and Deming, New Mexico. He turned down commissions for buildings in the East where he said he did not feel competent to understand the locale. The truth was that there was a limit to how long he could leave Hilda, both because of her needs and because of her distrust.

As the years passed, the teaching that had been done for money became work he grew to love. The University of New Mexico hired him for their 1938 Artist-in-Residence program sponsored by New York's Carnegie Foundation. He taught and prepared murals for the university library. The following year he became head of the art department for a girls' school in Albuquerque, returning to the university in 1942. He stayed with the school until 1963, retiring as professor emeritus.

The other change in Adams's work came when he began producing lithographs in 1932. He liked the technique and won prizes for such work as *Doña Ascensione* (The Print Club of Philadelphia, 1932), *The Miner* (Midwestern Artists' Exhibition, 1938), and others. He also delighted in the fact that such graphics ultimately brought far more money than paintings during the Depression years. Men such as Thomas Hart Benton and Grant Wood would sign work that often sold for $5.00 a copy, then sell it through graphic societies throughout the country. Adams was eventually joined by some of the other artists in Taos, many of whom, such as Ufer, had had experience in the print media and advertising.

While artists such as Blumenschein liked to make grandiose statements concerning art, Adams felt otherwise. Toward the end of his life (he died of cancer in 1966), he commented,

> *I have refused again and again, during the whole of my career as a painter and teacher to make any statement on art. I have never professed a personal credo and am no more ready to now than I was thirty years ago.*
>
> *I have read so many statements by painters of what their intentions were, listened endlessly to aesthetic argument and profundities associated with different theories that I feel the less said the better.*

The end of the Taos Society of Artists in 1927 did not upset Blumenschein. He had become a bitter, opinionated man emotionally alienated from the others. He felt that his importance in helping to found the TSA was overlooked, and his skills as an artist were underappreciated.

The criticism of him had been building on a national scale since the beginning of that decade. On November 12, 1921, the *New York Herald* ran an article attacking one of his paintings, which stated, "Mr. Blumenschein's 'Superstition' is a cheap and tawdry Indian picture. The Indians have suffered a good deal from the white man in times past, but it begins to seem as though we were destined to hound them to the very end."

A second painting, *Idealist Dreamer Realist*, was also attacked: "Less successful and even lacking in decorative qualities though highly stylized is the strange painting 'Idealist, Dreamer, Realist.' It might go as an illustration to a whimsically grotesque story, but as an oil painting it cannot hold our interest in any way." Although *Superstition* survives, either the criticism or Blumenschein's lifelong insecurity about his work caused him to destroy *Idealist Dreamer Realist*.

Even the early successes were tainted. He won the Altman Prize in 1921, but he won it by default. The prize was first given to a man who supposedly was a far better artist. However, it was learned that the winner was not a native-born American, a criterion for the award. Thus it was given to the person considered second best—Blumenschein.

By the time the TSA dissolved in 1927, however, Blumenschein was beginning again to receive a certain amount of success with the critics. The Grand Central show resulted in Elizabeth Cary of the *New York Times* writing, on February 6, 1927,

> The best examples of paintings have the double quality of faithfulness to nature and imaginative design. The painting titled "Extra Ordinary Affray" which was in a recent Academy exhibition, is one in which the painter lets himself work directly through nature, without imposing symbolism or literature upon the materials he has chosen.... When Mr. B. works in this way his talents surge towards greatness....
>
> His material is a mass of fighting savages, bare limbs and backs, slithering into battle with the easy motion of lithe muscles, shields raised, sharp lines of spears. An illusion of loud harsh cries filling the air. Mountains in the background with scarred faces, warriors in worse affrays; trampled weed and field growth in the foreground, a chieftain's headdress leading in a wedged movement towards the hills. No accusation possible of excessive celebration, of a technique overmastering the

*lively human interest of a good fight. Yet any close
attention to the design of the picture will disclose
the interest it also must possess for an intelligent
technician. The wedge-shaped mass pushing
toward the break in the hills. The ebb and flow of
motion determined by the swinging curves of line,
the contour of the hills against the sky.*

Blumenschein was pleased with the change in the
critics' reaction because he needed to have positive results,
partly because of his ego and partly because of the use of
photographs to illustrate magazines.

By the late 1920s, photographic emulsions had changed
radically. Light could be absorbed more quickly than in
the past. Photographs of moving objects could be taken
with ease. Cameras had become more portable, and the
use of photographs was increasingly important. In addi-
tion, there were mergers that reduced the total number of
magazines available for all forms of illustration. *Smart Set*
took over *McClure's* in 1928. *Scribner's* began using only
photographs, not artist's renderings, for illustrations in
1929. And *Century* was merged into *Forum* in 1930. The only
illustrators who were surviving were those who had devel-
oped a storytelling style so unique that they could sell
based on their special appeal. Thus Norman Rockwell
paintings would grace the covers of the *Saturday Evening
Post* long after the time when the same publication pre-
ferred photographers to artists for most of its needs.

Blumenschein was trying to find a new style to fit the
market for paintings. Illustrations often had expanses of
sky, especially when used for covers. These areas were
necessary for adding such material as the magazine logo-
type and any cover copy. But once he stopped illustrating,
his paintings began to have massive canyons and mesas
as design elements.

Blumenschein returned to Europe because his daugh-
ter, Helen, was living in Paris, becoming an artist like her
parents. Mary accompanied her, though working on her
jewelry rather than returning to the easel where she had
excelled. As most of his inspiration came from travels
around the Southwest, the trip was important only for

competing in tennis matches and bridge tournaments. However, the trips throughout the Southwest were fairly frequent and important to him. In 1933, he commented,

> *I usually brought back an art inspiration from these many trips to the Southwest. One of my best paintings, "Mojave Desert," came as the result of a tennis trip to Pasadena. It was in the afterglow when I saw the desert from the top of a hill. I was so impressed I memorized the color and light in the brief moment it lasted. We had to drive sixty miles to find a place to sleep, the minute we had holed up for the night I immediately made sketches in pencil and paint. I spent the next two days returning to the exact spot getting the structure of the hills and materials for the painting. There was never a tennis trip, or any other one, that did not yield a painting.*

The trips throughout the Southwest made Blumenschein a celebrity for reasons other than his paintings. Perhaps the most humorous was recorded by Henry Marion Hau, the writer, who with a photographer friend joined Blumenschein on a fishing trip. The photograph that was taken showed a new side to the artist, one he normally would have kept hidden. It appeared in *Outdoor Life* magazine with the following caption,

> *After a long dull stretch on a hot sultry day, Blumy planted the butt of his rod among the boulders and started to strip for a swim. Half undressed he heard the reel scream for attention. There followed one of the quaintest angling exhibitions on record. Blumy, filled with excitement, began to fight alternatively the leaping rainbow and sagging trousers. Trying to keep the fish free of the weeds, he was unable to keep himself free of his clothing. For a long time Victory couldn't make up her mind whether to settle on the fish, the clothing or Blumy. Ray overcame his convulsions sufficiently to set up the Graflex for a picture. He*

snapped it at the exact moment of consummation,
with Blumy rising naked but triumphant over the
line, fish and tangled underwear.

While Blumenschein was providing a humorous inci-
dent for the readers of *Outdoor Life*, he was further alienat-
ing himself from the people of Taos. On April 12, 1935, he
gave a talk before a meeting of the Dayton Lawyers Club
at the Biltmore Hotel in Dayton, Ohio. Despite the pres-
ence of a reporter from *The Dayton Journal* he proceeded
to attack the people of Taos. First he mentioned Mabel
Dodge Luhan: "She was a big, spoiled baby. If she saw a
husband better than the one she had, she bought him. She
was married to a Taos Indian named Tony. Her business
was building houses and upsetting plans."

Next Blumenschein turned against Couse. The reporter
for the paper wrote: "One other interesting character of
Taos the speaker told of was one painter named Couse,
who portrayed an Indian squatting. He sold the picture to
a calendar company and for 30 more years all he painted
were 'squatting Indians.'"

Then there were the closing remarks. They said more
about Blumenschein than he intended, though they were
meant to be an attack against his former friends. He
stated, "Taos would have the most happy people in the
world living there if it were not for professional jealousy
among the residents."

The article was not syndicated to other magazines, but
there were those in Dayton who knew members of the
former TSA, and they sent the story to Couse. He was
outraged and demanded an apology. Instead, Blumen-
schein sent his former friend a letter dated May 8, 1935, in
which he turned slander into libel. He stated, in part,

In speaking before the Lawyer's Club and
rather than give them a talk on art, of which they
knew very little, I told them of the famous men and
women I had encountered in my life, and gave
frank descriptions of how they appeared to me. I
began with Anton Dvorak, the great composer in
whose orchestra I played at twenty, continued

with the famous editors like Rich. Watson Gilde of
Century, *Burlingame and Bondesol of* Scribner's
and the authors I met as an illustrator. Edith
Wharton—Jack London—Ida Tarbell—Nela Cothe
—etc. etc. The part of my speech devoted to Mabel
was laudatory on the whole, and I ended that by
saying she was the most important and foremost
citizen of Taos.... What I said of you was as fol-
lows.—First I told of your early struggle painting
sheep. Then how one day for a calendar contest
you painted an Indian squatting before a buffalo
hide on which he was drawing. A child stood by
him. The painting won the competition prize and
made Couse famous. As a result of his success he
has been painting the same squatting Indian ever
since and it is still in demand.

The letter was both vicious and exaggerated. As noted
earlier, Blumenschein's famed connection with Dvořák
apparently never took place.

By 1936, the world was changing for everyone. There
were rumors of war coming in Europe, major changes in
government leadership, and problems with an economy
that still had not recovered from the Depression. The orig-
inal Taos artists were getting older, and the younger artists
drawn to the area were not a part of the world that Phillips
and Blumenschein had known during their trip more than
forty years earlier.

It was also the year that Blumenschein created what
he felt was his masterpiece. It was entitled *Jury for Trial of
a Sheepherder for Murder*, and by 1938 it was internationally
known. It won the National Arts Club Medal for that year,
then was shown at the American Art retrospective show in
the Tuileries Gardens at the Jeu de Paume Galleries in
Paris. After the exhibition, it was immediately purchased
by New York's Museum of Modern Art, the money coming
from a fund established by Mrs. John D. Rockefeller, Jr.

The honors the painting received had nothing to do
with its intended message. The content was simple, though
beautifully executed. Twelve Indian men sit solemnly in
the jury box, looking to their lower left where a man is sit-

ting at a table, writing. There is a symbolic portrait of George Washington, devoid of facial features, at the top center of the painting. Perhaps the best description was provided by Howard Cook during a 1948 retrospective of Blumenschein's work. He wrote, "There is classic grace throughout this honored picture which is based on a solid construction of basic abstract design. The use of huge harmoniously united color volumes in the figures reminds us of compositions of the great early Italian frescoes. Such important notes as the little window opening on snowy distance and the humorous placing of hats and hands on knees of the Jurymen serve to focus attention on the magnificently painted heads."

Nevertheless, the painting was a failure, because Blumenschein expected the public to view the painting as they would an illustration. He meant it to be the supreme combination of an illustrator's storytelling skill and the modernist's ability to convey emotion on canvas. He failed on all counts, because it is impossible to look at the painting and have any sense of the meaning of the title.

The painting began as a reaction to a real murder. Blumenschein wanted to convey the tragedy that was always possible with a sheepherder's work. Indian sheepherders were extremely lonely men. They had to work with the sheep for weeks or months at a time, a dog being their only companion. It was rare that another human being might be seen. Many of the men survived the loneliness by living inside their imaginations, but they knew that they were playing psychological coping games made necessary by the isolation. Ultimately, they returned to civilization, marrying and raising families, leading normal lives.

Other men could not handle the isolation, something they did not realize until it was too late for them. They were driven insane, creating a fantasy world filled with friends and enemies who were as real to them as flesh and blood. They could no longer differentiate between fact and fantasy and spent their entire lives in isolation or returning to civilization where they were shunned as crazy.

The painting was meant to illustrate the tragic story of a sheepherder who had been unable to adjust to the isola-

tion. He traveled armed, carrying a rifle with which to protect the sheep from predators, but he lost the ability to differentiate between a threat and a friend. By chance, a man rode through the sheep grazing area, his presence offering no threat to man or beast. But the sheepherder took his rifle and killed the passing stranger. Ultimately, he was arrested and put on trial.

Blumenschein viewed the case as a tragedy involving many innocents. There were only victims, and he wanted to portray this situation. Instead of sketching during the trial, he began the painting a year later. He used a single male model, then adapted the facial features and physical characteristics to match those of the Spanish mountain people he knew. Then he positioned his figures in a manner that revealed nothing of the drama that had taken place in the courtroom twelve months earlier. As a painting, it was a success. As an illustration, it failed completely, something Blumenschein should have realized because of his past training. Even the verdict—guilty of second degree murder—cannot be determined by looking at the faces. Yet he would later declare it to be his greatest work.

The same year that the painting was completed, Couse and Ufer both died, and the railroad drastically reduced its purchases. The old world was ending and would be completely destroyed by World War II.

It was not just the war that destroyed the Taos scene, however. America had changed radically in the previous fifty years. Automobiles and roads had improved, and no part of the United States was any longer truly isolated or inaccessible. The popularity of movies and radio was linking all cultures, creating an America more homogenized than ever before. The Grand Canyon and other tourist spots served by the railroad were well known and no longer had to be introduced to the American public. Communities such as Flagstaff, Arizona, eighty-five miles from the canyon, had become important cities with a diversity of industries and educational opportunities. General stores were being replaced by supermarkets. Filling stations dotted the highways. Billboards were common advertising tools.

The younger artists were entering the army and having

experiences that made the recording of a primitive, almost nonexistent life-style a trivial pursuit. The Works Progress Administration and the Farm Security Administration were using photographers to document the nation. _Life_ and _Look_ magazines brought photographs of the world to the most isolated settlements. Taos might remain an art colony, but the type of work and the philosophies of the artists who remained were radically different from what existed in the past. The Taos Society of Artists was dead. Many of its members were dying. And what had been a dynamic era—combining art and commerce, the opening of the West, and the introduction of paintings as a major selling tool—was over.

Blumenschein's family life was almost nonexistent as well. Mary spent most of her time in the East, and Helen lived both in Taos and with her mother. The Blumenscheins had a marriage in name only by then, neither of them making an effort to improve the relationship by the time the war in Europe had become a world war.

Helen Blumenschein was typical of the change. During World War I, her father and his friends had stayed at their easels, painting their range finders and continuing with their personal work. Helen, an artist, felt that she must serve by joining the military. She enlisted in the Women's Army Air Corps (WAAC), going to Officers Training School and graduating as a first lieutenant.

Helen was assigned to special emergency relief for army families. Composer Irving Berlin had taken the $10 million proceeds from his musical, "This Is the Army," and created the Army Emergency Relief Fund. It was for the fund that Helen worked her first year. After that, however, the money was transferred to the Red Cross and Helen was given a new assignment.

Helen was fluent in French, so she requested a transfer to French Morocco. Instead, she was assigned to New Guinea, where she worked as a censor because she also knew Spanish and there was a need for censors who could read the mail of Hispanic soldiers. It was Helen's job to be certain that nothing in them might be of value to the enemy. She also had to try to understand the morale of the men, writing regular reports for the other officers so that

they could know when there might be problems.
Helen later talked about her work:

> *We lost more men from disease than we did in the fighting, and it was terrible for those men living in the jungle camps, homesick, bored, heartsick and with only outdoor movies for recreation. Many of them went nuts until they were sent home. I preserved my sanity during my nine months there by painting watercolors in the jungle on Sundays. The other girls noticed that I was content so they began to paint with materials supplied by the Army. Then we had a huge art show.*
>
> *We were moved to the Dutch Island of Biak where we were confined to a compound because there were 50,000 Japs abandoned and loose in the jungle. Our next assignment was in Leyte. We hadn't seen Roosevelt for a long time, and it was a shock to see him in a newsreel looking so old and decrepit. The big ships were coming in for great sea battles, and they made an extraordinary array. We women were taken on a tour, and I went on the Missouri with a gunner.*
>
> *Mama wrote that she and Papa weren't well, and that our cook had expired from ptomaine poisoning contracted in her own kitchen. I took the letter to my commanding officer and asked for emergency leave, and that took three months to be processed before I went to Manila. There were 15 girls with emergency orders to go, but a WAAC captain held us up. I persuaded a friend to go with me to visit our Taos County National Guard POW's who had just arrived from prison camps in Japan. They were half-starved but excited at going home. There were no airplanes for them or for us. We were held for a 21-boat trip to California. The war was equal to a college education for me.*

By the time the war was over, Helen was on her way to becoming respected as an artist and her father had become an elder statesman of the art world. At last he had

the respect he had so long sought, although it was respect that comes from the death of one's enemies and contemporaries rather than from special achievements. It would only be later, after the death of all the TSA members, that Blumenschein would be hailed by many gallery owners as the best of the Taos artists, though all the members' works ultimately began selling for the same sums of money.

The reality did not matter for Blumenschein. He reveled in talking about modernism in art after visiting a San Francisco show in October 1952. He was genuinely one of the American pioneers of the trend, and he was proud of his own contributions. He mentioned how the early modernists who painted with color, using forms that were not known objects, were able to convey emotions in ways that had not been done before. He talked of how he, personally, had learned from the movement and grown as a result. He then made his usual attack against the artists of Taos who, with the exception of Andrew Dasburg, had not been a part of the accepted modernists: "In looking at the work of the Taos Society of Artists it is entirely proper and necessary to recognize their common source in the academic tradition of the nineteenth century, in the art schools of Chicago, Cincinnati, Paris, and Munich, and to acknowledge the range and popularity of their activity as illustrators and commercial artists. . . . They are all romantics at heart, with occasional digressions into a vigorous realism tempered by the light and color of the region. . . . Impressionism . . . served them only as a useful precedent for their own individual development."

Blumenschein died in 1960, and his studios became a historic landmark. Phillips had died four years earlier in Pasadena where he had gone to live with his family in his old age. His wife, Rose, had died in 1953 after fifty-four years of marriage. But Phillips continued painting to the end, simply changing where he worked.

Joseph Henry Sharp, like Catharine Critcher, lived into his nineties. He was 93 in September 1952 when he left Taos for Pasadena, planning to return. But he fell from a platform in his studio, breaking several ribs and never recovering from the injuries. He died in summer 1953 before he could return to New Mexico.

Critcher's death came in 1964 at the age of 95. She was not able to work at the end, spending her last years in a nursing home in Blackstone, Virginia.

Berninghaus died on April 27, 1932, and Dunton followed four years later, dying from cancer on March 18, 1936, the same year that Ufer died from appendicitis. Higgins suffered a heart attack on August 22, 1949, and Hennings died from the same cause on May 19, 1956. Adams was the last to die, his passing noted in 1966.

But it was the war that killed the ideals that had always been a part of the Taos Society of Art and the Depression that helped kill the economic incentives of the railroad. While Taos remains a popular artists' colony, the TSA has gradually faded from memory as the individual artists establish posthumous reputations through retrospectives in museums and galleries throughout the United States.

They were an eccentric lot, those drugstore cowboys who painted the changing face of the West. And the American art scene became all the richer because of them.

Notes Concerning Quotations

Chapter 1

Chaffin, Charles H. "Some New American Painters in Paris"; *Harper's Monthly;* Vol. 118; 1908-1909; pg. 285

Letheve, Jacques. *Daily Life of French Artists in the 19th Century;* New York: Praeger, 1972

Personal papers and letters of Bert Phillips from the collection of the Archives of Artists of the Southwest Nedra Matteucci's Fenn Galleries, Santa Fe, New Mexico.

Santa Fe *New Mexican*, 1939; "The Broken Wagon Wheel: Symbol of Taos Art Colony" by Ernest Blumenschein

El Palacio, May 1926, "Origins of the Taos Art Colony"

Taos News, September 12, 1968; "Seventy Years of Taos Art"

Chapter 2

Blumenschein. "The Broken Wagon Wheel: Symbol of Taos Art Colony; Santa Fe *New Mexican;* 1939

Personal papers and letters of Bert Phillips from the

collection of the Archives of Artists of the Southwest, Nedra Matteucci's Fenn Galleries, Santa Fe, New Mexico. These include December 14, 1898; December 18, 1898; January 4, 1899; January 15, 1899

Undated Bert G. Phillips memoir entitled *The Taos Art Colony*

"Blumenschein Is Interviewed," *El Palacio 6*, March 1919

CHAPTER 3

Ladies Home Journal; various issues in 1891 and 1892

John Hull poem from Ernest Blumenschein Collection, Archives of American Art, Smithsonian Institution, Washington, D.C.

Tom Foolery, various issues; Ernest Blumenschein Collection, Archives of American Art, Smithsonian Institution, Washington, D.C.

CHAPTER 4

June 4, 1891, letter from the Puzzles Editor of *Harper's Young People*

Blumenschein. "The Broken Wagon Wheel: Symbol of Taos Art Colony; Santa Fe *New Mexican*; 1939

"Blumenschein Is Interviewed," *El Palacio 6*, March 1919

Undated clipping (1896) Dayton *Herald* review of Ernest Blumenschein's *Flute-Player*

New Mexico magazine, August 1932; interview with Joseph Henry Sharp

CHAPTER 5

Letters from Phillips to Blumenschein; Ernest Blumenschen Collection, Archives of American Art, Smithsonian Institution, Washington, D.C.

Letters from Blumenschein to Ellis Parker Butler; September 1899; January 16, 1900; Ernest Blumenschein Collection, Archives of American Art, Smithsonian Institu-

tion, Washington, D.C.

Letter from Leonard Blumenschein to Ernest Blumen-
schein; January 12, 1905; Ernest Blumenschein Collection,
Archives of American Art, Smithsonian Institution,
Washington, D.C.

Century Magazine, April 1914

CHAPTER 6

Frontier Monthly; article entitled "The Penitentes of
New Mexico" written by Herbert Geer (pen name of Bert
Phillips); 1903

Letters from Phillips to Blumenschein; Archives of
Artists of the Southwest, Nedra Matteucci's Fenn Galler-
ies, Santa Fe, New Mexico

CHAPTER 7

Harper's Weekly, October 14, 1893

El Palacio, May 1926

Brush & Pencil, April 1899; March 1990

Letter from Sharp to the Office of Indian Affairs,
Department of the Interior; January 18, 1902; Archives of
Artists of the Southwest, Nedra Matteucci's Fenn Galler-
ies, Santa Fe, New Mexico

Letter from the Indian Commissioner to Sharp; Janu-
ary 21, 1902; Archives of Artists of the Southwest, Nedra
Matteucci's Fenn Galleries, Santa Fe, New Mexico

J. H. Sharp. *Early Biography*; unpublished manuscript;
Archives of Gilcrease Institute of American Art and History

Letter to Phoebe Apperson Hearst; exact date uncer-
tain; early 1913 (probably February or March); Archives of
Artists of the Southwest, Nedra Matteucci's Fenn Galler-
ies, Santa Fe, New Mexico

Kansas City Times; June 12, 1952; article on Oscar Ber-
ninghaus

The American Scene 3 (Fall 1960); article entitled "O. E.
Berninghaus: For the Artist, Taos Had Everything" by Jane
Slocum

The Art Review; January 1904

Bickerstaff, Laura M., with an introduction by Ernest

L. Blumenschein. *Pioneer Artists of Taos*; Denver: Sage Books, 1955. Also revised and expanded edition, Denver: Old West Publishing Company, 1983

CHAPTER 8

Blumenschein letters to and from William H. Simpson; October 12, 1910; June 8, 1911; September 11, 1911; Ernest Blumenschein Collection, Archives of American Art, Smithsonian Institution, Washington, D.C.

New Mexico Magazine, December 1932; "Art and Artists of New Mexico" by Ina Sizer Cassidy

Letter from Blumenschein dated July 15, 1922; Ernest Blumenschein Collection, Archives of American Art, Smithsonian Institution, Washington, D.C.

Kansas City Times, November 11, 1924

CHAPTER 9

Blumenschein notes and letters related to the Salmagundi Club, 1918; Ernest Blumenschein Collection, Archives of American Art, Smithsonian Institution, Washington, D.C.

Letter from M. L. Blumenthal of the National War Savings Committee; July 27, 1918

Letters from Major General Leonard Wood to Blumenschein (various dates in 1918); Ernest Blumenschein Collection, Archives of American Art, Smithsonian Institution, Washington, D.C.

CHAPTER 10

Chicago Sun-Times, April 15, 1917

New Mexico Magazine, January 1933; "Art and Artists of New Mexico" by Ina Sizer Cassidy

Kansas City Post, February 12, 1916

Minutes and letters of the Taos Society of Artists; History Library, Palace of the Governors, Santa Fe, New Mexico

Blumenschein, Helen G. *Sangre de Cristo, Taos*; privately printed, 1955

American Artist, January 1978; "Walter Ufer: Passion

and Talent," by Ted and Kit Egri

El Palacio, August 1916; "The Santa Fe-Taos Art Colony: Walter Ufer"

Catalogue from the Forum Exhibition of Modern Painters; Anderson Galleries; March 1916

CHAPTER 11

Jefferson Republican, December 23, 1948; article entitled "Personality of the Week: Miss Catharine Carter Critcher"

New Mexico Quarterly, Summer 1951; "Los Ochos Pintores" by Kenneth Adams

"Kenneth M. Adams: A Retrospective Exhibition," 1964 exhibition catalog; introduction by Van Deren Coke

Broder, Patricia Janis. *Taos: A Painter's Dream*; Boston: New York Graphic Society, 1980

SELECTED BIBLIOGRAPHY

BOOKS

Broder, Patricia Janis. *Taos: A Painter's Dream*. Boston: New York Graphic Society, 1980.

Garraty, John A., editor, and Sternstein, Jerome L., associate editor. *Encyclopedia of American Biography*. New York: Harper & Row, 1974.

Mott, Frank Luther. *A History of American Magazines: 1885-1905*. Cambridge, Mass.: The Belknap Press of Harvard University Press, 1957.

Tebbel, John. *The American Magazine: A Compact History*. New York: Hawthorn Books, Inc., 1969.

——— . *The Compact History of the American Newspaper*. New York: Hawthorn Books, Inc., 1963.

——— . *The Life and Good Times of William Randolph Hearst*. New York: E. P. Dutton & Co., 1952.

Winkler, John K. *William Randolph Hearst*. New York: Hastings House, 1955.

Woodward, Helen. *The Lady Persuaders*. New York: Ivan Obolensky, Inc., 1960.

INTERVIEWS BY
SHERRY CLAYTON TAGGETT

Helen Blumenschein
Lucille Brock
Eleanor and Lowell Cheetham
James Culbert
Charles Dutant
Miriam Folson (piano student of Leonard Blumenschein in
 1912)
Genevieve Jansen
Jean and Paul Kloss
Virginia Levitz (granddaughter of Couse)
J. J. Miller
Ralph Phillips
Mrs. Lucille Pond

INTERVIEWS CONDUCTED IN TAOS, NEW
MEXICO, IN AUGUST 1977 BY SUSAN
MEYER, EDITOR OF
AMERICAN ARTIST MAGAZINE

Jack Boyer
Dorothy Brandenburg
Regina Tatum Cooke
Ted and Kit Egri
Frank Waters

BLUMENSCHEIN BUSINESS LETTERS

Blumenschein, E. L., letter to Kenneth Adams, March 16,
 1938.
Blumenschein, E. L., to Kenneth Adams, October 6, 1948
Blumenschein, E. L., to Berninghaus, Taos Society of
 Artists, July 15, 1922.
Blumenschein, E. L., to Berninghaus, July 24, 1923.
Blumenschein, E. L., to Miss Booth, July 14, 1946.

Blumenschein, E. L., to Royal Cortissoz, February 27, 1923.
Blumenschein, E.L., to Royal Cortissoz, February 25, 1927.
Blumenschein, E. L., to Couse, May 8, 1935.
Blumenschein, E. L., to Mr. Eggers, Art Institute of Chicago, October 4, 1918.
Blumenschein, E. L., to Mr. Eggers, November 20, 1918.
Blumenschein, E. L., to Reginald Fisher, August 29, 1948.
Blumenschein, E. L., to Reginald Fisher, September 6, 1953.
Blumenschein, E. L., to Reginald Fisher, June 1, 1955.
Blumenshcein, E. L., to Reginald Fisher, August 7, 1955.
Blumenschein, E. L., to Mr. Gest, Cincinnati Art Museum, April 15, 1914.
Blumenschein, E. L., to Mr. Gest, September 23, 1914.
Blumenschein, E. L., to Mr. Gest, March 27, 1918.
Blumenschein, E. L., to Mr. Gest, July 16, 1918.
Blumenschein, E. L., to Mr. Gest, July 25, 1918.
Blumenschein, E. L., to Mr. Gest, August 25, 1918.
Blumenschein, E. L., to Mr. Gest, October 25, 1918.
Blumenschein, E. L., to Mr. Gest, May 1919.
Blumenschein, E. L., to Mr. Gest, February 19, 1928.
Blumenschein, E. L., to Mr. Gest, March 8, 1928.
Blumenschein, E. L., to Mr. Gest, May 7, 1928.
Blumenschein, E. L., to Mr. Gilcrease, September 10, 1945.
Blumenschein, E. L., to Mr. Gilcrease, October 10, 1945.
Blumenschein, E. L., to Mr. Gilcrease, December 24, 1948.
Blumenschein, E. L., to Mr. Gilcrease, November 26, 1949.
Blumenschein, E. L., to Mr. Gilcrease, March 4, 1951.
Blumenschein, E. L., to Mr. Gilcrease, August 7, 1951.
Blumenschein, E. L., to Mr. Gilcrease, August 29, 1951.
Blumenschein, E. L., to Mr. Gilcrease, June 10, 1952.
Blumenschein, E. L., to Mr. Gilcrease, September 2, 1952.
Blumenschein, E. L., to Miss Beatrice Howe, Albright-Knox Gallery, Buffalo, April 23, 1920.
Blumenschein, E. L., to Miss Howe, June 7, 1920.
Blumenschein, E. L., to Miss Howe, October 1, 1920.
Blumenschein, E. L., to Miss Howe, December 19, 1922.
Blumenschein, E. L., to Jaccaci, no date.
Blumenschein, E. L., to Hester Jones, Curator, Museum of New Mexico, July 18, 1949.
Blumenschein, E. L., to Henry Koch, October 3, 1918.

Blumenschein, E. L., to MacBeth Galleries, November 16 1915.

Blumenschein, E. L., to Dear Pal, August 22, 1950.

Blumenschein, E. L., to Miss Quinton, Albright-Knox Gallery, Buffalo, October 16, 1923.

Blumenschein, E. L., to Miss Quinton, October 20, 1923.

Blumenschein, E. L., to Miss Quinton, January 12, 1924.

Blumenschein, E. L., to Miss Quinton, January 23, 1924.

Blumenschein, E. L., to Mrs. Roberts, February 1, 1925.

Blumenschein, E. L., to W. H. Simpson (Atchison, Topeka & Santa Fe Railroad), September 9, 1911.

Blumenschein, E. L., to W. H. Simpson, March 16, 1913.

Blumenschein, E. L., to W. H. Simpson, March 26, 1913.

Blumenschein, E. L., to W. H. Simpson, April 5, 1913.

Blumenschein, E. L., to W. H. Simpson, January 17, 1917.

Blumenschein, E. L., to W. H. Simpson, March 27, 1917.

Blumenschein, E. L., to W. H. Simpson, August 3, 1926.

Blumenschein, E. L., to W. H. Simpson, October 14, 1926.

Blumenschein, E.L., to Mr. Stamm, May 26, 1929.

Blumenschein, E. L., to Mr. Stamm, March 15, 1932.

Blumenschein, E. L., to Mr. Stamm, March 22, 1932.

Blumenschein, E. L., to Booth Tarkington, December 4, 1901.

Blumenschein, E. L., to Booth Tarkington, January 20, 1926.

Blumenschein, E. L., to Booth Tarkington, January 22, 1927.

Blumenschein, E. L., to Booth Tarkington, no date.

Blumenschein, E. L., to Mrs. W. B. Thayer, April 16, 1913.

Blumenschein, E. L., to unknown person, September 16, 1918.

Blumenschein, E. L., to Mr. Woodward, Casson Galleries, January 5, 1923.

Blumenschein, E. L., to Mr. Woodward, August 14, 1923.

Blumenschein, E. L., to Mr. Woodward, August 29, 1923.

Blumenschein, E. L., to Mr. Woodward, September 12, 1923.

Blumenschein, E. L., to Mr. Woodward, October 16, 1923.

Blumenschein, E. L., to Mr. Woodward, November 11, 1923.

Blumenschein, E. L., to Mr. Woodward, November 28, 1923.

Blumenschein, E. L., to Mr. Woodward, December 11, 1923.

Blumenschein, E. L., to Mr. Woodward, December 18, 1923.

Blumenschein, E. L., to Mr. Woodward, June 21, 1924.

SELECTED BLUMENSCHEIN CATALOGS OF ART EXHIBITIONS AND GALLERIES

ART INSTITUTE OF CHICAGO

Catalog of the Annual Exhibition of Oil Paintings and Sculpture by American Artists, 34th, 1921, one illus., *White Son and Star Road*, by Blumenschein.

——— . 38th, 1925, one illus., *New Mexico*, by Blumenschein.

——— . 42nd, 1929, one illus., *Night Scene*, by Blumenschein.

Catalog of a Century of Progress Exhibition of Paintings and Sculpture, June 1 to November 1, 1934, words :"First Edition" on title page, 103 pp. plus 95 plates, including no. 82 by Blumenschein.

Half a Century of American Art, November 16, 1939, to January 7, 1940, 61 pp. plus 78 plates, including XXI, *The Chief Speaks*, by Blumenschein. Note on Blumenschein, p. 7. (Remington)

BABCOCK GALLERIES, NEW YORK

Paintings of the West, 1920, unpaged (16), one illus. by Blumenschein. (Dunton, Russell)

Carnegie Institute, Department of Fine Arts. Pittsburgh: Annual Exhibition of Paintings, 28th, 1929, one illus., *Landscape with Indian Camp*, by Blumenschein.

——— . 29th, 1930, one illus., *Marie*, by Blumenschein.

——— . 30th, 1931, one illus., *New Mexican Interior*, by Blumenschein.

Painting in the U.S., 1943, one illus., *Box Cars and Railroad Tracks*, by Blumenschein. (Hurd)

CINCINNATI ART MUSEUM

Annual Exhibition of American Art, 28th, 1921, one illus., *October*, by Blumenschein.

Same, 32nd, 1925, one illus., *White Son and Star Road*, by Blumenschein.

CITY ART MUSEUM, ST. LOUIS

Annual Exhibition of Selected Paintings by American

Artists, 15th, 1920, one illus., *Indian Battle*, by Blumenschein.
——— . 17th, 1922, one illus., *Superstition*, by Blumenschein.
——— . 26th, 1931, one illus., *Adobe Village, Winter*, by Blumenschein.

CORCORAN GALLERY OF ART, WASHINGTON, D.C.

Biennial Exhibition of Contemporary American Oil Paintings, 1928(-29), one illus., *White Son and Star Road*, by Blumenschein. (Dunton)
——— . 1930-31, one illus., *Adobe Village, Winter*, by Blumenschein.
——— . 1932-33, one illus., *The City*, by Blumenschein.

EL PASO MUSEUM OF ART

The McKee Collection of Paintings (1968), cloth with an illus. in color mounted on the front cover, tan endsheets, 67 pp., "Foreword" by Leonard P. Sipiora (Director), numerous illus. including one in color, p. 30, by Blumenschein. (Dunton, Hurd, Koerner, Lea)
——— . 1,000 copies in pic. wraps.

GALLERY OF SCIENCE AND ART, PALACE OF ELECTRICITY AND COMMUNICATION, GOLDEN GATE INTERNATIONAL EXPOSITION, SAN FRANCISCO

Contemporary Art of the United States, Collection of the IBM Corporation (1940), morocco, marbled endsheets, unpaged, all edges gilt, numerous illus. including one, *Mountains Near Taos*, by Blumenschein and a photo of him. (Lea)

GALLERY WEST, DENVER

The American Indian and Selected Western Paintings, January 1974, pic. wraps, 16 pp., eighteen illus. including one, p. 4, by Blumenschein. (Borein, Deming, Russell)

GRAND CENTRAL ART GALLERIES, NEW YORK

Exhibition of Paintings and Sculpture Contributed by the Founders of the Galleries, commencing June 27, 1923, wraps, unpaged, numerous illus. including one, *Indian and Red Mountain*, by Blumenschein and with a brief biographical sketch of him.

Year Book 1930, stiff boards with illus. in color on front cover, decor. endsheets, 79(1) pp., numerous illus. including one, *Adobe Village*, p. 8, winner of first prize for landscape, by Blumenschein. (Johnson)

Year Book 1938, wraps with illus. mounted on front cover, 72 pp., numerous illus. including one, *Moon, Morning Star and Evening Star*, p. (18), by Blumenschein. (Johnson, Leigh)

KENNEDY GALLERIES, NEW YORK

The Things That Were (nineteenth- and twentieth-century paintings of American West), June 1968, colored pic. wraps, pp. 52-123, (1), numerous illus. including one, no. 107, *Maurico of Taos Pueblo*, by Blumenschein. (Crawford, Leigh, Miller, Remington, Schoonover, Schreyvogel)

Western Words, June 1969, colored pic. wraps, 75 pp. numerous illus. including one by Blumenschein. (Johnson, Miller, Remington, Russell, Schreyvogel, Zogbaum)

The Great American West, June 1973, colored pic. wraps, pp. (131)-192, numerous illus. including one in color, p. 170, by Blumenschein. (Leigh, Miller, Remington, Russell, Schreyvogel)

LOS ANGELES COUNTY MUSEUM OF HISTORY, SCIENCE AND ART, LOS ANGELES

Catalog of the Mr. and Mrs. William Preston Harrison Galleries of American Art, 1934, one illus., *Juanita of Taos*, by Blumenschein.

MUSEUM OF MODERN ART, NEW YORK

Paintings and Sculpture from Sixteen American Cities, 1933, one illus., *Lone Fisherman*, by Blumenschein.

Art in Our Times, 1939, one illus., *Jury for Trial of a Sheepherder for Murder*, by Blumenschein.

MUSEUM OF NEW MEXICO ART GALLERY, SANTA FE

A Retrospective Exhibit of the Life Work of Ernest L. Blumenschein, May 30 to June 30, 1948, catalog of paintings (65), six illus. by Blumenschein and a brief biographical sketch.

A Retrospective Exhibition, 1902-1958, at State College,

N.M., December 14, 1958, to January 4, 1959, eight illus. by Blumenschein.

An Exhibition of Paintings from the Santa Fe Railway Collection, 1966, one illus. by Blumenschein. (Dunton, Leigh)

NATIONAL ACADEMY OF DESIGN, NEW YORK

Annual Exhibition Catalog, 85th, 1910, one illus., Portrait of a German Tragedian, by Blumenschein.

——— . 90th, 1915, one illus., *Violinist*, by Blumenschein.

——— . 92nd, 1917, one illus., *Medicine Man*, by Blumenschein.

——— . 98th, 1923, one illus., *The Gift*, by Blumenschein.

——— . 99th, 1924, one illus., *Idealist, Dreamer, Realist,* by Blumenschein.

——— . Centennial Exhibition, 1925, one illus. by Blumenschein. (Remington)

——— . 104th, 1929, one illus., *Burro*, by Blumenschein.

——— . 111th, one illus., *Jury for Trial of a Sheepherder for Murder,* by Blumenschein.

——— . 115th, 1941, one illus., *Homeward Bound*, by Blumenschein.

THE NATIONAL ARCHIVES OF THE UNITED STATES, WASHINGTON, D.C.

Indians and the American West, October 26, 1973-January 21, 1974, colored pic. wraps, unpaged, numerous illus. including no. 5 in color by Blumenschein. (Dunton, Schreyvogel)

NATIONAL ART SOCIETY, NEW YORK

American Art Today, World's Fair, 1939-40, one illus., *Red Symphony*, by Blumenschein.

OKLAHOMA ART CENTER, OKLAHOMA CITY

European and American Paintings (from the collection of Mr. and Mrs. W. E. Davis), November 5-27, 1964, colored pic. wraps, unpaged (16), 25 illus. including one by Blumenschein. (Hurd, Remington, Russell)

PENNSYLVANIA ACADEMY OF FINE ARTS, PHILADELPHIA

111th Annual Exhibition, 1916, one illus., *Chief's Two Sons*, by Blumenschein.

PHOENIX ART MUSEUM

An Exhibition of Paintings of the Southwest from the Santa Fe Railway Collection, February 1 through April 30, 1966, including one illus., p. 9, by Blumenschein. (Dunton, Leigh)

SESQUICENTENNIAL INTERNATIONAL EXHIBITION, DEPARTMENT OF FINE ARTS, PHILADELPHIA

Painting, Sculpture, and Prints, 1926, one illus., *Sangre de Cristo Mountains*, by Blumenschein.

SOTHEBY PARKE BERNET, NEW YORK

Important Eighteenth-, Nineteenth-, and Early Twentieth-Century American Paintings, Watercolors, and Sculpture, sale no. 3498, April 11, 1973, colored pic. wraps, unpaged, numerous illus. including one by Blumenschein. (Eggenhofer, James, Johnson, Leigh, Remington, Russell, Varian, Wyeth)

SOTHEBY PARKE BERNET, LOS ANGELES

Western American Paintings, Drawings and Sculpture, March 4 and 5, 1974, colored pic. wraps, unpaged, 252 lots, numerous illus. including lot 91 by Blumenschein. (Dunton, Johnson, Koerner, Leigh, Remington, Russell)

VIRGINIA MUSEUM OF FINE ARTS, RICHMOND

First Biennial Exhibition of Contemporary American Paintings, 1938, one illus., *Adobe Village*, by Blumenschein.

ILLUSTRATED BY E. L. BLUMENSCHEIN

American Art Annual, vol. 11. American Federation of Arts, Washington, D.C., 1914. Cloth, numerous illus. includ-

ing one, *Wise Man, Warrior and Youth*, by Blumenschein and with a brief biography of him.

Baird, Joseph A., Jr. (compiled by). *The West Remembered.* San Francisco and San Marino: California Historical Society, 1973. Colored pic. wraps, 88 pp., "Foreword" by Mitchell A. Wilder, introduction, numerous illus. including one, p. (37), by Blumenschein. (Borein, Dixon, James, Lungren, Marchand, Miller, Remington, Russell, Zogbaum)

Bart, Alfred A. (Director). *Art in Our Times.* Museum of Modern Art (N.Y.), 1939. Wraps. 384 pp., index, profusely illustrated including plate no. 142, *Jury for Trial of a Sheepherder for Murder*, by Blumenschein.

Bennett, Robert Ames. *Thyra.* New York: Henry Holt and Co., 1901. Cloth, 258 pp., four illus., frontis., and facing pp. 64, 154, and 239 by Blumenschein.

Bickerstaff, Laura M. *Pioneer Artists of Taos.* Denver: Sage Books, 1955. Cloth, 93 pp., "Introduction" by Ernest L. Blumenschein, 28 illus. including three, following p. 22, by Blumenschein. (Dunton)

Brady, Cyrus Townsend. *Indian Fights and Fighters.* New York: McClure, Phillips & Co., 1904. Words "Published December, 1904" on copyright page, pictorial cloth, 423 pp., preface, bibliography, appendices, index, 26 full-page plates including a frontis. by Blumenschein, 13 maps and plans. (Crawford, Deming, Elwell, Remington, Schreyvogel)

Breckenridge, J. Ellis *Something Else.* Chicago: A. C. McClure & Co., 1911. Words "Published September, 1911" on copyright page, cloth, 438 (1) pp., four illus. in color, frontis, and facing pp. 188, 360, and 404 by Blumenschein.

Coke, Van Deren. *Taos and Santa Fe: The Artist's Environment, 1882-1942.* Albuquerque: University of New Mexico Press, 1963. Words "First Edition" on copyright page, cloth, 160 pp., "Foreword" by Mitchell A. Wilder, selected bibliography, index, numerous illus. including five, pp. (19) in color, 62, 114 (two) and 115 by Blumenschein and a photo of him, p. 14. (Dunton)

Cortissoz, Royal (Introduction). *Annual of the Society of Illustrators.* New York: Charles Scribner's Sons, 1911. Words "Published November, 1911" on copyright page, cloth and boards, 9½x11¼", introduction of xxii (2) pp., list

of members, 85 full-page illus. including one by Blumenschein. (Fogarty, Keller, Remington)

Eastman, Chas. A. *Indian Boyhood*. New York: McClure, Phillips & Co., 1902. Words "Published October, 1902" on copyright page, cloth with small colored illus. mounted on the front cover, 289 pp., gilt top, four full-page illus., frontis., and facing pp. 76, 148, and 210 and other drawings and decorations by Blumenschein.

Fergusson, Erna. *Dancing Gods*. New York: Alfred A. Knopf, 1931. Words "First Edition" on copyright page, dec. cloth, 276 pp., tan top, introduction, index, illustrated including one full-page plate, *Deer-Dance at Taos*, facing p. 36, by Blumenschein.

Fitzpatrick, George, ed. *Pictorial New Mexico*. Santa Fe, N.M.: The Rydal Press, 1949. Words "First Printing, December 1949" on copyright page, dec. cloth, brown endsheets, 191 pp., "Foreword" by Gov. Mabry, acknowledgments, over 200 illustrations, including one in color, p. 102, by Blumenschein.

Gann, Dan, and Merrill A. Kitchen, eds. *The Westerners Brand Book*, 1949. The Los Angeles Corral, 1949 (copyrighted 1950). Morocco and cloth, pictorial endsheets, 263 pp., foreword by Sheriff Homer H. Boelter, index, numerous illus. including two pp. 182 and 183 by Blumenschein, notes on Blumenschein by Don Louis Perdeval. Limited to 400 copies. (Borein, Dixon, Johnson, Remington, Russell)

Getlein, Frank, et al. *The Lure of the Great West*. Waukesha, Wis.: Country Beautiful, 1973. Boards, 352 pp., introduction, 375 illus. including one, pp.(326)-7, by Blumenschein. (Koerner, Leigh, Miller, Remington, Russell, Schreyvogel, Wyeth)

Harmsen, Dorothy. *Harmsen's Western Americana*. Flagstaff, Ariz.: Northland Press, 1971. Morocco and cloth, blue endsheets, 213 pp., "Foreword" by Robert Rockwell, introduction, numerous illus. including one in color, p. (29), by Blumenschein and with a biographical sketch of him. Author's edition of 150 numbered copies signed by the author in slipcase with morocco title label. (Beeler, Borein, Dixon, Dunn, Dunton, Eggenhofer, Elwell, Hurd, Johnson,

Leigh, Marchand, Miller, Russell, Von Schmidt, Wyeth)
———. First trade edition, two-tone cloth with red end-sheets.

Hewett, Edgar L. *Representative Art and Artists of New Mexico*. Santa Fe, N.M.: School of American Research, Museum of New Mexico (Santa Fe Press), 1940. Pictorial wraps, 40 pp., biographical notes, numerous illus. including one, p. 9, by Blumenschein. (Dunton, Hurd)

Jackman, Rilla Evelyn. *American Arts*. Chicago, New York, San Francisco: Rand McNally Co., 1928. Cloth, 561 pp., illus. including one, facing p. 272, by Blumenschein. Biographical sketch, p. 269.

Keleher, William A. *Turmoil in New Mexico*. Santa Fe, N.M.: The Rydal Press, 1952—released in December 1951. Cloth, map endsheets, 534 pp., foreword, index, illus. including a frontispiece by Blumenschein.

———. *Violence in Lincoln County, 1869-1881*. Albuquerque: University of New Mexico Press, 1957. Words "First Edition" on copyright page, cloth, map endsheets, 390 pp., foreword, sources, index, illus. with a frontispiece by Blumenschein and with photographs.

Kipling, Rudyard. *The Day's Work*. New York: Doubleday & McClure Co., 1898. Pic. cloth, 431 pp., gilt top, eight illus. including two, facing pp. 114 and 150, by Blumenschein.

Kloster, Paula R. *The Arizona State College Collection of American Art*. Pasadena, Calif.: The Castle Press, 1954. Wraps, 108 (1) pp., "Foreword" by President Grady Gammage, introduction, acknowledgments, index, 113 illus. including one, p. 34, by Blumenschein. (Johnson, Remington, Russell)

Lanier, Henry W. *The Book of Bravery*. New York: Charles Scribner's Sons, New York, 1918. Words "Published September, 1918" on copyright page, pictorial cloth, 420 pp., preface, illus. including one full-page plate, facing p. 238, by Blumenschein.

Luhan, Mabel Dodge. *Taos and Its Artists*. New York: Duell, Sloan and Pearce. 1947. Cloth, red endsheets, 168 pp., acknowledgments, profusely illus. including plate no. 9, *Sheep Herder*, by Blumenschein. Photo and much on Blumenschein in text. (Dunton, Remington)

Major, Mabel, and Rebecca W. Smith. *The Southwest in*

Literature. New York: The Macmillan Co., 1929. Cloth, 370 pp., illus. including one, facing p. 121, *The Chief Speaks,* by Blumenschein.

Merwin, Samuel. *The Road to Frontenac.* New York: Doubleday, Page & Co., 1901. Decorated cloth, 404 pp., four illus., frontis. and facing pp. 36, 64, and 256 by Blumenschein.

Minton, Charles Ethridge (State Supervisor). *New Mexico, A Guide to the Colorful State.* Compiled by Workers of the Writers' Program, W.P.A. New York: Hastings House, 1940. Words "First Published in August 1940," cloth, map on front endsheet, 458 pp., "Foreword" by Clinton P. Anderson, "Preface" by Minton, chronology, Some Books About New Mexico, index, numerous illus. including one, between pp. 394 and 395, by Blumenschein, maps. (American Guide Series)

Neuhaus, Eugene. *The Galleries of the Exposition (A Critical Review of the Paintings, Statuary and the Graphic Arts in the Palace of Fine Arts at the Panama-Pacific International Exposition).* San Francisco, 1915, board, 98 pp., numerous illus. including one, *The Peacemaker,* facing p. 34, by Blumenschein.

——— . *The History and Ideals of American Art.* Stanford: Stanford University Press, 1931. Cloth with paper labels, 444 pp., tinted top, preface, bibliography, index, illus. including one, page (310), by Blumenschein. (Dixon, Remington, and Russell)

Pach, Walter, et al. *New Mexico Artists.* Albuquerque: University of New Mexico Press, 1952. Pictorial boards, 124 (7) pp., "Introduction" by Joaquin Ortega, numerous illus. including eleven by Blumenschein. (New Mexico Artist Series no. 3) (Hurd)

Paine, Ralph D. *The Praying Skipper and Other Stories.* Outing, N.Y., 1906, cloth, 229 pp., six illus. including one, the frontis., in color, by Blumenschein.

Parrish, Randall. *Molly McDonald.* Chicago: A. C. McClure & Co., 1912. Words "Published April, 1912" on copyright page, 403 (1) pp., four illus. in color, frontis. and facing pp. 108, 220, and 286 by Blumenschein.

Poe, Edgar Allan. *Tales by.* New York: Duffield & Co., 1909 (1908?). Words "Centenary Edition" on title page, cloth with

small colored illus. mounted on the front cover, 218 (1) pp., gilt top, seven illus. in color, frontis., and facing pp. 36, 48, 74, 91, 110, and 168, by Blumenschein.

Reed, Walt. *The Illustrator in America 1900-1960's*. New York: Reinhold, 1966. Cloth, pic. green endsheets, 271 (1) pp., "Is Illustration Art?" by Albert Dorne, bibliography, numerous illus. including one, p. 47, by Blumenschein and with a brief biographical sketch of him. (Crawford, Dunn, Dunton, Eggenhofer, Fischer, Fogarty, Goodwin, Keller, Koerner, Remington, Russell, Schoonover, Stoops, Wyeth)

Rossi, Paul A., and David C. Hunt. *The Art of the Old West (from the Collection of the Gilcrease Institute)*. New York: Knopf, but printed in Italy, 1971.Words "First Edition" on copyright page, pic. cloth, pic. brown endsheets, 335 (1) pp., preface, listing of artists and works, bibliography, numerous illus. including two in color, pp. (305) and (306-7), by Blumenschein. (Borein, James, Leigh, Miller, Remington, Russell, Schreyvogel, Wyeth)

The Second Annual of Illustrations for Advertisements in the United States. The Art Directors Club, N.Y., 1923. Cloth and decor. boards, tan endsheets, 171 pp., numerous illus. including one in color, *The Indian Suite*, p. (18), by Blumenschein. It was the First Award Medal winner for Paintings and Drawings in Color. (Dunn, Keller, Wyeth)

Taft, Robert. *The End of a Century—The Pictorial Record of the Old West XIII*. Reprinted from *The Kansas Historical Quarterly*, Topeka, Kan., August 1951. Pictorial wraps, pp. 225-253, illus. including a photo of Blumenschein, and one full-page plate, between pp. 248-249, by Blumenschein. (Dixon, Leigh, Lungren, Remington, Russell, Schreyvogel)

———. *Artists and Illustrators of the Old West*, 1850-1900. New York: Charles Scribner's Sons, 1953. Code letter "A" follows copyright notice, cloth, map endsheets, 399 pp., preface and acknowledgments, sources and notes, index, 90 numbered illus. including one, no. 89, by Blumenschein. (Leigh, Remington, Schreyvogel)

Watson, Thomas J., et al. *Contemporary Art of the United States*. New York: International Business Machines Corp., 1940. Wraps, unpaged, foreword, numerous illus. including one, *Mountain Near Taos*, by Blumenschein. (Dixon, Lea)

Weaver, Paul E. *Autumn* 1973 Book List. Flagstaff, Ariz.:

Northland Press. Colored pic. wraps, unpaged, numerous illus. including one by Blumenschein. (Beeler, Dixon, James, Perceval, Remington, Santee, Von Schmidt)

THE ARTIST AND HIS ART
(E. L. BLUMENSCHEIN)

Abousleman, Michael D. (compiler). *Who's Who in New Mexico*. Albuquerque: The Abousleman Co., 1937. Fabricoid, 254 pp., preface. Biographical sketch of Blumenschein. (Dunton, Hurd)

Blumenschein, Helen G. *Sangre de Cristo (A Short Illustrated History of Taos)*. Privately printed in Taos, 1955. Pic. wraps, unpaged, illus. by the author; mentions her father on the page about Taos artists and writers.

Dippie, Brian W. "Brush, Palette, and the Custer Battle— A Second Look," an article on the art of the Little Big Horn in *Montana* 24:1, Winter 1974, with one illus. by Blumenschein. (Dunton, Remington, Russell, Schreyvogel, Von Schmidt)

Clark, Edna Maria. *Ohio Art and Artists*. Richmond, Va.: Garrett and Massie, 1932. Cloth, 509 pp., preface, appendices, index, illus. Blumenschein, pp. 319 and 336-337 and biographical sketch, p. 444. (Deming)

Dunton, W. Herbert. "The Painters of Taos," an article in *The American Magazine of Art*, August 1922, with one illus. by Blumenschein. (Dunton)

Ewing, Robert, et al. *50th Anniversary Exhibition, November 12, 1967 to February 18, 1968*. Museum of New Mexico, Fine Arts Bldg., Santa Fe. Colored pic. wraps, unpaged, "Foreword" by Ewing, includes a biographical sketch and a photo of Blumenschein and lists his three paintings in the exhibition.

Ferbrache, Lewis. *Theodore Wores*. Privately printed, San Francisco, 1968. Colored pic. wraps, 63 pp., "Preface" by Joseph A. Baird, Jr., illus. by Wores; Wores mentions Blumenschein a number of times in his letters (summer 1917) from Taos.

Fisher, Reginald (compiled and edited by). *An Art Directory of New Mexico*. Santa Fe: Museum of New Mexico and

School of American Research, 1947. Words "Edition-1000" on copyright page, wraps, 78 pp., foreword. The Blumenschein sketch appears on pp. 10 and 11. (Hurd)

Forrest, James T. "Ernest L. Blumenschein," an article in *The American Scene* 3:3, Fall 1960, Gilcrease Institute, Tulsa, with four illus. by Blumenschein. This issue also includes "Tribute to an Artist" by C. L. Packer—reminiscences of an art class at Taos where Blumenschein served as a critic. (Dunton)

Hewett, Edgar L. "On the Opening of the Art Galleries," an article in *Art and Archaeology* 7:1-2, Jan.-Feb. 1918, one illus. by Blumenschein. (Dunton)

———. "Recent Southwestern Art," an article in *Art and Archaeology* 9:1, January 1920, one illus. by Blumenschein. (Dunton)

Hinshaw, Merton E. (Director). *Painters of the West.* Santa Ana, Calif.: Charles W. Bowers Memorial Museum, 1972. Includes a biographical sketch of Blumenschein. (Johnson, Miller, Remington, Russell)

Hoeber, Arthur. "Painters of Western Life," an article in *Mentor Magazine*, June 15, 1915. Includes one illus. by Blumenschein and a photo of him. (Dunton, Leigh, Remington, Russell, Schreyvogel)

Ortega, Joaquin, ed. *New Mexico Quarterly Review*, Vol. XIX, no. 1. The University of New Mexico, Albuquerque, Spring 1949, dec. wraps, 144 p., five illus. between pp. 24 and 25 by Blumenschein, contains "Ernest L. Blumenschein—The Artist in His Environment" by Howard Cook, pp. 18-24.

Perceval, Don Louis, et al. *Art of Western America.* Pomona College Art Gallery, Claremont, Calif., November 1-31, 1949. Pic. wraps, unpaged, foreword, very brief sketch of Blumenschein and lists his two paintings in the exhibition. (Russell)

Ronnebeck, Arnold. "Blumenschein," a biographical sketch in *El Palacio* 24:25, June 23, 1928, Museum of New Mexico, Santa Fe.

Russell, Don. *Custer's Last (The Battle of the Little Big Horn in Picturesque Perspective).* Amon Carter Museum, Ft. Worth, 1968, cloth, 67 pp., notes, bibliography, 17 plates; includes material in text on Blumenschein. (Deming, Dunton, Russell)

"Second Annual Exhibit of the Taos Society of Artists."
Palace of the Governors, Santa Fe, n.d. (1916?). Pic. wraps,
unpaged, includes a biographical sketch of Blumenschein.
(Dunton)

MAGAZINES ILLUSTRATED BY
E. L. BLUMENSCHEIN

MCCLURE'S

February	1895	8 illus., J. Templis.
September	1897	1 illus., R. Kipling.
November	1897	6 illus., Cpt. M. Davis.
January	1898	13 illus., C. Y. Warman.
January	1898	1 illus., J. H. Holmes.
February	1898	8 illus., S. Crane.
July	1989	6 illus., W. A. Fraser.
January	1899	6 illus., H. Garland.
February	1899	illus., A. C. Humbert.
April	1899	5 illus.
May	1899	5 illus., H. Garland.
July	1899	10 illus., W. A. Fraser.
September	1899	1 illus., C. Moffett.
November	1899	6 illus., W. A. Fraser.
January	1900	5 illus.
May	1900	vol. 15, no. 1
May	1901	illus., J. London.
November	1902	5 illus., H. Garland.
August	1903	4 illus., D. Robinson.
October	1905	3 illus., A. Kinross.
December	1905	"Love of Life," J. London.
February	1906	vol. 26, no. 4
August	1906	vol. 27, no. 4, 2 articles
December	1906	"Chancy of the Jack-Pot," C. Frederic.
January	1907	2 illus., A. Meluin.
February	1907	"Two Men and the Desert," F. L. Wheeler.
April	1907	2 illus., V. Roseboro.
May	1907	vol. 29, no. 1
October	1907	illus., M. K. Waddington.

November	1907	Vol. 30, no. 1
February	1908	illus., M. K. Waddington.
March	1908	illus., M. K. Waddington.
March	1909	Vol. 32, no. 5

HARPER'S MONTHLY

June	1898	Vol. XCVII
July	1898	Vol. XCVII
February	1899	Vol. XCVIII
June	1899	Vol. XCIX
January	1901	Vol. CII
September	1901	Vol. CIII

HARPER'S WEEKLY

March	4, 1899	1 illus., E. L. Blumenschein.
March	12, 1898	Vol. XLII, no. 2151
April	30, 1898	Vol. XLII, no. 2158
July	1898	Vol. XLII
December	10, 1898	Vol. XLII, no. 2190
August	19, 1899	Vol. XLIII, no. 2226
October	28, 1899	Vol. XLIII, no. 2236
January	27, 1900	Vol. XLIV, no. 2249
May	5, 1900	Vol. XLIV, no. 2263 3 articles
May	26, 1900	Vol. XLIV, no. 2266 2 articles
June	9, 1900	Vol. XLIV, no. 2268
June	30, 1900	Vol. XLLIV, no. 2271
July	28, 1900	Vol. XLIV, no. 2275
January	19, 1901	Vol. XLV, no. 2300
May	18, 1901	Vol. XLV, no. 2317
November	25, 1905	Vol. XLIX, no. 2553 paintings
April	30, 1910	Vol. LIV, no. 2784 paintings
January	4, 1913	Vol. LVII, no. 2924 paintings

SCRIBNER'S

March	1897	Vol. XXI
October	1903	Vol. XXXIV, no. 4
August	1910	Vol. XLVIII, no. 2
August	1915	5 illus., J. Lee.
August	1916	1 illus., E. Peixotto.
October	1916	3 pages, Mary Symon.

CENTURY

March	1901	16 illus., W. Fawcett.
April	1901	13 illus., W. Fawcett.
June	1901	Vol. LXII, no. 2
August	1901	Vol. LXII, no. 4
January	1902	2 illus., A.Ruhl.
November	1902	Vol. LXV, no. 1
March	1903	Vol. LXV, no. 5
April	1903	Vol. LXV, no. 6
November	1903	6 illus., C. E. Stedman.
June	1904	Vol. LXIII, no. 2
December	1909	Vol. LXXIX, no. 2
January	1910	Vol. LXXIX, no. 3
August	1910	Vol. LXXX, no. 4
September	1911	Vol. LXXXII, no. 5
February	1912	2 B&W illus., 1 Color, P. Wilkins.
September	1913	illus., A. O'Hagen.

AMERICAN MAGAZINE

December	1906	3 illus., E. Peple.
August	1907	Vol. LXIV, no. 4
October	1907	Vol. LXIV, no. 6
April	1908	Vol. LXV, no. 6
September	1908	Vol. LXVI, no. 5
December	1908	Vol. LXVII, no. 2
February	1910	Vol. LXIX, no. 4
October	1911	Vol. LXXII, no. 6
July	1912	Vol. LXXIV, no. 3
January	1913	Vol. LXXV, no. 3
November	1913	Vol. LXXVI, no. 5
May	1914	Vol. LXXX, no. 5
June	1914	Vol. LXXX, no. 6
January	1915	Vol. LXXIX, no. 1
February	1915	Vol. LXXIX, no. 2
July	1916	Vol. LXXXII, no. 1
August	1916	Vol. LXXXII, no. 2
September	1916	Vol. LXXXII, no. 3
December	1916	Vol. LXXXII, no. 6
January	1917	Vol. LXXXIII, no. 1

April	1917	Vol. LXXXIII, no. 4
November	1917	Vol. LXXXIV, no. 5
December	1918	Vol. LXXXVI, no. 6

TOWN & COUNTRY MAGAZINE

October 20, 1919

PARIS SALON CATALOGS 1907, 1908

The Second Annual of Illustrations for Advertisements in the United States. The Art Directors Club, N.Y., 1923.

Dorsey, George Amos. *Indians of the Southwest*. Chicago: Passenger Dept. Atchison, Topeka & Santa Fe Railway System, 1903.

OTHER

Blumenschein, E. L. Autobiographical, 1882

"Speech to Students," undated, untitled, 1891, American Archives.

Nov. 1958. An interview with E. L. Blumenschein, KOB Radio.

Clurman, Irene. "63 years of New Mexico Painting." *Rocky Mountain News*, March 26, 1978, p. 13.

Blumenschein, E. L. "Behind the Scenes at a Wild West Show." *Harper's Weekly*, April 10, 1898, 10 illus. and story.

Blumenschein, E. L. Autobiographical Paper, 1898.

Schwartz, Santoro. "When New York Went to New Mexico." *Art in America*.

Twitchell. "Santa Fe-Taos Artists." *Leading Facts of New Mexican History*, Vol. 5.

Morril, Claire. "A Taos Mosaic, Portrait of a New Mexico Village."

Stram, Ron Allen. "Forward to Fishing." *New Mexico* magazine, May 1937.

Pyle, Ernie. *More about Ernie Pyle*.

Pollock, Duncan. "Artists of Taos and Santa Fe, from Zane Grey to the Tide of Modernism." *Art News*, January 1974.

Cassidy, Ina Sizer. "Blumenschein in Retrospect." *New Mexico* magazine, Vol. 26, no. 7, July 1948.

Interview of Blumenschein, El Palacio, Vol. VI, no. 6,

March 1, 1919.

Blumenschein, E. L. "San Geronimo: The Pueblo Indian's Holiday." *Harper's Weekly*, December 11, 1898. 11 illus.

Young, Dr. Jon. Excerpt from unpublished paper, Kit Carson Memorial Foundation, September 1978.

Nelson, Mary Carroll. "Ernest L. Blumenschein N.A. Pioneer Artist of Taos." 1924.

Blumenschein, E. L., Autobiographical Paper, 1901

Peixotto, Ernest. "The Field of Art" (from *The Archives*), Vol. LX-26, p. 257.

Blumenschein, E. L. "This Transitional Age in Art: The Paintings of Tomorrow." *Century*, April 1914.

Blumenschein, E. L. Post-impressionism, around 1914.

Morang, Alfred. "Art in the News" (no source, no date), 1915.

Coke, Van Deren. "Why Artists Came to New Mexico, 'Nature Presents a New Face Each Moment.' " *Art News*, January 1974, vol. 73, no. 1.

Blumenschein, E. L. Personal notes, undated, around 1915.

———. Dayton, Ohio paper, October 3, 1915.

———. Art News article, 1918, probably fall.

Salmagundi War Service, letter from committee, October 6, 1918.

Blumenschein interview, *El Palacio*, March 1, 1919, Vol. VI, no. 6.

Speech presented by a friend about E. L. Blumenschein, American Archives, untitled and undated.

Taos Valley News, article, about 1930, American Archives.

El Palacio, Museum Events.

Cook, Howard, "New Mexico Artists, Series No. 3, 'E. L. Blumenschein and His Environment.' " *New Mexico Quarterly*, Spring 1949.

Peixotto, Ernest. "Our Hispanic Southwest. 'Northward to Taos.' "

Article—Untitled, American Archives, 1920.

Clurman, Irene. "63 years of New Mexico Painting." *Rocky Mountain News*, March 26, 1978.

Hennings, William. "Introduction to the 1978 Colorado Springs Catalog." 1978.

Associated Press Reporter. "Interview: Modernism."

American Archives, October 1952.

Cassidy, Ina Sizer. "Art and Artists of New Mexico." *New Mexico* magazine, July 1948.

Blumenschein, E. L. "The Artist Explains." *New Mexico* (newspaper), September 13, 1953, American Archives.

Marvin, Katy. "City's Intellectual Growth Lags, says Blumenschein." Newspaper, February 27, 1952.

Van Soelen, Theodore. "Blumenschein Exhibit Sets Important Precedent." Santa Fe *New Mexican*, June 4, 19148.

Newspaper (untitled). *New York Herald*, November 12, 1921.

"Ernest L. Blumenschein, Artist of Taos." *El Palacio.*

Rindge, Fred Hamilton. "Taos—A Unique Colony of Artists." *The American Magazine of Art,* vol. 17, September 1925.

"Santa Fe and Taos Artists." *El Palacio*, 1927.

"New Mexico Artists—Blumenschein Exhibit in Denver." *El Palacio*, 1928.

"Painters in Taos: The Formative Years." The Eiteljorg Collection, Exhibition Catalog, 1930.

"Fine Paintings on Exhibition." *Shreveport (La.) Times* (Sun. morning), 1930.

Cook, Howard. "The Art of E. L. Blumenschein." Speech presented at 1948 Retrospective Santa Fe, American Archives.

Read, Helen Appleton (of the *Brooklyn Daily Eagle*). "Blumenschein, Out of the West." *Art Digest*, April 1, 1934.

Breuning, Margaret. "Art World Events." The *New York Post* (?), March 27, 1934.

Article (no title), *The Sun*, New York, N.Y., March 24, 1934.

Cooke, Regina. "The Blumenschein's, A First Family." *El Crepusculo*, September 25, 1952.

"Blumenschein to be included in Paris Exhibition" (newspaper clipping). 1936.

Robins, Elizabeth. "Embry Americans." September 1901, 2 full-page illus.

Breckenridge, J. Ellis. *Something Else.* Chicago: A. C. McClure & Co., 4 illus. , 1911.

Cather, Willa Sibert. "The Namesake." March 1907.

Robins, Elizabeth. "Come and Find Me." Series of illus., April 1907 through March 1908.

Waddington, Mary King. "Chateau & Country Life in France." *Scribner's*, 21 illus.

Mena, Maria Cristina. "The Gold Vanity Set." November 1913, 1 full-page color.

American, "May of Art," article, September 1917.

Luhan, Mabel Dodge. "Taos—A Eulogy." October 1931.

Blumenschein, Helen Greene. *Recuerdos: Early Days of the Blumenschein Family*. Silver City, N.M.: Tecolote Press, 1979.

"The Blumenschein Exhibit." *El Palacio* 25 (August 1928).

"Blumenschein Explains What Makes a Painting New." Santa Fe *New Mexican*, September 13, 1953, Section B.

"Ernest Blumenschein: Artist of Taos." *El Palacio* 53 (March 1964).

Berninghaus, O. E. "E. Irving Couse, N.A.—W. Herbert Dunton." *The Western Artist* 2 (July-August 1936).

"Eanger Irving Couse." *The Art Review* (January 1904).

Nelson, Mary Carroll. "William Herbert Dunton: From Yankee to Cowboy." *American Artist* 42 (January 1978).

Fisher, Reginald. "E. Martin Hennings, Artist of Taos." *El Palacio* 53 (August 1946).

White, Robert Rankin. "Taos Founder, E. Martin Hennings." *Southwest Art* (April 1974).

"Exhibit by Higgins." *Southwestern Artists* 33 (December 1932).

Hogue, Alexandre. "With Southwestern Artists: Victor Higgins—Some Opinions of Apothegmatic Artist." *Southwest Review* (Winter 1931).

Harvey, Betty. "E. Irving Couse." *Artists of the Rockies and the Golden West* 4 (Winter 1977).

Henderson, Rose. "A Painter of Pueblo Indians." *American Magazine of Art* 11 (September 1920).

Nelson, Mary Carroll. "Eanger Irving Couse: The Indian as Noble Innocence." *American Artist* 42 (January 1978).

"Personality of the Week: Miss Catharine Carter Critcher." The *Jefferson Republican* (December 23, 1948).

Exhibition of Paintings by Miss Catharine Critcher. Washington, D.C.: Cosmos Club.

Exhibition of Paintings by Catharine Critcher. New

York: Studio Guild, 1938.

Special Exhibition of Oil Paintings by Catharine Critcher. Washington, D.C.: Corcoran Gallery of Art, 1940.

An Exhibition of Portraits and Personalities: Paintings in Oil by Catharine C. Critcher. Hagerstown, Maryland: Washington County Museum of Fine Arts, 1949.

Nelson, Mary Carroll. "Victor Higgins: Creative Explorer." *American Artist* 42 (January 1978).

Nelson, Mary Carroll. "Bert Geer Phillips: Taos Romantic." *American Artist* 42 (January 1978).

Holt, Vashti Y. "Joseph Henry Sharp: The First Artist to Visit Taos." *The American Scene* 3 (Fall 1960): 4.

Nelson, Mary Carroll. "Joseph Henry Sharp: Dedicated Observer." *American Artist* 42 (January 1978).

"The Art of Walter Ufer." Santa Fe *New Mexican* (August 30, 1919), Rotogravure Section.

Egri, Ted and Kit. "Walter Ufer: Passion and Talent." *American Artist* 42 (January 1978).

"The Santa Fe-Taos Art Colony: Walter Ufer." *El Palacio* 3 (August 1916).

The complete letters of Mary G. Blumenschein to E. L. Blumenschein.

INDEX

Other Books from John Muir Publications

Adventure Vacations: From Trekking in New Guinea to Swimming in Siberia, Richard Bangs (65-76-9) 256 pp. $17.95

Asia Through the Back Door, 3rd ed., Rick Steves and John Gottberg (65-48-3) 326 pp. $15.95

Being a Father: Family, Work, and Self, *Mothering* Magazine (65-69-6) 176 pp. $12.95

Buddhist America: Centers, Retreats, Practices, Don Morreale (28-94-X) 400 pp. $12.95

Bus Touring: Charter Vacations, U.S.A., Stuart Warren with Douglas Bloch (28-95-8) 168 pp. $9.95

California Public Gardens: A Visitor's Guide, Eric Sigg (65-56-4) 304 pp. $15.95 (Available 3/91)

Catholic America: Self-Renewal Centers and Retreats, Patricia Christian-Meyer (65-20-3) 325 pp. $13.95

Complete Guide to Bed & Breakfasts, Inns & Guesthouses, Pamela Lanier (65-43-2) 520 pp. $15.95

Costa Rica: A Natural Destination, Ree Strange Sheck (65-51-3) 280 pp. $15.95

Elderhostels: The Students' Choice, Mildred Hyman (65-28-9) 224 pp. $12.95

Environmental Vacations: Volunteer Projects to Save the Planet, Stephanie Ocko (65-78-5) 240 pp. $15.95 (Available 10/90)

Europe 101: History & Art for the Traveler, 4th ed., Rick Steves and Gene Openshaw (65-79-3) 372 pp. $15.95

Europe Through the Back Door, 9th ed., Rick Steves (65-42-4) 432 pp. $16.95

Floating Vacations: River, Lake, and Ocean Adventures, Michael White (65-32-7) 256 pp. $17.95

Gypsying After 40: A Guide to Adventure and Self-Discovery, Bob Harris (28-71-0) 264 pp. $12.95

The Heart of Jerusalem, Arlynn Nellhaus (28-79-6) 336 pp. $12.95

Indian America: A Traveler's Companion, Eagle/Walking Turtle (65-29-7) 424 pp. $16.95

The Indian Way: Learning to Communicate with Mother Earth, Gary McLain (Young Readers, 8 yrs. +) (65-73-4) 114 pp. $9.95

The Kids' Environment Book: What's Awry and Why, Anne Pedersen (10 yrs. +) (65-74-2) 192 pp. $12.95 (Available 1/91)

Mona Winks: Self-Guided Tours of Europe's Top Museums, Rick Steves and Gene Openshaw (28-85-0) 456 pp. $14.95

The On and Off the Road Cookbook, Carl Franz (28-27-3) 272 pp. $8.50

Paintbrushes and Pistols: How the Taos Artists Sold the West, Schwarz and Taggett (65-65-3) 280 pp. $17.95

The People's Guide to Mexico, Carl Franz (65-60-2) 608 pp. $17.95

The People's Guide to RV Camping in Mexico, Carl Franz with Steve Rogers (28-91-5) 320 pp. $13.95

Preconception: A Woman's Guide to Preparing for Pregnancy and Parenthood, Brenda E. Aikey-Keller (65-44-0) 232 pp. $14.95

Rads, Ergs, and Cheeseburgers: The Kids' Guide to Energy and the Environment, Bill Yanda (8 yrs. +) (65-75-0) 108 pp. $12.95 (Available 2/91)

Ranch Vacations: The Complete Guide to Guest and Resort, Fly-Fishing, and Cross-Country Skiing Ranches, Eugene Kilgore (65-30-0) 392 pp. $18.95

Schooling at Home: Parents, Kids, and Learning, *Mothering* Magazine (65-52-1) 264 pp. $14.95

The Shopper's Guide to Art and Crafts in the Hawaiian Islands, Arnold Schuchter (65-61-0) 256 pp. $12.95 (Available 11/90)

The Shopper's Guide to Mexico, Steve Rogers and Tina Rosa (28-90-7) 224 pp. $9.95

Ski Tech's Guide to Equipment, Skiwear, and Accessories, edited by Bill Tanler (65-45-9) 144 pp. $11.95

Ski Tech's Guide to Maintenance and Repair, edited by Bill Tanler (65-46-7) 144 pp. $11.95

Teens: A Fresh Look, *Mothering* Magazine (65-54-8) 240 pp. $14.95

A Traveler's Guide to Asian Culture, Kevin Chambers (65-14-9) 224 pp. $13.95

Traveler's Guide to Healing Centers and Retreats in North America, Martine Rudee and Jonathan Blease (65-15-7) 240 pp. $11.95

Understanding Europeans, Stuart Miller (65-77-7) 272 pp. $14.95

Undiscovered Islands of the Caribbean, Burl Willes (65-55-6) 232 pp. $14.95

Undiscovered Islands of the Mediterranean, Linda Lancione Moyer and Burl Willes (65-53-X) 232 pp. $14.95

A Viewer's Guide to Art: A Glossary of Gods, People, and Creatures, Shaw and Warren (65-66-1) 152 pp. $9.95 (Available 3/91)

22 Days Series

These pocket-size itineraries (4½" x 8") are a refreshing departure from ordinary guidebooks. Each offers 22 flexible daily itineraries that can be used to get the most out of vacations of any length. Included are not only "must see" attractions but also little-known villages and hidden "jewels" as well as valuable general information.

22 Days Around the World, Roger Rapoport and Burl Willes (65-31-9) 200 pp. $9.95

22 Days Around the Great Lakes, Arnold Schuchter (65-62-9) 176 pp. $9.95 (Available 1/91)

22 Days in Alaska, Pamela Lanier (28-68-0) 128 pp. $7.95

22 Days in the American Southwest, 2nd ed., Richard Harris (28-88-5) 176 pp. $9.95

22 Days in Asia, Roger Rapoport and Burl Willes (65-17-3) 136 pp. $7.95

22 Days in Australia, 3rd ed., John Gottberg (65-40-8) 148 pp. $7.95

22 Days in California, 2nd ed., Roger Rapoport (65-64-5) 176 pp. $9.95

22 Days in China, Gaylon Duke and Zenia Victor (28-72-9) 144 pp. $7.95

22 Days in Europe, 5th ed., Rick Steves (65-63-7) 192 pp. $9.95

22 Days in Florida, Richard Harris (65-27-0) 136 pp. $7.95

22 Days in France, Rick Steves (65-07-6) 154 pp. $7.95

22 Days in Germany, Austria & Switzerland, 3rd ed., Rick Steves (65-39-4) 136 pp. $7.95

22 Days in Great Britain, 3rd ed., Rick Steves (65-38-6) 144 pp. $7.95

22 Days in Hawaii, 2nd ed., Arnold Schuchter (65-50-5) 144 pp. $7.95

22 Days in India, Anurag Mathur (28-87-7) 136 pp. $7.95

22 Days in Japan, David Old (28-73-7) 136 pp. $7.95

22 Days in Mexico, 2nd ed., Steve Rogers and Tina Rosa (65-41-6) 128 pp. $7.95

22 Days in New England, Anne Wright (28-96-6) 128 pp. $7.95

22 Days in New Zealand, Arnold Schuchter (28-86-9) 136 pp. $7.95

22 Days in Norway, Denmark & Sweden, Rick Steves (28-83-4) 136 pp. $7.95

22 Days in the Pacific Northwest, Richard Harris (28-97-4) 136 pp. $7.95

22 Days in the Rockies, Roger Rapoport (65-68-8) 176 pp. $9.95

22 Days in Spain & Portugal, 3rd ed., Rick Steves (65-06-8) 136 pp. $7.95

22 Days in Texas, Richard Harris (65-47-5) 176 pp. $9.95 (Available 11/90)

22 Days in Thailand, Derk Richardson (65-57-2) 176 pp. $9.95

22 Days in the West Indies, Cyndy & Sam Morreale (28-74-5) 136 pp. $7.95

"Kidding Around" Travel Guides for Children

Written for kids eight years of age and older. Generously illustrated in two colors with imaginative characters and images. An adventure to read and a treasure to keep.

Kidding Around Atlanta, Anne Pedersen (65-35-1) 64 pp. $9.95

Kidding Around Boston, Helen Byers (65-36-X) 64 pp. $9.95

Kidding Around Chicago, Lauren Davis (65-70-X) 64 pp. $9.95

Kidding Around the Hawaiian Islands, Sarah Lovett (65-37-8) 64 pp. $9.95

Kidding Around London, Sarah Lovett (65-24-6) 64 pp. $9.95

Kidding Around Los Angeles, Judy Cash (65-34-3) 64 pp. $9.95

Kidding Around the National Parks of the Southwest, Sarah Lovett 108 pp. $12.95

Kidding Around New York City, Sarah Lovett (65-33-5) 64 pp. $9.95

Kidding Around Philadelphia, Rebecca Clay (65-71-8) 64 pp. $9.95

Kidding Around San Francisco, Rosemary Zibart (65-23-8) 64 pp. $9.95

Kidding Around Washington, D.C., Anne Pedersen (65-25-4) 64 pp. $9.95

Automotive Repair Manuals

How to Keep Your VW Alive (65-80-7) 440 pp. $19.95

How to Keep Your Subaru Alive (65-11-4) 480 pp. $19.95

How to Keep Your Toyota Pickup Alive (28-81-3) 392 pp. $19.95

How to Keep Your Datsun/ Nissan Alive (28-65-6) 544 pp. $19.95

Other Automotive Books

The Greaseless Guide to Car Care Confidence: Take the Terror Out of Talking to Your Mechanic, Mary Jackson (65-19-X) 224 pp. $14.95

Off-Road Emergency Repair & Survival, James Ristow (65-26-2) 160 pp. $9.95

Ordering Information

If you cannot find our books in your local bookstore, you can order directly from us. Please check the "Available" date above. If you send us money for a book not yet available, we will hold your money until we can ship you the book. Your books will be sent to you via UPS (for U.S. destinations). UPS will not deliver to a P.O. Box; please give us a street address. Include $2.75 for the first item ordered and $.50 for each additional item to cover shipping and handling costs. For airmail within the U.S., enclose $4.00. All foreign orders will be shipped surface rate; please enclose $3.00 for the first item and $1.00 for each additional item. Please inquire about foreign airmail rates.

Method of Payment

Your order may be paid by check, money order, or credit card. We cannot be responsible for cash sent through the mail. All payments must be made in U.S. dollars drawn on a U.S. bank. Canadian postal money orders in U.S. dollars are acceptable. For VISA, MasterCard, or American Express orders, include your card number, expiration date, and your signature, or call (800) 888-7504. Books ordered on American Express cards can be shipped only to the billing address of the cardholder. Sorry, no C.O.D.'s. Residents of sunny New Mexico, add 5.625% tax to the total.

Address all orders and inquiries to:
John Muir Publications
P.O. Box 613
Santa Fe, NM 87504
(505) 982-4078
(800) 888-7504